ALSO BY SHELLEY SINGER

THE JAKE SAMSON AND ROSIE VICENTE SERIES

Samson's Deal
Free Draw
Full House
Spit in the Ocean
Suicide King

THE BARRETT LAKE SERIES

Following Jane
Picture of David
Searching for Sara
Interview with Mattie

§

Royal Flush

A JAKE SAMSON AND ROSIE VICENTE MYSTERY

by

Shelley Singer

A PERSEVERANCE PRESS BOOK
JOHN DANIEL & COMPANY, SANTA BARBARA, CALIFORNIA, 1999

This is a work of fiction. Characters, places, and events are the product of the author's imagination or are used fictitiously. Any resemblance to real people, companies, institutions, organizations, or incidents is entirely coincidental.

A Perseverance Press Book
Published by John Daniel & Company
A division of Daniel & Daniel, Publishers, Inc.
Post Office Box 21922
Santa Barbara, California 93121
www.danielpublishing.com/perseverance

Book design by Eric Larson
Cover illustration by Patricia Chidlaw; design by Frank Bucy/No Waves Press

LIBRARY OF CONGRESS CATALOGING-IN-PUBLICATION DATA
Singer, Shelley.
 Royal flush : a Jake Samson and Rosie Vicente mystery / by Shelley
Singer.
 p. cm.
 ISBN 1-880284-33-2 (alk. paper)
 I. Title.
PS3569.I565R69 1999
813'.54—dc21 99-10411
 CIP

For my daughter, Sonya

§

Thanks to those who didn't want their names used.

§

ROYAL FLUSH

The boy was about nineteen. He had a black eye, a shaved head, brown boots with yellow stitching and red laces, a bomber jacket, muscles, and an attitude.

When he'd showed up at my door with Deeanne, my first impulse was to spin him around and shove him back down the stairs. But heaven help us, he was Deeanne's boyfriend, so there he was, sitting on my couch and glaring at me, while she begged me to help him.

"See, Jake, I didn't want to tell Artie I was coming to see you because he doesn't, you know, have a lot of sympathy for, like, mistakes." She shrugged her bony adolescent shoulders helplessly.

She was talking about my oldest friend, Artie Perrine. Her godfather. Her keeper for the past half year while her parents were off somewhere on the other side of the world doing God knows what. Artie had told me she'd begged to stay with him and finish high school where she was. Being Artie, he'd agreed. But the more I heard about Deeanne, the more I thought her folks had planned the whole thing just to get away from her.

And now she wanted me to keep secrets from him. I needed a minute to think, and the September heat gave me an excuse to get up and move around. I opened a window, then I opened the front door. When I turned back, the boy had taken off his jacket. He was wearing black suspenders, and the short sleeve of his black T-shirt didn't cover the swastika tattoo.

I stared at it, disgust rising in my throat like a fast-food meal. "Mistakes? What kind of mistakes are we talking about, here?"

The kid jabbed a finger toward the ugly black symbol on his arm."This kind."

I tore my eyes away. I had an almost irresistible urge to spit on

the floor three times like my mother used to do. An old Yiddish spell against the evil eye.

"Hey, man! I was drunk. My buddy told the guy to do it."

I controlled my impulse. I hate washing floors.

"But you don't believe me. Come on, Deeanne, let's get out of here." He started to stand up, but the movement was pretty half-hearted.

Deeanne sighed and stroked his untattooed arm. He sat back again, sulky, James Dean but without the elfin charm.

"Royal, he's really okay. He'll listen."

That was his name. Royal. Royal Subic. And this wasn't the first time, if Artie's poker-night complaints were any indication, that Deeanne had shown weird taste in boyfriends. Maybe he was a little more presentable than some of the others—clear blue eyes, military posture, and a strong chin—but as far as I was concerned, he had to be the worst of the bunch.

"I think you should talk to Artie."

Deeanne shook her head hard, and her ragged shoulder-length blond hair played peekaboo with her ringed and studded ears. "You know what he'll do? He'll start yelling about Hitler. Like it wasn't a million years ago and like he hasn't lived here all his life or some-thing."

"You think I've got more sympathy than he does for that crap?" I glared in the general direction of the boy's tattoo. Not to mention what Rosie would think.

"But you're reasonable! And Royal's not a skinhead anymore."

I glanced doubtfully at his bald head. He stared defiantly back at me.

"I am, I'm still a skin. Dee doesn't understand. I just don't want to be an Aryan Command skin anymore." He seemed to be making a fine point there. I had no idea what it was.

Deeanne hesitated, frowning. Apparently she didn't get the fine point, either, but she recovered nicely. "Really. He wants to stop them."

"Yes, you said that." I gave Deeanne my best private eye scowl. "You need to know this—if I did decide to help I wouldn't keep it a secret from Artie."

"I knew that, Jake. I knew you'd talk to him."

"The point is, you don't want to."

She gazed at me, all pathetic Juliet. "He doesn't know about Royal. He's never met him."

I could believe that. It might be kind of fun to be there for the introduction, though. "Before we go any further, or stop altogether, what is it you want me to do?"

"Royal, honey, you tell him?"

He shrugged. "It's like this. I joined Aryan Command because I thought it was kind of cool, the boots and tattoos and shit, like a club, only more exciting. Like a war, but without getting killed."

He stopped, chewing on a dirty-nailed thumb, groping for words. Dumb kid.

I pushed. "And? How did that change?"

"They're connected, man. All over the place. Real Nazis in places like, well, Germany, and South America. And Washington." I hoped he meant the state, not the city. I didn't ask. "And they're serious."

Tigris and Euphrates were bumping against my legs, meowing for their Friskies Buffet. "Come on, Royal, it's dinnertime. Get to the point."

"Okay. They want to kill somebody."

"Who?"

"Preston Switcher."

The kid was loony. "The conservative radio guy?" Wasn't he their pal?

"Yeah. See, then they'll hit the other side, too. Burn down a black church or something, maybe kill a lefty. They got it all planned out. A giant, like, race war. Everywhere at once."

Big plans for a bunch of morons, but hey, morons have succeeded before. Suddenly, I wanted to close the door, close the window. I felt cold, so I sniped at the skinhead.

"And you used to think that was a good idea, but now you don't?"

"Come on! I said they're serious, man. I think they already killed a guy." His voice shook on the word "killed," and his lock on my

eyes faltered. Royal's newfound conscience seemed to have a personal angle.

"Someone you knew?"

"Someone who tried to leave, tried to quit." That was it, then. This was the personal part, and maybe the only real part. He was scared. He wanted to quit and he was afraid to. I wouldn't be surprised if he'd made up the rest of it. The story sounded like a kid's idea of making the world self-destruct. A movie.

"I didn't want to come here. I told her you wouldn't care. But Deeanne said you would. She said you're really smart and you can stop them."

Yeah. Smart. Smart enough to know when a dumb punk was trying to con me with flattery.

I turned to Deeanne. "How deep are you into this Aryan Command?"

"Oh, like not at all, Jake. See, by the time I met Royal he was already, you know, disenchanted. I was at this bar they go to, a couple times for a few minutes. He didn't want me to get to know the people." But they'd met her.

"Go to the police, Royal."

"No. I can't do that. No cops. I want you to stop them."

"And exactly how would I do that? Shoot them all? Go to a Bund meeting and sign up? I don't think I'd pass. You know, they say that under stress we all revert to our first language. I might call somebody a schmuck."

He looked puzzled, almost smiled, and decided he shouldn't. "I don't know. You could hang out. Hell, you got light-colored hair. And your nose…" He must have caught the look in my Jewish blues because he stopped right there. "I could be your snitch. Your ringer. And maybe I can get you into one of the meetings. It's hard, though."

Hang out? Sure. Have a little beer. Do a little goose step.

"When do they plan to start this war?"

"Couple weeks, I guess."

"Let me think about it. And I'll need to talk to my boss." Did I mention Rosie Vicente's my boss now? It's a long story.

"I can pay you a lot of money."

"We'll talk about that part later." Where would this guy get a lot of money?

"I'll call you," he said. "At two o'clock tomorrow."

"Where can I reach you, Royal? In case we miss each other."

He just shook his head. He wasn't ready to trust me with that information.

I gave him my home number and my car-phone number. Like I trusted him. The kids stood to go, Deanne's baggy flared jeans flopping around her calves.

"Just a minute, Royal, I want to give you something." They waited while I went to the bathroom and got a cardboard box of Band-Aids. I tossed the box to him.

"What's this for?"

"Any time you're with me, you keep that damned tattoo covered."

His grubby hand clutched the box tightly. For a minute, I expected him to throw it back at me. But Deeanne was quick. She took his arm and led him out the door.

I watched them go, chewing my lip and wishing I still smoked.

With any luck, the cops were already on top of this Aryan Command thing. For all I knew, and certainly for all Royal Subic knew, the FBI had a ringer in the local chapter. Or platoon, or whatever they called it. Of course, the FBI might not care about pulling Royal's butt out of the fire, and there was Deeanne to worry about. If Royal's buddies went after him, they might get her, on purpose or by accident, it didn't matter which.

But before I did anything, even began to try to make a decision, I needed to talk to Rosie.

We're gumshoeing together again now, after a long and not-so-wonderful break. The only difference is that these days I work for her, in a loose kind of way, instead of the other way around. No big deal, you understand. As the French say: The more things change, the more they stay the same.

It all started one night when Rosie and I were sitting in my Oakland living room drinking a glass of California red. Suddenly, she dropped the news on me. She was moving, running off to Marin

County with a woman I didn't like. I had been pretty upset. Rosie was my best friend and sometime investigative partner. She'd been my tenant for nearly ten years, close quarters, too. My house was fifty paces down the path at the back of the lot. And she'd turned her little cottage—a studio slapped together in 1910—into a show-place. She was a professional carpenter who could, in a pinch, do plumbing, and that property had lots of pinches. On top of all that, she always paid her rent.

We'd seen each other through a few hard times, she'd worked some jobs with me, and we'd taken care of each other, too.

How were we going to do that if she lived in Fairfax, Gateway to West Marin?

"You can't live there," I told her. "I've seen the place. The sign says, Population 7,500."

"The sign exaggerates."

"I can't hold the cottage for you."

"You don't have to."

"I need your help with the agency."

She gave me the look she always gave me when I used that word. I'm not licensed. "No, you don't need me."

I did, but she wouldn't listen. She poured herself another glass and waved the bottle in my direction. I shook my head. My stomach was upset.

"Stop pouting, Jake."

Pouting? I never pout. I picked up Euphrates and nuzzled his ear. He purred.

There was more. She sipped her wine and looked at the ceiling. That made me really nervous. There's nothing up there but a few cracks, a few webs. She was avoiding my eyes. "I got a job. In Marin."

"You can do carpentry anywhere."

"A PI job. With an investigator."

This was too much. "You're going to work for someone else?" I couldn't believe it.

"I want my license. I have to work for a licensed PI. And you refuse—"

"Damn right. I'm not interested in being some guy's apprentice

for six thousand hours, or six million, or whatever it is, just to get a piece of paper that says I can do what I've been doing all along." I don't believe in pieces of paper. They clutter up the world. Computers are cluttering up something, too, but I can't figure out what it is.

"Well, I am. Interested. And it's not a guy."

"I don't care if it's a suckling pig."

She laughed. "Jake, come on!" I couldn't help it. I grinned back. I do love the fool, after all.

The years were slipping by, she said. She wasn't getting any younger.

I told her I thought she was. It didn't work.

She said she didn't want to be schlepping two-by-fours when the hot flashes kicked in. It was time, maybe past time, to set herself up in a business she could stay with.

What could I do? Nothing there I could argue with. So I told her to go with God. That was five years ago. She'd lived with the woman I didn't like for three of those years until she decided she didn't like her either. I never said, "I told you so," but she still didn't come back to my side of the bridge. She found her own place, got her license, and opened up an office in San Rafael. Sunny San Rafael. County seat and the only place in the county that bore any resemblance to a city. Population 50,000.

And meanwhile, during those five years, I sat around the house in Oakland watching my cats Tigris and Euphrates slip fatly into middle age while I tried not to, running through six hopeless tenants, working not very much, chasing women, pouting some more, and harping at Rosie to come back to the East Bay, which she would not.

I was doing a bit of harping one night not too long ago, in my favorite Thai restaurant, when Rosie came up with another idea.

"Sell the house, Jake. Move to Marin. Come to work for me."

I guess I must have stared at her because she burst out laughing.

"Why not? I worked for you. Now it's your turn."

I started to sing, "I cried for you, now it's your turn to cry over me...."

She waited, patient, an ascending eyebrow, a condescending smile.

I shook my head. "I lived in Marin once. My wife left me." Of course, that wasn't Marin's fault.

"You don't have one now, so she can't leave you."

"I'm used to Oakland. Berkeley."

"And too old and soft to change? Flexibility gone to pot, along with your once-flat gut?"

"Hey!" That was too much. A small spare tire, perhaps.

She grabbed my hand. "Sorry. You're still gorgeous. But you'd love it, I know. And for God's sake, it's twenty minutes away!"

"Half an hour."

"Give or take. Sell the house. Join me in Marvelous Marin."

"I love my neighborhood—don't you miss Rockridge?" Oops. What was that sudden funny feeling in my gut? An itch for something different?

"Sure. But Marin has whole towns like this. And a tax base, too."

My turn for the eyebrow routine. "Snobbery? From my politically correct Rosie?"

"I've never been politically correct. And I don't think it's snobbery to want to live someplace where you can forget to lock the door and where you can walk anywhere at night without a black belt."

"You're the one that's getting soft, Vicente." And I missed her like crazy. Obviously, she missed me, too, and that was nice. We made an effort to get together often, but that's what it was, an effort. Not a ten-second walk down the path.

"Could be." She plucked at her fat-free waistline. "But think about it. The agency's doing great. I could use the help."

She wasn't going to cave. That left only one option I could see— the caving would have to be mine. "Maybe I can find a place with a cottage?"

"If you did, maybe I'd move."

So I went home to think about it, and found thinking about it fairly easy.

For one thing, I did like Marin. It is both cosmopolitan and beautiful—an unbeatable combination. For another thing, it was not like my "agency" could not be moved. Thanks to my mother's will, I had a small but steady income that meant I only had to take cases I really wanted anyway.

For a third thing, there were my weekly poker games. Lately, they'd been more like monthly. Two of my poker buddies had moved away in the past year, one to Seattle and one to D.C. Of the two who'd stuck around, one of them had always lived in Marin and traveled to my house for games: Artie Perrine, my best friend next to Rosie. Artie ran an investigative magazine, a slick monthly called *Probe*; he'd given me a press card years ago so I could fake my way into places an unlicensed PI might want to go. I'd given him tips about stories a few times, and once spent a couple weeks hanging out at his mildewed Mill Valley canyon getting his nephew out of some trouble that involved a dead guy he found. That was one of the first cases I'd worked on back when I first decided to parlay a brief, disastrous, and very youthful career on the Chicago Police Department into an occasional moneymaker as an unlicensed PI.

So that made portable work, two very good friends living across the Bay, a crippled poker game in Oakland, and a feeling of restlessness I hadn't admitted even to Rosie.

That night I dreamed that Tigris and Euphrates asked me to buy them a house in the woods and hang up a lot of bird feeders.

And wouldn't you know it would be that very night that some son of a bitch broke into my classic blue and white 1953 Chevy Bel Air, which I'd dared to park on the street, took it for a joyride, and ran it into the barred front of a west Berkeley liquor store. Totaled. Worst of all, the guy lived.

I had decided to consider it an omen, and put the house up for sale.

Rosie was on a stakeout right now, down in Sausalito, and would be, late into the night. I called her car phone.

"You're kidding, right, Jake? You thought I must be bored so you made this up."

"I wish."

"Some skinhead wants us to save the world?"

"That's what he says. I think he wants us to save him."

"Call the FBI, my friend. Kiss this one good-bye. We don't need the money."

"There's something else, though. You remember Art's god-daughter, Deeanne? She's involved with the boy."

"Oh. Damn. She's not in the group, is she?"

"If she is, she's a turncoat like Royal."

"Okay. Let me make some calls, Jake, and see what I can find out. Does Artie know about this?"

"Not yet, but I'm going to call him the minute we get off the line."

"I'll get back to you. Where'll you be in two hours?"

"In bed, sleeping."

"I'll wake you."

"That'll be a first." She didn't say good-bye, but the raspberry damned near broke my eardrum.

I called Artie. He wasn't home so I left a vague message. Very vague. Then I fed the cats, got into my red '64 Ford Falcon Futura convertible, and went up to College Avenue for takeout, a falafel sandwich with plenty of hummus. Heading back home again, I was hoping Rosie would find out that the FBI had someone inside the Aryan Command, and everything was under control.

A couple of hours later, my bedside phone rang. It was Rosie.

"Okay, Jake. Here's the story. Pauline says they have some of their meetings in a house in San Rafael." Pauline was her buddy on the San Rafael PD, survivor of a nasty divorce that had left her generally pissed off and especially pissed off at men. She refused to give me information directly, or so Rosie insisted. The mention of her name irritated me enough to bring me fully awake.

"So they're Marin people."

"Not all of them. And they've got a hangout in Berkeley, too. Anyway, the FBI had a guy in there for a while. He was a member for over a year, couple years ago, and no one ever did anything but talk, and half the time all they talked about was their boots and their haircuts. Pauline says this informant of yours, this Royal, he's maybe dramatizing things, showing off for his girlfriend. She says that as far as she knows, nobody's going to get back onto these people unless someone brings them something real. I mentioned that Royal told you someone already got killed, but she says nobody

knows anything about that. And Pauline says that if the boy's telling the truth he needs to take it to the right people."

"He won't. I don't think he likes cops."

"Right. Just the Gestapo. Okay, then, how about this—why don't you keep away from those people, but let this Nazi be your snitch. Risk his skin, not yours. If he's telling the truth, let the FBI worry about it. If he isn't, let the cops worry about him."

"That won't work. I'll have to get more involved. He's not that bright."

"I don't think we should touch this."

I didn't think we should either, but I honestly didn't know what I was going to do.

"Say for the sake of argument that we do get some kind of information. Did Pauline give you a name to take it to—any G-man in particular?"

"Yes, San Francisco office. Pauline said, an agent named Harry George."

"Sounds like a kid's stuffed animal."

"Ha. Ha."

I thought it was funny. Something had to be.

I had barely fallen back to sleep when the phone rang again. This time it was Artie. Boy, did I not want to talk to him.

But I did. And when I'd finished, there was dead silence. Then a deep sigh, the kind I'd heard before when he talked about the girl. The sigh tailed off into a puppyish little groan. And more silence.

"Artie. About Deeanne—take it easy on her. You don't want her to bolt for good, spend the rest of her life with people like this."

Silence for a moment, then another sigh. "No, I guess not."

Royal didn't expect an answer until the next afternoon, but the part of my mind that pokes me awake wanted a decision that night.

Every dream reminded me, left me flapping around for an answer so I could go to sleep again. I thought about Rosie's idea of letting Royal do the inside work and then having the cops circle back toward him whether he liked it or not. But that had a couple of problems. We'd be lying to a client, which in this case I wasn't so sure I cared about, and—here was the big one—he was a dope who'd screw it all up, and in the process of getting himself hung out to dry, could put Deeanne in big trouble, too.

Until I took a look at the group, I had only his word for it that he couldn't just quit. If he was telling the truth, the only way to cut him loose was to bust the Aryan Command. Which also sounded to me like a good idea.

At 1:30, thrashing around in the sweaty sheets, I decided I was pissed at Deeanne for getting me into this. She needed to dump the little asshole and I needed to turn the job down. By 2:00, I was thinking I'd do it because I was worried about Deeanne and the people Royal said the group was planning to kill. By 3:00, the worry weighed about as much as the fear on the other side of the scales.

By morning, I'd decided to flat-out refuse.

Some things scare me a lot more than others. Hitler freaks, for instance, are much higher on my fear scale than your average run-of-the-mill killers. Terrorists. Zealots of any kind, any religion, any place along the spectrum. I believe in leaving people like that to the G-men, to the police, to those who are paid to uphold the Constitution.

Once upon a time, I had sworn to uphold the law. I'd been a

rookie when the Democrats came to Chicago in 1968, along with the Yippies and the hippies and the just-plain idealistic and the just-plain dumb. The people who came to shake things up knew damned well what the Chicago cops were like, had to know they'd lose it, had to know what would happen. I was supposedly on the other side, but that didn't keep me out of the just-plain-dumb category. It never occurred to me that my fellow cops would riot. When everything blew apart, when the tear gas hit the hot night air, I lost it, too. When a kid close to my own age came at me, screaming, "Pig!" I hit him with my nightstick. He fell, bleeding. I ran, leaving a trail of my own vomit. I'd been on the force a year. That was my last night.

Now, no matter how much I might get caught up in the problems of my clients, I am, after all, paid only to uphold my mortgage. I've got no official status of any kind, not even a PI license I could lose. What's the point of all that freedom if I can't turn down a bad-assed case? These days, I can run before I get to the point of throwing up.

So I was happy with my decision and happy that I'd made one. I left a message on Rosie's machine and went outside to the garden to pick some tomatoes. Off the hook, free as a bird, and clichés aside, maybe yellow as a sapsucker's belly.

I should have known better than to trust a cliché. Rosie didn't get back to me right away, but while I was out having words with the hornworms, Deeanne called. The number she'd left was mid-county. Not right for the place she was supposed to be spending her mornings for one more school year—Tamalpais High in Mill Valley.

I called the number. Deeanne was right there to pick up the phone, wherever *there* was.

"Oh, Jake, I'm glad you called. See, we were all, 'He's not gonna do it,' and Royal was like, 'Maybe we should call him this morning.' I didn't want to bother you, but we were scared you'd just decide, well, you know…"

"You were right to worry, Deeanne. That is what I decided. It's way out of my league." My league is bush. Farm. "You need to stay away from him before you get hurt. And Royal needs to take his problem to the police."

"He won't do that! And I won't leave him." I was afraid she'd say that.

An agitated-sounding male voice said something in the background.

"Is that Royal? Are you with Royal?"

"Yes. He wants to talk to you."

"Is this his home number?"

"No. Here he is."

"There's no point—"

Royal Subic was on the line.

"Mr. Samson, I been thinking. I was worried about how you feel about me and like that, but Deeanne, she says you're really good at this stuff and we can trust you, and I can't go to the police, I really can't. They wouldn't believe me anyway. And besides, there are other reasons."

"See, that's one of the things that worry me. You aren't telling me everything. You're hiding something."

"Oh, jeez, I'm sorry. I don't mean to. I just got used to being, you know… Listen, I'm really sorry I ever thought these guys were cool. I'm not like them. I don't hate nobody."

"Royal, I can't do it."

"What do you usually get a day, for the detective work?"

"Three hundred plus expenses."

"I'll give you six. I'll give you seven. I need help. And I've got the money."

Yeah, he'd said that before. "What do you do for a living, Royal?"

"I'm a plumber's helper. Part-time."

I asked the obvious question. "So where did all this money come from?" Images of Royal and his friends robbing blind beggars came to mind. No wonder he couldn't go to the police.

"I didn't steal it, if that's what worries you." I didn't like the way he emphasized the word *I*. "My dad, well…he's rich." For some reason, Royal didn't sound happy about that. "He'll give it to me. I can pay you whatever you want right in front, like for a week? That's…"

The calculation was taking him a while. I was in a hurry, so I did

it for him. "At seven hundred dollars a day it's forty-nine hundred, plus expenses."

"Fine. Please. Make it five thousand."

The balance was tipping again. Someone was going to have to get these kids out of the hole Royal had dug. I didn't know whether to believe all that conspiracy crap, but if any of it was true the feds needed to know. There was that, and there was Royal's more respectful, more beseeching attitude, his remorse, the money, and Deeanne. Against fear. I counted on my fingers. Five against one. So much for a night of decision-making.

"Okay. I'll give it a try. But if it looks too crazy, too impossible, too bad, I'm going to back out fast."

"That's fair."

"Thank you." He'd said his father would give him the money. That raised another question. "Your family—are they in this Command thing? Have they been involved in it?"

"Jesus, no! They don't even know about it. They met one of the guys once, and—well, they hated him."

Deeanne was back on the line. "Oh, Jake, I don't know how to thank you for this. You won't be sorry. I'll be grateful forever. Whatever you want, I'll—"

"Fine. Whatever I want? I'm going to take you up on that, Deeanne. Where are you?"

"We're in a diner. At a pay phone."

"Hang up the pay phone, leave the diner, and go to school. That's what I want." Get a little smarter. Maybe you'll learn to avoid the Royals of this world. "You'll only be a couple of hours late."

She hesitated for several seconds. "Okay. 'Bye. Don't tell Artie I wasn't in school, okay?" I grunted. "And I won't hang up yet because Royal wants to talk to you again, okay?"

I didn't have time to answer. Royal was back on the line. "I'll try to think about where you could start, and what all I need to tell you, and then I'll call you this afternoon, okay?"

"What time?"

"When I was going to before. Two. Okay?"

"Fine. You fill me in and we'll do some real planning. Then I can think about getting started."

"Thanks, Mr. Samson."

I said something like "Gmph" and cradled the receiver.

Rosie called me from the office to tell me she was glad I hadn't taken the case.

"Well, uh, I kind of decided that maybe we should..."

"Oh, Jesus, Jake. Why don't we have lunch and talk about it?"

"Okay, pick you up at the office at, what—?"

"Make it twelve-fifteen."

I had a couple of must-do chores that morning. First, I had to return a phone call from a client whose case I'd wrapped up the month before. He didn't understand some of the expenses he'd been charged for. The man had had a hard time understanding a lot of things, including how his girlfriend managed to embezzle a hundred thousand dollars from his electrical business. His wife didn't understand it either.

I spent fifteen minutes on the phone going over the costs with him. The one he balked at was the fifty bucks I'd given a waiter to listen in on the girlfriend's conversation with her accomplice, a guy who looked like he spent every waking hour working out. The client finally whined an agreement and said next time he'd hire a real PI. Yeah. Go with God.

Then I sat down at my 486—listen, it works okay—to check my e-mail. That's right, a computer. Blame Rosie for it. I personally am convinced that one of these days the airwaves or the circuits or whatever the hell are going to fill up and spontaneously combust and we're all going to drown in a shower of cybershit. But people kept trying to e-mail me, and Rosie asked really nice, and I'm going to make up for giving in by refusing to upgrade for as long as I possibly can.

So, the e-mail. Not much of interest there. A friend of a friend had what sounded like a pretty sleazy divorce case. After the electrician, I didn't want to touch it, but I'd run it by Rosie anyway.

Then I went outside to try, for the seventeenth time, to fix my front gate. It sagged and scraped the ground, no matter what I did to it. Sometimes I thought the place hated me because it knew I wasn't going to stay. The Oakland house had sold fast, and I'd had

to hustle to find this one. It was in Fairfax, and that was good. But there was no cottage for Rosie, the lot wasn't as big as the one I'd had in Oakland, and the house had carpeting and no fireplace. The droopy gate was just a bonus.

I had an appointment with a realtor the next day, matter of fact.

When I opened the office door at Sphinx Investigations, Rosie was on the phone, sitting in her executive swivel facing the window, only her short, dark hair visible above the chair's high back. Her black standard poodle, Alice B. Toklas, stood up to greet me with a bow, a squeaky yawn, and a wag. She, like Tigris and Euphrates, was getting on in years and had gone from unbridled enthusiasm to friendly dignity. Like me, too, I guess.

Rosie swung around and nodded to me, said a few more words to whoever was on the other end of the line, and hung up.

"About this Nazi job, Jake…"

"I think we should do it." I told her about the pay.

"I was going to ask you to do this one—" she looked down at a letter on the desk and shoved it toward me "—divorce case, hourly cut or straight salary basis."

I laughed, and slid my own e-mail printout across to her. "I was going to give this one to you, in case you had some time."

She let it sit there, looking at me hard, her hazel eyes a little too motherly for my taste. She's younger than I am.

"I mean it, Jake."

"I'm a big boy. I think we should do it. You don't have to help. I don't want to risk your neck." If she can be motherly, I can be fatherly.

She was silent for a moment, fiddling with the e-mail. Then she pushed it aside.

"What's the next step?"

I told her Royal was supposed to call that afternoon.

"Get money in front, Jake, and make sure it doesn't have a picture of Adolf on the hundred-dollar bill."

After which we went out for some healthy burritos—a contradiction in terms as far as I'm concerned—and argued about Nazis some more.

§

I got home just before 2:00, and while I waited for Royal to call I thumbed through that afternoon's Marin *Independent Journal.*

There was a story on a new history curriculum in the local school system. The high school kids were going to get a bigger dose of the twentieth century, for one thing. That made me think of Royal. If my new client had ever heard or read anything about World War II, it had slipped his mind, buried under a mountain of adolescent fantasies. He had probably been too busy thinking about sex, or boot wax, or hangover remedies.

I unrolled the San Francisco *Chronicle* that had been delivered that morning, skipped the front section, and went right to "Bay Area" to check out what was new over in the East Bay. Berkeley was enjoying the latest escapades of a far-left group called ThePeople, and their leader. Or maybe they called him a facilitator. Moderator? Chair? The *Chron* wasn't clear. Anyway, his name was Cary Frasier. I'd been seeing him around Oakland and Berkeley for years, and he was always up to something political. Frasier believed in a lot of things I cared about—the environment, free speech, human rights—but he was such a pamphlet-mouth he embarrassed me, and he wasn't very good at drawing a line between protest and violence. He was also not very good at picking a few causes and sticking with them. He attacked anything right of center, scatter-shot. He was always in some kind of war, and he was always on the side of the angels. The group was currently being investigated, the paper said, for involvement in some window-smashing. Which brought me full circle to World War II and the Nazis. The story didn't say who the windows belonged to, but it could be almost anyone.

Right about the time I was getting tired of the world as we know it, and dropping all the newspapers into the recycling box, the phone rang. Royal, I thought.

As it turned out, though, the caller was Deeanne. He'd asked her to do it for him. Busy polishing his head, no doubt.

"I expected to hear from Royal, Deeanne."

"Oh, he was all, maybe you'd change your mind again and maybe it would be better because you like me."

The message he was sending through her was that he would meet me that night at the Aryan Command's hangout in northwest Berkeley, a bar called Thor's.

Thor's. I'm a little light in the Norse god department. Thor, I thought, made thunder with a hammer and tossed lightning around. He didn't have the status of Odin, who was, I thought, the Big Guy, the Zeus of the north, but he was loud.

"Tell me about Thor's."

"It's just this, you know, like, sleazy bar. With hamburgers."

"Is it owned by the group?"

"I don't know. Maybe. I guess the bartender likes them okay."

"How do the people who go there dress?"

"Dress?"

"Dress."

"The usual stuff. Let's see. Some of them are skins, and they wear flight jackets and Docs—"

"Docs?"

"Doc Martens. They're boots. Some of the women wear leather miniskirts. Some of them don't, though. Jeans. The men wear jeans or camouflage pants. Gee, I can't remember anything specific. A lot of them look pretty tacky."

"So you won't be there tonight?"

"No. Artie's taking the family out for dinner."

"Good. Keep away."

"You don't even have to say it. I don't want to be around those people. They scare me."

"They should. Another thing, Deeanne—how old is Royal?"

"Twenty."

"Isn't he a little old for you?"

"I'm almost eighteen."

Wow. That old. "And the crowd that hangs out at this bar—are they all young?" And underage?

"Oh. Well, mostly, I guess. There were some older people, too, though, I think."

She clearly hadn't paid much attention, and I was concerned about the age factor, along with a dozen other things. Would I look out of place? Were all the men twenty years old?

My qualifications for this job could have been better.

I couldn't do anything about my birth date or my ancestry, but I could do a couple of things to change my looks for a walk on the far-right side.

The hair. Curly, but for general master-race purposes, light enough, especially with the threads of gray. Blue eyes from my Riga *bubbe*. Very non-Semitic nose, also courtesy of Bubbe Fanny. But I didn't want these weirdos to know what I really looked like. I had to change something and I didn't have time to grow a toothbrush mustache.

I picked up the phone and punched in the number for Hairfax.

"Betty, this is Jake. I'm desperate. You've got to squeeze me in this afternoon."

"Sure, hon. Need a cut?"

"I want it bleached and straightened."

A second of silence, followed by laughter. "You're kidding, right?"

"No."

Betty still thought I was putting her on. "I watched the news this morning, Jake. They didn't say anything about hell freezing over."

"Please?"

"Come on in at three. But stop and see your therapist first."

If I had one, I might consider it.

Okay. Now for the outfit. I looked in my closet. Jeans, no problem. Crammed into the back of a T-shirt drawer I found a black muscle shirt that qualified as tacky, I guessed. It didn't smell too good and it was wrinkled.

Shoes. I figured running shoes weren't right. I did, however, have a pair of cowboy boots I'd worn twice. Black with some really ugly stitching in red. I didn't have a leather jacket, but there was the old denim job I'd had since the Seventies.

I put it all together, took a good long look in the mirror, gave up, and went shopping.

The night was unusually warm, even for September, and the door to Thor's Bar and Grill stood open. The hard heartbeat of heavy metal pulsed into the street. I walked in like I belonged.

The wooden floor was gray with age and deeply embedded dirt. Decades of traffic had worn a hollow in the floorboards along the bar, a shallow cup carved by the feet of generations of drinkers. The bar itself was a thrown-together pile of cheap paneling and Formica, the dozen or so stools a scratched collection of red plastic seats and crippled legs. The air smelled of stale beer and old grease. Off to one side was a grill, where the cook, a scrawny, sweating skinhead kid who looked too young to be there, was frying burgers. He wore a clean white apron over his jeans, and his black suspenders looked new. He yanked a dripping basket of fries out of the well and dumped them on a couple of plates.

I had a little trouble picking Royal out of the crowd. I'd met him only once and although I generally remember faces, hairless people in skin-drag tend to look a lot alike. Then I spotted him, sitting at the bar waiting for me.

He didn't recognize me at first either. I had to walk right up to him and poke him in the swastika before he reacted. After a blank first look, his eyes widened. Staring, he took it all in, beginning with the straight platinum hair and moving down to the new leather jacket—I was sweating under the damned thing—and the shiny black Doc Martens boots.

When Royal had recovered from the sight of me, he grabbed a paper napkin from under his beer, wiped off the next bar stool, and invited me to sit. I guessed that meant he was impressed by my disguise.

"Uh, good to see you, Ja—"

The bartender was at the other end, and no one else seemed to be listening, but I grabbed his hand and shook it, saying, "Shut up" under my breath. Then, through gritted teeth: "Yeah, kid, been a while since you and your old cousin Jason tossed one back together." Meaning, Get it kid? I'm not using my real name. At least he hadn't called me "Mr. Samson."

"Jason?" Well, I already knew he was none too bright.

"Oh, that's okay. You just keep on calling me Jase. You been drinking too much?"

Light dawned behind his pale eyes. "How about a beer, Jase?"

"Sure." There were a lot to choose from. Domestic on tap and in the bottle, Guinness, a couple of West Coast ales. A bunch of German beers.

While he ordered the drinks, I looked around the dim bar. A big Confederate flag was tacked to the wall above the jukebox. A couple of the men wore them on their backs, one on a T-shirt and one on a leather jacket. Since he was the only other guy wearing his jacket, and he was sweating more than I was, I figured it was okay to take mine off. I draped it on my bar stool and sat on it.

Most of the customers were men, and I wasn't the only one over forty. The women covered a wide range, too. The youngster with the shaved head, leather miniskirt, and nose ring looked underage. Another looked like she was in her thirties, had too much messy hair, wore a polyester dress and heels, and hung on the arm of an older guy dressed in suit pants and a frayed white dress shirt. She looked very excited to be there. Hey, so was I.

The cook slid two plates of burgers and fries down the bar in the other direction, wiped sweat off his shaved head with a large red kerchief, and turned back to his grill. The bartender poured my beer. Domestic. On tap. No political overtones of any kind.

A man who'd been sitting a couple of stools down was watching me. I nodded to him.

He was about thirty-five, maybe an inch or two taller than my five-eleven. He was wearing boots, jeans, and a black T-shirt with a white skull on the chest. He had a black crew cut, wide-open pale eyes, and—there it was—a toothbrush mustache, straight and thick across his lip.

He ran a large hand over the dark stubble on his head and nodded back at me. "Friend of Royal's, huh?"

"Cousin. Name's Jase. Jason Dormeister." Was that Aryan enough? Did it just sound stupid?

Apparently not to him. He didn't smile.

"Floyd Burke." He nodded again, this time in the direction of my feet. "Nice Docs. Ten-hole smooth. Like the greasies, myself." He waved one of his feet at me. He was wearing black Docs, too—I could just make out the "Dr. Martens" stamp in the leather above his ankle. Same smooth, rounded toe, same macho combination of work and combat boot. But his had a matte finish. I had tried on a pair of those "greasies." They'd felt oily and looked grungy to me. I'd decided to go with the smooth.

"Floyd's a good friend of mine, Jase." I thought Royal might be trying to tell me this guy was a member of the Nazi club, but we hadn't set up any codes for the evening. I wasn't sure Royal would have remembered them anyway.

"Any friend of Royal's…" A half dozen other idiotic phrases ran through my head, including, Hot enough for you? I didn't say any of them out loud. I had to save something for later.

Floyd slid off his stool and leaned on the bar next to me. He clapped me on the shoulder, grinning, his mouth wide and shark-like under the clipped face fur. "How about you and me pick out some music on the jukebox? Something a little more grown-up?"

"Sounds like a good idea, Floyd." The heavy metal was giving me a headache, so I meant it. But he was being too friendly. Checking out the stranger. Was he in charge of that? I'd have to watch myself with this guy.

He led the way, weaving through the growing crowd. I wouldn't say the place was packed, but it did a good enough business. The jukebox was newer than half the music it offered. Along with the heavy metal, and some groups I'd never heard of—Curb Stompers?—there was some good Fifties stuff and a bunch of male crooners.

"What do you think of the selection?"

"Looks okay."

"Notice anything unusual about it?"

Was this some kind of test? He was smiling, but his fishy eyes were narrowed. Yep. This was a test.

I studied the titles. No "Horst Wessel Song," no "Deutschland über Alles." What was I supposed to be looking for?

"Hey, Floyd, gimme a hint." I was trying for a macho whine, and I think I achieved it.

He laughed smugly. "Don't see no Whitney Houston."

"No…"

"Don't see no Hammer. No Nat King Cole."

There was definitely a pattern there. I decided to keep looking dumb, because he seemed to appreciate stupidity.

"No Ink Spots, either." He grinned at me. "Not an ink spot anywhere."

"Oh, I get it…"

"This is a jukebox for white men. What do you think about that?" He punched in a few numbers.

I think you're a dickhead, I thought, but out loud, I guffawed. "Hyuck hyuck." A sound guys like Floyd make when they're trying to bond with each other. "I think that's just fine with me."

"Yeah?" He punched me on the shoulder. A little too hard. "Go ahead, there's two left. You pick."

I chose "You Ain't Nothin' but a Hound Dog" and "I Did It My Way." I knew he wouldn't get the message.

"You like The King?"

I nodded enthusiastically, but the truth was that my Elvis knowledge was pretty limited, and I didn't want to get into a deep discussion of "Don't Be Cruel." Then, of course, there were those friendly punches on the arm. I couldn't stand there bonding forever. I had people to meet and plots to overhear.

Excusing myself from Floyd's presence to go to the john, I strolled slowly through the bar taking mental notes. Another underage girl, this one with very short hair. She was saying something snide to a bald young man about someone being a "freshcut." I'd have to make a vocabulary list. Since she had some hair, was she still a skinhead? Or was she some other kind of neo-Nazi? Did the women count? She must have noticed me looking at her; she gave me a sullen stare that was probably meant to be flirtatious.

Some of the men looked like blue-collar neighborhood guys. One was dressed in business clothes, a cheap gray suit. I counted four in fatigues, half a dozen in jeans and boots and buzz cuts, a few with shaved heads. Lots of suspenders on the younger people. Lots of patrons in black and two guys wearing, I swear, brown shirts. They all looked mean as hell, but any jerk can look dangerous if he dresses for the part and sneers a lot. At least that was what I kept trying to tell myself.

As I squeezed between two beer bellies in fatigues, I noticed a tattoo on the hand of one of them. A double lightning flash. Kind of like a disassembled swastika. I'd have to find out what that meant. Mental note: I was going to need vocabulary lists and tattoo translations. The same guy also had a buck knife in a sheath snapped over his belt. Now that made me nervous.

A little skinny guy, forty, forty-five, and dressed all in black, was talking softly on the pay phone near the toilets. He stopped talking when I came near and watched me, deadpan, as I passed. He didn't start talking again until I pushed open the men's room door.

By the time I got to the toilet, my skin was crawling and I felt slightly sick to my stomach. Every drop of my non-Aryan blood was chilled, and my only friend in the place, Royal, was too dumb and weird to trust. Second thoughts were crowding out all the reasons I'd taken the job, including my concern for Deeanne, loyalty to Artie, and curiosity about the affiliations of Deeanne's latest boyfriend. A cop-shy turncoat skinhead with altruist pretensions and a wild story about murder and a race war conspiracy. I was pretty sure the altruism, and maybe even the conspiracy, was a crock. His fear was personal. Getting a good look at the customers in Thor's made it understandable, too.

I washed my hands and glanced in the mirror, gingerly. The man who looked back at me was an aging punk, a hoodlum. A Nordic god gone to trash. The hair didn't quite match my coloring. The clothes, well... The disguise seemed to work on Floyd, which goes to show.

When I returned to sit beside Royal again, he was talking to another young guy, this one with a short brush of dark brown head-bristles. Royal was saying something about being "knee-deep in

shit"—I figured he was probably talking about his job, not his private worries—and his friend laughed loudly.

I interrupted their merriment to ask, "What's a freshcut?" and that made them laugh even louder.

"A brand-new skin," Royal said.

"Yeah," his friend grunted. "Someone who really doesn't know the scene."

Like me. "I'm Royal's cousin, Jase."

"I'm Zack. Pleased to meet you." Maybe he was, but he immediately began talking to Royal about his boots, or some boots he was buying, and shut me out. I took the hint and turned away.

Floyd was deep in conversation at a table across the room with one of the men in fatigue pants, the one with the double-lightning tattoo and the knife. They were both eating burgers, probably bloody ones. As I watched, the skinny man who'd been having the very private phone conversation walked over to join them. He had a stiff kind of walk that could have been a limp or just a funny way of moving.

The bartender asked me if I wanted another draft.

"Sure."

He was thickset, heavy with muscle and a roll of fat around his middle. His wavy hair was gray and carefully combed. I was guessing he was a member of the group. If he wasn't, why would he let all these underage kids in the bar?

He drew the beer with a practiced efficiency. No flourishes. Scraped the foam off the top with a mother-of-pearl–handled double-edged knife that looked like a letter opener. There were no tattoos on his hands, and his long-sleeved shirt concealed any messages he might be conveying on his arms.

This man looked a lot older than most of the others in the bar, maybe sixty or sixty-five. The rest of them ranged from sixteen to fifty, I thought.

Just as I was reaching for my beer, a woman came up to the bar and ordered a red wine. The newcomer was someone I hadn't seen in my earlier surveys. She moved lightly, her slender body graceful as she swung himself up onto a stool a few away from me. She glanced at me, her eyelids drooping in a second's speculation. Her

hair was shoulder-length. Warm gold. Or maybe it was just the light from the neon beer signs that made it look that way. I guessed her to be somewhere in her thirties. As I kept on looking, she smiled and turned away. I needed to get a grip on myself. Gorgeous she might be, but she was hanging out in a Nazi bar. Not exactly my perfect mate.

Floyd, I noticed, was watching me again. Either he thought I was beautiful or he was trying to make me nervous, challenging me, running some kind of alpha-dog game. I didn't think he thought I was beautiful.

Only one way to deal with it, then. Turn it back on him. Put him on the defensive. I interrupted Royal and Zack, whose conversation had turned from boots to jackets.

"Hey, Royal, can I ask you something?"

He looked startled. "Sure."

"Excuse us, Zack." Zack shrugged at me.

Squinting speculatively at Floyd, I pulled Royal into an empty corner of the room and spoke softly.

"Tell me about Floyd. He's in the group, right?"

I nodded in Floyd's direction. Floyd caught the nod. He looked confused and self-conscious. Good.

"Yeah. He sure is. He's almost Inner Circle."

"Inner Circle, huh? What does that mean, one of the bosses?"

"Yeah."

"But only almost? Not really one of the bosses?"

"Yeah. Right. But he will be soon. That's how it works. You move up."

I'd have to find out more about that later. "Glance at Floyd now," I told Royal.

"Huh? What for?"

"Just for-Christ's-sake do it."

Royal's head jerked around toward the object of my questions. I looked, too. Floyd squirmed, glared, and looked away. That'll teach him.

I punched Royal's arm, Floyd-style, and wandered back to my beer. Zack wasn't sitting at the bar anymore. Neither was the gorgeous woman.

"Nice place," I told the bartender.

"Thanks."

"Are you Thor?"

He didn't laugh or even smile. "Steve. And you're Jason."

He'd been paying attention.

"Nice clientele."

This time he smiled, with half his mouth like a movie villain, and went to the other end of the bar to take care of an order.

Even though Thor's was their home away from home, Royal's friends weren't exactly cutting loose. One of the beer bellies was grumbling about "driving long-haul," and the little skinny guy was throwing around words like "upgrade" and "hard drive." I overheard a few nasty references to various groups of people. I heard some bragging about expertise with firearms. But I didn't see any actual guns, and nobody stood up in the middle of the room and announced he was going to torch a synagogue or toss a bomb into the Supreme Court. Nobody said anything that any stray G-man could really use.

They were probably always careful in public. I wondered if there was a back room where they cut loose, where they planned their vandalism and mayhem. That's what I'd been told about a string of IRA bars around the country: The theoretical politics were obvious in the public rooms, but if anyone had any action in mind, lips were not loose with strangers around.

I didn't know what other groups with secrets congregated in saloons. I guessed the Islamic Jihad didn't. Coffee bars, maybe.

But for a bunch of Nazis, a beer garden seemed appropriate.

Floyd was watching me again. I considered going over to join him and his friends but I didn't want to look too eager. Casual interest, yeah. Gee-whiz, no. This was not a gee-whiz kind of club.

I found Royal near the jukebox and told him I was taking off, but I'd meet him there again the next night.

The day didn't start out too well.

I'd made plans with my realtor, Jim, to look at a couple of properties, one with a cottage, one a duplex. When I called to confirm a meeting time, the woman who answered the phone told me that Jim had suddenly moved to L.A.

"What do you mean, suddenly?"

"Yesterday. His ex-wife called, said she wanted him back. He went. Can I help you with something?"

I felt bad for me and bad for Jim. It's not easy to find a realtor who understands, not for me, anyway. And he'd told me a little about his marriage. She'd left him to find some space or some damned thing. He was young, good-looking—he was making a big mistake. And probably missing a really great sale, too.

I told the woman about the houses we'd been planning to look at and she said she'd take me to see them. Her name, she said, was Sally Roskov. Did I want to meet her at the one in San Anselmo?

I did, and when I got to the duplex, I pulled into the driveway behind a blue Saturn with a tall, red-haired woman leaning against it.

"Jake?"

I nodded. Normally at this stage of things I'd have been looking the house over, but she was walking toward me and she was wearing tan hiking shorts and boots and a gauzy-looking, reddish-brown shirt that matched her hair—it was short, like Sharon Stone's at the '98 Oscars—and she walked like a cougar. I know because I saw one once on Mount Tamalpais, just above Mill Valley, the day before my wife did to me what Jim's wife had done to him. Except mine never wanted me back.

Anyway, she handed me a card that said SALLY ROSKOV, REALTOR AND TRAIL GUIDE and showed a silhouette of Mount Tam in back of

the printing. She couldn't have been more Marin County if she'd been driving an SUV or a '65 Mustang.

I graciously mumbled hello, sneaking a glance at her left hand—no rings at all—and we both turned to look up at the house's façade. Beige. Flat. Early Sixties. It had parking, that was always a plus on these narrow roads, and the fifty or so steep wooden steps up to the lower door looked new. The lot swept up a wooded hillside spotted red with poison oak.

"The lot backs onto the ridge up there—no one can ever build above you. And there's a trail at the top."

She was waiting for me to say something, so I did. "Jim said it needed some foundation work."

She nodded. "That's why it's so cheap." Cheap meaning only $289,000. "Come on, let's have a look. I haven't seen this one myself."

She stood back to let me go up the stairs first. After the first thirty or so, I had to work a little at not trudging. Just a little. I couldn't help but get the feeling she would have run to the door if I hadn't been in the way.

The place was vacant, which didn't make it any more charming. The upstairs, the bigger unit, had a square living room with a pink stone-faced fireplace and white carpeting. There's no way I'd ever remember to take off my shoes when I came in, and I sure as hell wouldn't ask my friends to. There were two little bedrooms and a small front deck. The view was nice, a piece of the Ross Valley. The downstairs had one little bedroom and the bottom twin of the upstairs fireplace.

We looked at the foundation. It was bowed slightly in front.

"The drainage problem has been fixed," she said, pointing to some black plastic corrugated stuff sticking out of the hillside. "We have an estimate for a $10,000 length of foundation wall, and they'd be drilling it into the bedrock."

That was good.

"Tell you the truth, Sally, the place doesn't sing to me. I like Fairfax better than San Anselmo, too."

"But San Anselmo has higher property values. It's a better investment."

"It's a great town, but Fairfax, well, Fairfax…"

"Is Fairfax. Hippie-town. Musician- and artist-town. Funky and cool and…" She was laughing.

"Lower-income."

She appreciated my humor, her eyes crinkling at me. I love a woman who loves my jokes.

"I understand. I like Fairfax, too." I could tell that she did.

"So let's go look at that house and cottage." And maybe have lunch? Too soon to ask that.

The property was on the mountain side of Fairfax, up a skinny, winding road five minutes above town. I followed her into the carport and down the twenty or so not-so-hot wooden steps.

It wasn't exactly a house and cottage, in the strictest sense. More like a cottage-and-cottage. A one-bedroom on the right, about thirty paces down a dirt path from the two-bedroom directly to the left of the steps. You could barely see the neighbor slightly below the house and a couple hundred feet away, and if there were any houses anywhere near the cottage they were completely hidden in the trees.

We went into the two-bedroom first. It was a moldy little two-level house teetering on the edge of a canyon, and it had a decent-sized living room that needed painting, a Franklin stove, and Douglas fir floors that hadn't been refinished in a couple of decades. The deck, which could have used a few new boards, was built around a big bay laurel tree and looked down on more bay, eucalyptus, madrone, buckeye, and California live oak, and out over another piece of the valley.

Sally pointed to a dry gully down at the bottom of the property. A big gully.

"That's a winter stream down there."

Now, in September, it was just a ditch, but it looked wide enough to hold a small river in February. Far enough from the house not to wash away the foundation, close enough to be nice to live with.

The kitchen had a newish fridge, adequate gas stove, an old dishwasher, pretty fair cabinet space, and just enough room for a table for two. There was a small bathroom off the living room.

Downstairs, two little bedrooms and a slightly bigger bathroom. The smaller of the two bedrooms stood on stilts over the gorge. That could be my office-slash-guestroom.

Tigris and Euphrates, I thought, would love the place. Especially the big bay tree. The winter stream would scare them, but they'd flirt with the foam because they're cats, and cats, contrary to current mythology, are idiots.

"It could use some cosmetic work, and the termite report on the stairs is not good, and the deck…" Sally was talking about details, but I wasn't really listening. I was crazy about the place.

"Let's go look at the cottage."

The cottage was all on one level. It had fir floors, too, its own Franklin stove, a deck, a living room that could use some new Sheetrock, a tiny bedroom, and a bathroom that needed tiles. The kitchen cabinets were pretty ratty and the sink was stained. The place sat tucked among the trees, cozy as hell, a big red-barked madrone right outside the kitchen window. I expected Hansel and Gretel to pop out when I opened the oven, which could have been cleaner.

Sally, who touched my arm twice and my shoulder once, kept trying to talk to me about termite reports and drainage, and I kept smiling. Love always believes everything is fixable. I couldn't wait for Rosie to see the place.

I told Sally someone else had to take a look and hastened to reassure her that the someone was not a wife, although she didn't ask. As for the contemplated lunch invitation, it seemed premature, after all, since I'd probably be seeing her again in the next couple of days and didn't want to look over-eager.

She gave me a couple more business cards. We parted with lots of smiles and promises to be in touch, and I wound down to Sir Francis Drake Boulevard and drove the ten minutes to the office in San Rafael.

I'd forgotten that Rosie hadn't seen my new hair.

"What happened to your head?"

I explained that this was my disguise.

"Then why are you wearing your disguise to the office? We really don't want you leading the Gestapo here."

She was right, of course. I'd meant to cover that eventuality and had spaced out.

"I'm going to get a wig for my non-Aryan appearances. A wig that looks like my real hair."

"Why didn't you just get a blond wig in the first place? Why go through the hassle of bleaching your hair?"

"I thought it would be better to use real bleached hair for my undercover work and a wig to make me look like my real self. I figure none of our regular clients are too likely to yank on my hair. The Aryan Command might not either, but if they do, I don't want it coming off in their hands."

She thought about that for a minute before she grinned at me.

"Okay, Jake, I suppose that makes a strange kind of sense. Fill me in on what you've done so far."

I told her about Thor's and all the great guys who hung out there.

By the time I'd finished, she had that tight-lipped, angry look I know so well. "I really wish you'd back out of this case. Leave the little Nazi hanging out to dry. And Deeanne. I think Artie should lock that girl in her bedroom for the rest of her adolescence."

"Damn it, why aren't the cops involved in that group?"

"Jake, maybe they are. I don't know. They could be. Pauline might not know about it." Or might not be able to say so. Or might not want to tell me. "She said she called some East Bay guys about Thor's, but if she got anything more, she didn't tell me. I've called Hank, too. But you know how he is." I did. Hank was with the Berkeley PD, a nice enough guy and a good cop, but no risk-taker. He helped out when he thought he should, and that wasn't often.

"I think I have to at least find out more about them. Get something more, proof of conspiracy or something. I'm going back tonight."

"Oh, for Christ's sake, Jake. You're Jewish. You'd make a lousy martyr."

I stared at her. "On the contrary. We make very good martyrs."

Rosie stared back, but she blinked first. "You're a grown man. I can't tell you what to do. I can't lock you in your house. But if you insist on risking your life with those morons, do it fast and get out."

"From your mouth to God's ear, kiddo. Now I've got some good news." I told her about the house and gave her one of Sally's cards. She promised she'd take a look.

I got up to leave, but before I could she came around her desk and grabbed me in a big hug. She even kissed me on the cheek, something she hardly ever does.

"Give me a day or two to clear away some things, then find a way to get me into this. I'm your sister or girlfriend or something."

"You going to bleach your hair, too?"

"You can bet I'm not."

I stopped at a wig shop on the way home and picked up a light brown rug with curls. It looked pretty stupid, but did bear a resemblance to my real hair.

My striped companions were lounging on the deck. They hadn't been fooled by the bleached hair and they weren't offended by the wig. The minute they saw my face peering through the French doors, they started whining for food. Tigris followed Euphrates through the cat door into the kitchen. I opened a can of Friskies beef and liver and dumped the contents into two dishes. After which I checked the bowl of wildly expensive urinary-tract–healthy dry food—Euphrates had a bout with cystitis a couple of years ago—and it was full. As usual, they weren't really hungry; they just didn't want what they had.

I checked my answering machine. A message from Artie, asking me to call. Probably not just about the next night's poker game. I made a ham sandwich and punched in his work number.

"Perrine."

"Hey, Art."

"Jake! Thanks for calling. What's happening with that...with Deeanne and..."

He couldn't say his name. I said it for him. "Royal."

"Yeah."

"I'm working the case."

"And?"

"And unless my client says otherwise, the work is confidential. You know that."

"Your client! What kind of crap is that? You're talking about a twenty-year-old jackass who—"

"Yes, that's the one. Tell you what. You talk to Deeanne, I'll talk to them both, you stay out of the case, I'll do my best to keep you informed."

"I want to help you."

"Like hell. I don't want you anywhere near Royal's buddies. I don't want me anywhere near them, either."

"Jake, I know you're doing this for me—"

"Not just for you."

"For Deanne?"

"Well, her, too…"

"Not for Royal! I can't believe it!"

"Not just for him, either. Look, this kid is dumb as a…I don't know, what's really dumb? A chicken? Anyway, he's not evil. I think he might actually be a human being some day. No guarantees. But this group, Artie, this group looks bad."

"I'll talk to Deeanne."

"Good. Don't forget, she did come to me for help. She may be a pain in the ass, but she's got courage."

He grunted. "There's a fine line between the brave and the foolhardy."

"Who said that?"

"I did. See you tomorrow night. Prepare to lose."

W hen I walked into Thor's that night, Floyd was sitting at the same table, like he'd never moved at all. The skinny paranoid one was there, too, but the guy with the fatigues and the double-lightning tattoo had been replaced by someone else. This one had curly hair, almost as blond as my new do. I'd noticed him the night before because he'd been wearing a jacket with a ten-inch Confederate flag stuck to the back. Maybe his horoscope had warned him to lower his profile today; I didn't see the jacket, and his T-shirt didn't threaten or insult anyone. He was about thirty and looked a little smarter than Floyd. I strolled over, casual, just to say "Hey" on my way to the bar and my cousin Royal, who was perched on a stool next to his pal, Zack.

Blondie's blue eyes took me in, slowly and coolly. "Who's this, Floyd?"

"His name's Jase. Cousin of Royal's. Jase, meet Pete Ebner. And this guy—" Floyd didn't look at the skinny one, he sneered and jerked a thumb in his direction "—he's Karl." Karl had nasty, squinty little dark eyes, disco-length greasy brown hair, and a tight angry smile that matched his black clothes, but he nodded at me in a reasonably friendly fashion. Obviously, Floyd didn't like him, didn't even do him the favor of mentioning his last name. I, on the other hand, liked his greeting much better than I liked Pete's frozen glare.

"Pete. Karl." I started to walk away, but Floyd didn't want me to.

"Why don't you sit down, Jase?"

"Well, thanks—I'll just get myself a beer first."

Steve drew me a foamy one while I slapped Royal on the back. I drank an inch of beer, small-talking with my cuz and his buddy, looking around the bar. Then I took my time wandering back to the table, plunked my beer down, and slid onto a chair.

It was Karl who spoke to me first. "How come I've never seen you around before, Jase?"

"Haven't been around before."

Pete's question matched the unfriendly look. "So you haven't been around before, huh? How come you're around now?"

Floyd was watching my reaction. I gave Pete a cold Clint Eastwood kind of look.

Karl snickered. "Don't mind old Pete, Jase. He talks to everybody that way." He stood. "Need a beer." And I was left with Floyd and Mr. Congeniality, who was still waiting for my answer.

"Look, I'm new in town, you know? And Royal's been telling me about some of his friends. I thought we had some things in common." I surveyed the room with approval, then brought my eyes back to Pete. "Tell me, Pete, I see a lot of bald heads and buzz cuts. How come you got those nice curls? How come you don't shave your head?"

"Not a skin. Skins are kids. What do you mean, things in common?"

I was betting he'd been a skinhead a few years back. "Guts and ideas. I've seen Royal's tattoo. You guys stand for something."

"We won't stand for nosy strangers."

"Who put a bug up your ass, Pete?"

"You got a foul mouth. Jason. That's not what this is about. Everything clean. Everything decent. We're white men. You want to talk like that, go to east Oakland." Pete gave me a last suspicious glance and shoved his chair back.

"Later, Floyd."

"Yeah, Pete."

The blonde swaggered to the bar. He wedged himself in between Royal and Zack, and caught Steve's attention. While Pete waited for his drink, he said a few quiet words to the boys. They nodded seriously. A couple of minutes later, when the barkeep slid the glass across, Zack hopped off his stool and followed Pete to the rear of the bar. I couldn't see where they went. I hadn't scoped out the back hallway all that carefully the night before. Maybe there was one of those mythical back rooms. I resolved to go to the toilet again soon.

Floyd was silent, so I was, too. I yawned. He burped.

The guy with the double-lightning tattoo waddled toward us. His belly hung over his fatigues. His brown T-shirt was stained with grease spots. The top of his bald head was freckled. Possibly he was unaware of Pete's age limit for skinheads. This one was no kid.

He spoke to Floyd while he looked expressionlessly at me. "Goin' okay, Floyd?"

"Yeah."

"Good."

"Hey, Red, this is—"

"I know. Jase. Royal's cousin. Pleased to meet you, Jase." He lifted his upper lip in what was probably a smile and I could see he was missing a couple of incisors. He sat down. Now three of us were silent. Floyd broke first.

"So. Jase. Tell us about yourself."

Floyd had pulled his chair closer. He clutched his beer glass and tried the suspicious look again, but I was suddenly aware he'd had too much beer. Those narrowed eyes were also a bit glazed.

Which made it as good a time as any to unroll the cover spiel I'd worked on that afternoon. I'd put a lot of thought into it, because it needed to make sense and it had to include some stuff I thought would help me keep unwanted visitors from my actual home.

"Where should I start?"

"At the beginning." Red grinned. Like a wolf.

"Okay. I was born in St. Paul, Minnesota." Close enough. Chicago. "My parents were working people. She was of Scandinavian descent. He was German." Close enough. Russian Jews. "I was an only child."

"Threw away the mold, huh?" Red snorted.

Hot enough for you?

I grinned like I appreciated his joke. "Guess so. Anyway, we lived in a working-class neighborhood until it started to go bad."

Floyd nodded wisely, clucking his tongue. He knew what kind of "bad" I was talking about.

"Sonsabitches," he said.

"Yeah. Anyway, after Mom died, my dad, he moved out here to be near some family. My dad, he's not doing so great, kind of needs

me to help him out." I looked very sad. Dad was on his last legs. Not at all up to visitors. "So I decided to come on out here and take care of him. I like it here just fine. Great weather. Some—" I emphasized the *some* "—great people."

Red sneered. "We got our share of problems. Point is, we don't have to take it laying down." His hand went to the knife sheath hanging from his belt.

"I agree." I slapped the table. "Royal's just a kid, but I know what he means when he says we gotta take this country back."

"Damn right we do."

Floyd's eyes were closed. Looked like the conversation was now two-way, me and Red.

"I've been thinking, maybe I should join this club of Royal's— are you in it?" I made it sound like his being in it would just about clinch my decision.

Red bared his sharp-looking teeth at me again. "Yeah. I'm in it, all right. Big time."

"Yeah? You run the organization?"

He shook his head and laughed. "Oh, I wouldn't go that far."

I was trying to talk to Red and keep my eye on the action, too. Pete came back to the bar, without Zack. He said a few words to my "cousin," and marched him back to that mysterious place where he'd taken his friend.

I stood up. "I gotta pee."

This time I went past the men's, past the women's, and saw the door to what had to be the Back Room, between the women's room and the rear exit. It was paneled like the wall and damned near invisible, except that it had an EMPLOYEES ONLY sign on it. I could just hear mumbling voices inside. No point in taking a chance on someone catching me eavesdropping—I'd ask Royal what this was all about. Quickly, I slid back down the hall and into the toilet, stuck around for a minute, flushed, and headed back toward Floyd and Red. On my way to the table I passed the young buzz-cut female, who was saying something earnest about a black helicopter—a black helicopter?—to another young woman. I was trying to catch the other kid's answer when the bristle-head noticed me.

"Hey!" she said.

I turned all the way back toward her. There was that long, sullen look again, this one ending in a smile. Maybe it takes two nights to earn the friendlier version. Then she spun all the way around on her bar stool until she faced me again, very coy. She was all of eighteen, tops, small and stocky, kind of like a tree stump, with short legs squeezed into a pair of black tights. Boots just like Floyd's, except they were red-brown. Her hair was about a quarter-inch long all over her head, and bleached white. She was wearing a black leather miniskirt and a red T-shirt that said SIEG HEIL.

Very seductive. I smiled noncommittally and walked on.

I sat back down with Floyd and Red and scanned the bar with what I hoped was a satisfied "home at last" expression. Pete and the two boys reappeared. The boys went back to the bar, and Pete walked out. Royal grabbed for his beer stein, knocked it over, spilling on himself, jumped up, yelled, "Shit!" and stomped toward the john. He looked rattled, big-time—more than spilled beer seemed to account for. In the hall entry, he nearly collided with Karl, who was just coming through in the other direction.

Floyd's eyes were open again, but he was practically snoring. Red sat drinking his beer, looking around, occasionally scratching some part of his anatomy. Royal reappeared and stood leaning against a wall, staring into space.

I looked at my watch.

"Hey, this has been great, but I got to get home. I like to listen to Preston Switcher—you know him?" I studied their faces for reaction. Floyd's was blank, Red's was sly.

"Yeah," Red said. "He's one of the truth-tellers."

Whatever that meant. I nodded enthusiastically and stood to leave.

"See y'around, Jase." Oh, good. Red liked me.

Royal looked up when I approached.

"Walk me to my car, Royal." He nodded and followed me out the door.

I was going to wait until we were well down the street before I said anything, but Royal spoke first.

"Listen, I got the money. Your pay. I just didn't want to carry it around tonight."

"Carry it around? It's in cash?"

"Well, yeah."

I figured I'd get it when I got it. "Tell me about the bartender. Steve. Is he in the Command?"

"I never see him at a meeting or anything. Kind of seems like he just likes having us—them—come around. He owns the place. Makes them welcome, you know. But everyone does what he says. Everyone."

"I'm not surprised." Steve had a certain...presence. "And Red?"

"Yeah. Red. He really is Inner Circle."

"What's the tattoo mean? Seems I've heard of it...."

"Aryan Brotherhood. Some skins wear it, too."

"And Karl? Tell me about him."

"Smart. Real smart. He fixes computers!" This seemed to amaze Royal. "Talks a lot about brainy things. Kinda sickly. Almost Inner Circle."

"Zack? Is he in the group?"

"Yeah. Me and him are warriors."

"And what does that mean?"

"We do the work. I got to tell you—"

"Just a second. What about Pete Ebner? The guy who was so busy with you and Zack?" If they did the work, what did he do?

"Pete. Yeah. He's real dangerous, I do know that. He's killed a bunch of guys."

Killed. A bunch of guys.

"You actually know that, or is it just his rep?"

"Well, I didn't, like, see him do it, you know."

I let that go. "Is he Inner Circle?"

"Oh, yeah. And he commands the warriors." Aha. Some kind of sergeant. That explained the attitude.

"Sit in my car for a minute and tell me what was going on in that back room with Pete tonight. What was he talking to you about?" I unlocked the doors and shooed him inside.

He shook his head. "Well, that's just it, you know. I got to go talk to Zack. Pete gave him some orders, and how it works, Zack's supposed to pass them on down to me. All Pete said to me was, 'You ready to be a real warrior?' I had to say yeah without knowing what

he meant. I had to, like, make the commitment." That must have been when the kid had come back into the bar and spilled his beer. He shook his head again. "Shit. Anyway, something's going down."

I was hoping that wasn't the case. The cops thought the Command was big on talk and small on action, and after meeting this bunch of morons and freaks I wouldn't put it past them to play loyalty games, putting these kids through weird initiations that had nothing to do with anyone or anything else. I saw a documentary once on how this one tribe somewhere pierced a guy's belly muscles and hung him by a strip of rawhide. Courage-testing.

Royal was holding the door handle, waiting for me to say he could get out of the car. I wasn't ready to lose him yet. I needed to get a fix on all this crap about Pete telling Zack and Zack telling Royal.

"So there's the Inner Circle, and there are warriors. What are some of the other levels? The hierarchy?"

"I don't know what that means."

"Tell me about the levels of power."

"Oh. Okay." He stuck a finger in his ear and probed. A hair-twister, I thought, when he had hair. When he didn't, an ear-poker. "The Inner Circle, they're the ones who, like, connect with other countries, other cities, like that. Then there's the lieutenants."

Lord. "What's a lieutenant?"

"A manager, like. Pete's one. Warriors get our orders from them."

"And warriors do the dirty work?"

"Well, we're the tough ones, you know, the strong ones. The runners, the fighters. If we do our jobs we get to be lieutenants sooner or later."

"Are there levels of soldier? Privates, corporals, sergeants?"

"Zack's a corporal. I'm a private. That's why he's going to give me the orders."

"Do they all hang out there every night?"

"Yeah, pretty much. Sometimes there are meetings."

"Where are those?"

"Sometimes in the back room. Sometimes at a house over in San Rafael."

"When's the next meeting?"

"I can find out, but they won't let you come. They don't always let the warriors come. Listen, I better get back, okay?"

"Call me when you find out what it is you're supposed to be doing."

"Yeah. Shit." He got out and closed my car door too hard.

R osie hadn't forgotten that I'd planned to visit Thor's again.
"Hi, Jake—call and let me know how the Nazis were to-
night. Tomorrow's soon enough if you get home really late." Very
casual. Probably dying to know about my latest adventures in
Fascistland. "I'll be looking at that house in the morning with your
new realtor. I have to say she seems unusually interested in wheth-
er or not I'm your girlfriend. I got the feeling she thinks you're
pretty cute."

Hmm. Well, why not? There are those who think I could pass
for a Baldwin brother. Just my luck, though, she'll think Rosie's the
cute one.

Twelve-fifteen. I'd let Rosie sleep. But since I'd told my new
pals I was going to listen to Switcher, I thought maybe I'd better
listen to him. I'd caught the show a couple of times by accident, so
I remembered it was on this time of night. I turned on my bedside
radio and started getting undressed. He was somewhere in the
middle of his oration.

"The trouble with so-called employment rights laws, my friends,
is not so much that they give the jobs to incompetents and homo-
sexuals and take women away from their primary function as
homemakers and caregivers and mothers…" I grinned, thinking of
Rosie "… but that they discourage the competent among us. De-
stroy the will to succeed, to innovate. They tear at the fabric of our
great land. And that's precisely what they are meant to do. Yes!"

I let him babble on while I brushed my teeth, which was taking
longer than usual. I'd brought home a bad taste in my mouth. I'd
been involved with murderers before, with crazies and killers who
should not have been born. But never a whole group of lowlifes.

And certainly, never with anyone who scraped me raw this way, exposing childhood memories of bullies who threw punches and slurs. Kike. Sheeny. Memories of adults I'd met who'd survived the Holocaust, survived the camps. Tattooed family members, friends, who had spent their childhoods starving behind barbed wire.

Tattoos, for Christ's sake.

The phone rang. I rinsed my mouth and went to pick it up, catching another bit of Switcher on the way.

"...you don't see our competition in the world market sacrificing their economies on the pagan altar of phony fairness. Oh, no..."

"Hello?"

"Jake? Are you there?"

"Yes, Royal, I'm here." If he got any more ridiculous I might find myself liking him.

"You're not gonna believe this. I got my first assignment as a warrior." He sounded sick, his voice weak and strangled. Were they going to hang him from a strip of rawhide after all?

"And?"

"And me and Zack, we're supposed to kill Preston Switcher."

Okay. No rawhide. He had to slay a dragon. And the target was saying in the background: "We have been duped by those who want to see us fail. My friends, the thieves of the left want nothing so much as the complete destruction of capitalism. Remember that the next time you hear some women's libber raving about equal pay—for what, inferior work? Destroyed homes? Criminal children? A ruined economy? A great white empire crumbled into ruins? My friends..."

Your friends, you lying, opportunistic asshole, want to kill you. And I guess I'm going to have to try to stop them.

"You still there, Jake?"

"Go to the police, Royal. Now." I already knew what his answer would be.

"I can't."

"Why not? I don't care how you feel about cops—we're talking about murder here. Just do it."

What was that snuffling sound? Oh, God. He was crying.

"I can't. I got good reasons. And besides, if I go to the cops,

they'll kill me. The Command will find out and they'll kill me."

I tried not to sound exasperated. "Why do you think so?"

"Because there are Command guys in the police departments."

"No. I don't believe that." Didn't I?

"It's true. Pete Ebner says so, and he would know."

Oh, right. Like Ebner had nothing to gain by warning these punks that the police would turn them in to the Command. But it occurred to me that I had no way of knowing it wasn't so, and if Pete Ebner wasn't lying... My head was spinning with possibilities.

"Tell me more about your other reasons."

"No. I can't."

Switcher was closing now with his signature words of wisdom: "And I hold this truth to be self-evident—the right, my friends, knows right from wrong."

Yeah. And the Aryan Command thought killing him was right. A sacrifice to a good cause. This was a little like a fight to the death between two poisonous snakes, one with slightly broader stripes and access to a microphone. But I still didn't have anything but hearsay and guesswork and strutting, bald, tattooed roosters to take to the police.

"Jake?"

"Shut up and let me think."

And here was the problem: Bring in the cops and go against my client's wishes—and maybe put Royal in danger; or not alert them and certainly endanger Rosie's agency, my job, and the lives of Royal, Zack, and Preston Switcher.

No contest; the cops. The world might be a better, kinder place with that raving righty dead, but I was developing a connection with Royal that could have been either affection or pity. I didn't want him killing anyone—not even Switcher—and either getting caught and jailed or getting away with it and dragging that load around with him for the rest of his life. He wasn't a killer. He wouldn't carry it easy. We'd have to take our chances and guess Ebner was lying.

"Jake? You have to help me." He'd gotten himself back under control. He was begging, but he'd stopped crying.

"When are you supposed to do it?"

"Next week. He's going to Washington or someplace for a speech or something, like on Tuesday? I don't know. Anyway, we do it when he comes back home. I guess we tail him around until it's safe for us to do it and then we shoot him. Zack and me. That's all I know so far. I'll hear more tomorrow, Zack says."

"Okay. If you're supposed to do it, you have some control over the act. Slow things down as much as you can. Figure out ways to screw up the plan."

"I have to go along with Zack. I got no choice. And Zack, he's really excited about doing it. He's really ready, man, big time. He wants to be a lieutenant, and he thinks this'll set him up good."

"You have to try."

"Ah, shit, maybe I'll just end up dead no matter what I do. Jesus. Shit." He was crying again.

"Royal, I need a way to get in touch with you."

"You can always get a message to me through Deeanne."

"That's not good enough."

He sighed. "Yeah. Okay. What I'll do, I'll get a pager. But just use it when you have to, okay?" I told him that would work.

Modern communications are amazing and truly wonderful. Any time you want, you can beep your doctor, your drug dealer, or your local skinhead assassin.

I left a message for Rosie on the office machine. "See if you can get Pauline to work up a little enthusiasm about this, Rosie…" Or a lot. Enough to get the law back on it. Not just watching Switcher. Watching the Aryan Command. Enough to get someone on it besides me.

Then I called the number Rosie had gotten from Pauline, the number for the FBI agent, Harry George. Good old Hairy George. I hoped I never had to write him a note. I was sure I'd slip and spell it wrong. Was he blue, like a Smurf? Purple, like Barney? I realized I was very tired.

I told the machine that answered that I was Jake Samson, that Pauline had given me his name, and that I was calling about the Aryan Command. I left all my phone numbers.

I realized, lying in bed, stewing, that I hated the Aryan Command. That I wanted them stopped. Dead, if necessary. And that I

wanted someone else, preferably big, powerful someones with guns and power, to do it for me.

Isn't that what government is for?

And where is it when you need it?

By 10:30 the next morning, Rosie had met Sally, seen the house, and talked to Pauline again. She's very efficient.

"I love the property. The cottage is a little small, but Sally says we can add rooms if we need to. The lot's big enough even if the planning commission's feeling snarky that day."

"So, you saying it's a go?"

"I'm saying I'd rent the cottage, the rest is your call."

"I'll put this place up for sale. Right now." Or at least as soon as we'd finished talking. And hope to God it sold before someone else grabbed my mildew mansion in the woods.

Reluctantly, I switched to business. "Did Pauline say the cops would get on it? The Switcher thing?"

"She wouldn't say. Just said thanks for the info."

Pauline was Pauline. "I called Harry George, but I haven't heard from him. So until I do, or until Pauline can come up with something encouraging…"

"I know. We're stuck with it."

"Or Royal's going to end up killing someone because he's scared not to."

"Artie's really going to owe us for this."

"Yeah. Maybe he'll throw the poker game tonight."

She laughed. "Fat chance. See you there."

I'd barely put the phone down when it buzzed again. This time it was Royal.

"I was so upset last night I forgot to tell you what else."

"What else, Royal?" I braced myself.

"Well, you wanted to know about the next meeting. It's tomorrow night. The warriors are invited. Maybe I can get you in, I don't know."

"Try."

"I will. The other thing?"

"What other thing, Royal?" I braced myself again. This kid needed prompting every step of the way.

"There's maybe something gonna happen tonight. Everybody was like, wait and see, and some of the other warriors were like, laughing, acting like they had some big secret job. But nobody will say."

"Keep trying."

"I will if I can. Oh, and, I want to give you your money."

I ran my day's plans through my head. I wanted to get this house sale thing going with Sally, then I wanted to drop in at Thor's in the late afternoon. "How about you meet me for a quick dinner around six?" That would get me home in time for poker. He said it worked for him and we set it up.

Sally came over after lunch—another chance blown. We talked about termite reports and amenities and open houses and cosmetic problems, set an asking price that seemed high to me, and put up a For Sale sign. I offered her a glass of iced tea and she accepted, so we sat together on my little deck with a view of the neighbor's too-manicured yard.

"This isn't really your kind of house, is it, Jake? I mean, now that I've seen what you want to buy."

"It's nice enough. I came over here from an Oakland neighborhood and this wasn't a big change. A house on a block, five-minute walk to shopping. But I like the place on Scenic better."

I told her I was nervous that we wouldn't sell this one fast enough, that we'd lose the one on Scenic.

She patted my arm. "This is more conventional. It should sell quickly. Don't worry." I had a moment's fantasy of Sally, for years into the future, patting me on the arm and telling me not to worry. That scared me. Fortunately, she didn't have a lot of time to chat. She had more appointments, and in half an hour, with a smile and a very warm handshake, she was gone again.

At five, I pulled on my Nazi suit and went in search of the Aryan Command.

When I arrived at Thor's, three teenage boys were hanging around outside admiring a motorcycle. An enormous black, shiny Harley.

I recognized Royal's friend Zack, with his cropped dark brush of hair. The other two were shaved bald. They didn't look familiar, so they must not have been around the night before. One was small and short, maybe five-five, his big, tough leather bomber hanging on his skinny shoulders and making him look like a kid in Daddy's jacket. He had a pointy little chin and pale eyes set too close together. The other one was muscular, with a tiny waist. He looked like he worked out three hours every day. "Whose hog?" I asked, friendly, interested.

They gave me that look teenagers give adults who break in on their private, arcane worlds. As if I had just stepped off a space ship.

"Skink's."

"That's me," the buff one said.

"Nice."

Zack laughed. "Nice?"

Skink sneered. "Thanks."

I decided not to keep trying to socialize with them. They had no interest in talking motorcycles with a middle-aged man.

The place was all but empty—just Steve, leaning on the bar reading the paper, and Red down at the other end, sitting on a stool behind a beer. It occurred to me that Red would have looked more natural with a cigarette hanging out of his mouth. I wondered: Did Steve enforce the anti-smoking laws while serving alcohol to minors? Or did the Aryan Command frown on smoking?

I gave Steve a friendly nod and asked him for a cup of coffee. He didn't acknowledge the nod, but he poured me one. I took it down to where Red was sitting, staring at the bottles lined up along the back wall.

"Hey, Red!"

"Jase." He glanced at me out of the corner of his eye.

"Thought I might run into Royal, but I guess not."

"He'll be in. It's early."

"Mind if I shoot the shit with you?"

He gave me a grin that was half a sneer.

"My lucky day, huh?" He turned slowly, heavily, on the small seat of the bar stool, breathing stale beer into my face, his chest puffed out nearly as far as his belly. Glowering. Challenging. Making himself big and scary. Had he decided I was a threat since he'd last seen me? Was he marking his territory while the other tomcats were away? Or did he just have mood swings? I went with the mood swings.

"Well, Floyd thinks you're a hell of a guy. So does Royal. And I can see you're important. I figure you know the score, know what I mean?"

He swiveled back partway, letting his chest sag again. I'd deflated it, along with his challenge, with just a few words of flattery. Was he always that easy?

"Good to hear. So, what's new, Jase?"

"Not much, same old same old. Looking for work, looking out for my dad… You?" My cover story included a work history as a supermarket checker, but Red didn't ask.

"Nothing much."

"That's hard to believe. Everyone I met here last night seemed like somebody. Bet there's some interesting life stories." I shook my head in wonder. "Bet there's a dozen TV shows in this bar, even maybe movies." I'd almost said books, before I caught myself. He probably didn't read.

I jerked a thumb toward his hand. "That tattoo. Bet there's a story connected with that. It looks familiar, but I can't place it."

He glanced down at the double lightning, flexing his fingers, then tilted his head and gave me that sly look again. "Familiar, huh?"

"Well, it's not like a Nazi thing—what is it, anyway? I noticed a couple of the warriors have them."

He snorted. "Skinheads. Kids. They copied it, it's bigger than a bunch of kids. Buncha guys I joined up with in the joint. White guys needed to band together to fight off the niggers and spics. Helluva bunch of guys."

"The joint? Shit, you were in prison?" I made myself look excited. "What did you do?"

He narrowed his eyes at me. Was I asking too many questions? Steve was folding up his paper, glancing our way. He moved down the bar toward us.

Red thought a few seconds before he decided to tell me. "Killed a guy. He got in my face. I ran him down." He gave me a fierce scowl. I looked impressed and he relaxed again.

"With your car?" Maybe he rolled over the guy with his belly.

"Yeah. So they could call it manslaughter." He guffawed and swallowed half a stein of beer.

Steve was staring at me. He was trying to give me the creeps and almost succeeding. "Red's the kind of man," he said, "you can count on in a fight. Any kind of fight. The kind of man who don't take no crap from no monkeys. A real soldier. A weapons expert. You understand?"

Soldier. Weapons expert. The image that came to mind was a camp somewhere in the woods, full of goofy losers like Red, out of shape and puffing, running around shooting at trees, playing war games, dreaming of world domination.

"Yeah, and I could be dropped off on top of a mountain and survive for days on what I know and what I can kill."

I made my eyes glow hot with the thought of all the things he could kill. "You must do some really heavy work for the Command." Awe, that's what I was going for. Awe mixed with testosterone poisoning.

Red looked warily at Steve. "I do lots of heavy work, Jase."

Steve grunted and moved closer, inserting himself into the conversation again. "You ask too many questions, Jase. Wait until you got a reason to know, that's my advice. We decide you fit in, you'll have a reason."

Red came to my defense. "Oh, don't be too hard on the man, Steve—he's just a little overexcited, that's all. Can't blame him. You finally find what you been looking for, see where you belong. I remember feeling like that." Okay, I was his pal again.

"You felt like that when you were fifteen, Red. He waited a lot longer." Steve flashed a nasty little smile. "But he could do worse." Was I being recruited?

Red slugged down his beer and slid his stein across the bar.

"Steve's right, Jase. Can't be too careful, but we need guys like you. And you wouldn't want to know something you weren't ready to know, would you?"

I pasted a slack-mouthed, confused look on my face, and told him, "Guess not." Steve strolled off to the other end of the bar again to get Red a refill.

"So, Jase. How's life treating you?"

Not bad, I told him, for a guy who was working his ass off taking care of a sick old man. As I was chatting away about my fictional life, the three boys I'd seen outside marched into the bar, Zack and his two pals. Skink leaned over the mahogany and grabbed Steve's hand, shaking it once, hard.

"Thanks, man."

Steve shrugged the kid off and slid Red's beer down the bar.

Thanks?

"Those boys are sure excited about that Harley-Davidson," I said.

Red laughed. "Yeah. Rather have a truck, myself. But kids, you know."

"That Skink must have money to burn—aren't those things expensive?"

"Yeah, they are. But the kid works. And he's got friends."

"Friends? No friends of mine ever gave me a motorcycle."

"He earns it."

I wondered how.

The "friend" he'd thanked was good old Steve, the man who had also had enough money to open this very swank establishment. Maybe it came from Steve. Maybe just through him.

Zack and his friends got their beer and headed for the hallway, swaggering.

To the back room, I supposed. I really wanted to get a look at that back room.

"They're something, those kids," I said, smiling after them.

"Hope of the world," Steve snarled. I couldn't tell whether he was serious or not. I didn't think I would ever be able to tell, with Steve.

Zack seemed like a smart enough boy. He apparently had a great future as a leader of creeps.

"These warriors," I said. "I bet they're very loyal to each other, aren't they?" Would Zack stand by Royal if he found out he wanted to leave the Command? I doubted it. I thought the Command would come first.

"To the death," Red said. "To the death. That's the whole point. One of them gets jumped, his buddies fight alongside. That little guy?" He jerked a thumb in the direction of where the kids had gone. "Saw him take on a couple of big guys once. Washburn, he don't look tough, but he is. They all are. Have to be. A real pleasure to work with."

"But isn't it Ebner who works with them? Isn't he their leader?"

Suddenly Red was less affable. "Hey, I am, too. Those kids look up to me. When it hits the fan, it's me and them. And don't forget it. You can't always tell who's really in charge."

"Sorry. I'm new here. Can't see the forest for the trees, maybe."

"Yeah. Well. Got to go have a few words with the boys now, matter of fact." Red slid off his bar stool, his belly jiggling, and followed the warriors to the back.

Steve leaned on the bar. "You meeting Royal here?"

"Just thought I might run into him. Hey, I'm confused. Isn't Ebner in charge of the warriors?"

His lip curled in a smile. "Everybody wants the good jobs. You want another coffee?"

"Yeah." He poured me one. I sat and nursed it until Red and the three warriors came back and sat down together at a round table near the front door. They were talking low and grinning and looking edgy.

A couple of seconds later, she came in.

The woman I'd seen the night before. The beautiful one with the warm gold shoulder-length hair.

Steve wiped the bar in front of her. "What'll you have, Gilly?"

"Club soda."

Gilly glanced at me and smiled. I smiled back.

"Afternoon. I'm Gilly Johns."

Steve handed the woman her club soda. "This here's Jase. He's a cousin of Royal's, just moved here, right, Jase?"

"Right, Steve."

Gilly picked up her drink and moved down to sit beside me. Her eyes were hazel, her hair fine and soft-looking. She had perfect teeth, too. I could see that when she smiled.

"I'm very pleased to meet you, Jase."

I noticed that Steve was grinning and shaking his head.

"You're something, Gilly, you know that?" he said.

"That's right." Gilly winked at me. "I am."

There was nothing subtle about the hormones the woman was shooting at me, but they hit the mark anyway. I leaned away from her, trying to escape those estrogen rays. The last thing I wanted was to actually be attracted to one of these people. And how could I be? Brainless lust.

"What do you do, Jase?"

I couldn't say it. Couldn't tell this woman I rang up canned goods. I opted for mysterious. "Oh, lots of things. I'm looking for work now." She nodded. "You?"

"I'm a bookkeeper. I balance the books. Credits, debits, credits, debits…" She laughed softly. She could have been saying, "Eenie, meenie, minie, mo" and it would have sounded sexy.

Fortunately, just at that moment, the stumpy-looking female skinhead walked in. No danger of feeling any lust in that direction. Today she was wearing a black T-shirt with two lightning flashes crossed on a red and black shield. Around the shield were the words THUNDERSKIN NATION. I wondered what that was about. She tossed a casual wave toward the round table and its knights and walked up to the bar, nodding to Gilly, and to Steve. Then she eyed me.

"See you came back."

Flattery had worked on Red. No harm in trying it again. "Maybe I came looking for you, beautiful."

She looked past my shoulder at Gilly, smirking.

Gilly laughed. "Jase, this is Leslie."

Leslie didn't like the laugh, but she took advantage of the invitation to sit on my other side. Gilly got up and wandered toward the back of the bar, and Leslie scooted a little closer.

"You really Royal's cousin?"

"Yeah. I am. Why?"

"He's a sexy guy. Very tough. Real masculine, the way I like them."

What was she trying to prove, I wondered, and to whom?

I laughed and took a sip of my coffee. "I guess he is. But you know, it's not like I see him that way."

"Yeah." Not the littlest laugh. I guessed that kind of thing was not to be joked about in Thor's. "Why are you hanging here?"

I gazed around the bar. "The people. The politics and the people. No mush-brained liberals in here."

"Yeah." She pulled meditatively on her nose ring. "Maybe you can tell me something, though?"

"Probably not."

She ignored that. "It's about Royal. I met that stupid, wimpy, straight-edge little bitch he goes with. Deeanne, her name is."

"Straight-edge?"

Leslie sneered at my freshcut ignorance. "Preppy. Conservative."

Wow. Deeanne straight-edge. Preppy. Artie would love to hear that. It might give him hope. It was giving me some. Not a good thing that she remembered Deeanne that well, though.

"And what I wonder is, why does he want her?"

"When here you are, this terrific skinhead girl, just ready and waiting?"

"Something like that, yeah. Maybe not exactly waiting. Sexy kinda runs in Royal's family." She leered at me.

"Well, Leslie, maybe he'll come around if you wait for him to."

She narrowed her eyes and flexed her hands. "Maybe I should just stomp her."

"Maybe he likes delicate and ladylike women." She snorted. I pointed at the symbol on her chest. "What's that?"

"Thunderskins. We're worldwide. Whites only, dedicated to the race. No druggies, Jews, homos, government leeches, or niggers allowed. Worldwide. I got this shirt in London." Light dawned. Thunder. Lightning. Skins. Thor's. Thor made lightning and thunder with his hammer. I tried to look impressed.

Gilly returned from the rest room and sat next to me again. "London?" she asked.

Leslie ignored her. "You're new in town, Jase. Maybe I should show you around a little, you know, for Royal. Go someplace nice."

"Hey!" Steve had come back to our end of the bar. "You're someplace nice now."

Leslie glowered at him. "You know what I mean. What do you think?"

"Well, I think that's a pretty good idea." Like shaving my head and growing leaves.

"What are you doing tonight, like for dinner?"

"Oh, sorry. I'm busy."

"Really?" She flashed an angry look at Gilly. "Who with?"

"My dad. Got to take him to see someone. Tomorrow night, too." What can I say? I panicked.

The crease between her eyebrows flattened out again, and the heavy ridge over her eyes relaxed. I saw a forehead like that once on a statue at the Chicago Museum of Natural History, in an exhibit with a cave in the background.

"Oh. Well, another time, then."

I looked at my watch. I didn't have to. I knew what time it was. "In fact, I need to be going now."

Leslie slid off her stool and looked me up and down in a way that could have been a challenge. "See you?"

"Sure."

It was unavoidable.

She headed toward Red's table, swaying her chunky little hips all the way. A couple of the guys eyed her, but only for a second. They didn't look interested enough to follow through.

Isn't that always the way? You dress in the style they supposedly like, you pierce your nose, you shave your head, and the damn men still don't ask you out.

But I'd said I was leaving. "'Bye, Gilly."

"'Bye Jase." She didn't look up.

I pushed through the front door. There was something I'd been meaning to do. Before I headed off for dinner with Royal, I needed to scope the place out better. I sauntered across the sidewalk and put my foot up on a fireplug, facing the front of the bar, untying and retying my bootlaces.

When I'd reconnoitered the hallway at Thor's, I'd noticed, along with the doors to the toilets and the back room, another door, the exit way at the back, with a deadlock and a bolt on the inside.

A PI never knows when he'll have to use a back door.

First, I took a good look at the front of the building. On the north, an eight-foot fence inches from the bar marked the boundary between Thor's and the auto repair shop next door. On the south, another tall piece of fence, this one with a gate, ran from the corner of Thor's and across the front of the bar's narrow side yard. But the tall fencing ended there. The piece with the gate joined a flimsy four-foot tall fence that enclosed the yard of the rundown cottage next door. The four-foot fence was all that separated the cottage lot from the bar's side yard. I glanced around. No one was in sight, so I gave the gate a nudge. Locked.

Casually, I strolled past the cottage. The driveway was open and gateless. There was nothing but that four-foot fence between the street and the side and back of Thor's.

If I ever needed to slide out and run like hell, this would be the way.

Royal and I had planned to meet at an Oakland Chinatown restaurant that I knew would be empty.

It was. He wasn't there yet, so I ordered some tea and spring rolls.

When Royal walked in, the man who'd brought my order—waiter, manager, owner?—hurried to intercept him. Royal jerked a thumb in my direction, and earned an escort to my table. A nervous escort. Apparently the addition of Royal's youth and baldness to the leather and boots we both wore made the mix a bit too strong for the poor guy.

And the boy was looking particularly skin-ish that day. The stitching on his greasy Doc Martens looked a brighter yellow, his flight jacket gave him a powerful, broad-shouldered look, his jeans had been ironed, and his head gleamed.

He grabbed a spring roll before he even sat down, dunked it in the sweet red sauce, and chewed. The waiter handed us menus, asked Royal if he wanted anything to drink, and zipped off toward the kitchen to get the milk he'd ordered.

Royal handed me a fat envelope. I looked inside. A wad of bills.

"Five thousand in cash," he mumbled. I'd count it later.

"We'll be depositing this in the agency account, Royal, so there will be a record of it. I don't know why you're paying with cash, but—"

"It don't matter."

He took off his jacket. He had taken me seriously when I'd insisted that he wear a Band-Aid over his tattoo when he was with me. We'd had to modify that agreement so he could wave the damned thing in front of his cronies, even if I was around. But now there was no one to wave it at.

Kid-like, though, or maybe just Royal-like, he'd half messed up.
He was wearing only one Band-Aid, which covered the center of
the thing and left one bent piece of arm, or leg, or whatever it was,
and one straight piece sticking out of both the bottom and the top.
Anyone who bothered to really think about how those bits might
connect would get the idea.

"You need two bandages, Royal."

"Huh? Oh, yeah. Guess so. Sorry."

"So you and Zack are supposed to kill Preston Switcher."

He jerked his head around, scared that I'd said it, and realized
there was no one in the place but us and the waiter, who was taking
a long time to come back with that milk.

"Yeah. How you going to get me out of this?"

"I've passed what you've given me on to the cops, along with de-
scriptions of you and Zack." I would have passed it on to the FBI if
Harry George had called me back. I had to assume, for the time
being, that the cops would take care of that.

"No! You didn't!"

"Damn it, Royal, I had to. If there's no way to get you out of this,
no way to stop it—look, even if you don't pull the trigger, Zack will.
Switcher's life is in danger. The police need to keep an eye on him.
And he needs to know that he has to be careful. Maybe that way,
he'll leave town, disappear, and solve the whole problem." Maybe
he'd disappear forever and solve a lot of problems.

Royal didn't seem convinced. "Why do you care about Preston
Switcher?"

Tough question. "Don't you?"

"No. Well, maybe. I mean, I got a lot of respect for the guy. But
even if I, like, thought he was bogus, I just don't want to kill any-
body."

"Well, I wouldn't exactly say I care about him. I think he's an
idiot, and dangerous to boot, but the death penalty seems a bit
harsh, even for his radio show."

Royal smiled a little and shook his head. "Come on, Jake, he's
just a conservative. He don't say people should kill people."

"Not directly."

He looked puzzled.

"Just slowly, with frustration and rage."

"Sometimes I don't get what you're talking about."

"I know, Royal. Maybe you will some day."

He rolled his eyes. A look that every grown-up knows means, "Right, when I'm a big, smart adult."

"Well, I really don't get why you told the cops. That envelope I gave you?" His voice rose half an octave. "I guess I just paid you to get me killed." I knew he was thinking about that mythical pipeline between the Command and the cops. He didn't look angry, just sad. This kid was not meant to be a Nazi. I had a quick flash of fear and doubt. What if there really was a pipeline? It wasn't impossible. I pushed the doubt away. The fear stayed. But I'd had no choice.

The waiter came back to take our orders. He must have heard Royal's last few words, because now he was looking at me nervously, too. He wrote down our choices and went away again.

"I did it to protect you." Partly. I also did it to protect myself and Rosie and Rosie's license. "I had to do it. There was no choice, and you're safer this way." Or at least I thought so. "Now tell me the rest of the plan. What did Zack have to say?"

Royal sighed and drank some of his milk. "A little more. Switcher comes back into town. We know what day, and we can find out what time—there's a guy who works at the airport, he says he can get passenger lists—and we sit outside his house and we wait. He shows up, he's alone, we shoot him dead, burn rubber outa there. We're supposed to spray his house, write something like 'Racist white pig,' you know, so the cops will think maybe some Muslim or something killed him, and the papers will pick up on it, and all kinds of white people will get really pissed off."

"Yeah? Then what?" Simpleminded crap. I didn't think most people got that excited about other people's deaths. The Aryan Command was judging the general population's boiling point by its own warped thermometer. "What's supposed to happen after that?"

Our food came. Royal waited while the man put our plates on the table, waited until he had gone back to the kitchen.

"That's just part of it, see, part of the plan. First Switcher. Then this lefty guy and then a black church. If that doesn't start something, we do more, until people are screaming and yelling and

looting and shit. See, we're trying to make them all think that the lefty and the church thing is payback for Switcher. Then we'll do something that looks like payback for the church."

"Who's the lefty they've got in mind—anyone in particular?"

"I don't know. But someone mentioned that People guy, Corey—um—or maybe someone else, I don't know...."

"You mean Cary Frasier, the one with that group he calls ThePeople?"

"Yeah." He began to eat. "But maybe not."

"We need to know that." He nodded, his mouth full.

"Okay. So exactly when are you supposed to kill Switcher?"

"Next Wednesday, the twenty-third. He'll be out of town for, like, a day or two, then home on Wednesday. But like I said, I don't have a time yet."

"What if it's broad daylight?"

"I don't know. Maybe we wait until he goes out at night. None of that's set yet."

Which might mean we wouldn't get a lot of notice.

Aside from the fuzziness around the actual time of this supposed assassination, the overall rabble-rousing plan as laid out by Royal was more than a little vague. But still...maybe enough of that kind of thing, getting enough of the right people excited, could start a pretty big ruckus. Not to mention that at least two people would be killed or injured before the big ruckus even started.

"And the man giving the orders is...?"

"Pete Ebner. He's our commander. I told you that."

"You're supposed to shoot the man—you've got a gun?"

"Not yet, no. We get them special for the job. From Red. He runs the arsenal. Guns, knives, all that shit. He's in charge." Why wasn't I surprised? He sighed heavily. "Jesus, it scares me to death just telling you about all this. You know what they'd do to me...?"

"Why don't you just take off, now? Leave town? Get out of sight? For good, if necessary." And get me off the hook.

"I can't do that. There's Deeanne. She won't leave." Well, that was something positive to report to Artie. "And there's my dad. He relies on me for stuff. And I'm not willing to take off and give up my inheritance."

"Inheritance? You mean your dad's money?"

"Yeah." He laughed bitterly. "My inheritance."

I remembered the last time we'd talked about his money. Something about it felt bad to him. "What's wrong with the money, Royal?"

"Nothing. It's just money. And it's paying you."

I wasn't sure I wanted to think about that.

"Royal, I'm sorry I had to let the cops in on this. The one cop we told I know can be trusted." Well, Rosie trusted her. I'd never met her and I couldn't stand her. "But I understand why you're scared. Tell me about your friend. The one who was in the group, and got killed."

Royal pawed at his face, like a dog with an itchy nose.

"What do you want to know?"

"Who he was, what he was in the Command, when he was killed, how, and why you think it happened."

"That's a lot of questions. Okay. Who he was. He was Richard Kramer. Rich. A good guy. Eighteen, I think he was. A skin."

"Was he a warrior?"

"Yeah."

"For how long?"

"Couple years. Ebner was always saying he was the best. He was, too. Man, he was really tough. Got in a fight once, on the street, with some—well, he was tough."

"Who do you think killed him?"

"I don't know. Someone in the Command."

"Why do you say that? What makes you think someone in the group killed your friend?"

"Because he started thinking he wanted to do something else, you know? There was this fire they set, before I was in, and he told Ebner he didn't want to be a warrior anymore after that."

"Tell me about the fire."

"No big thing, just a Dumpster in back of a church. But, like, the building caught fire and some guy was hurt trying to put it out before the fire department got there, and…he just decided he didn't feel real great about that, so he told Ebner he maybe wanted to not be a warrior anymore. And he told me he was thinking of

going way over the other way." Royal wasn't meeting my eyes. What was he hiding? "Some lefty gang, can't remember which one, maybe that People thing. He said they did really cool things. I told him that was stupid. He said he was after adventure, man. Anyway, couple weeks later he was dead."

Ebner. I could see Ebner killing someone. I remembered the church fire, too. In Oakland. The janitor had been burned pretty bad.

"How was Rich killed, Royal?"

"He was shot." Royal was crying. "In the head. Some guy found his body down in the Emeryville mud flats, you know, where all those statues are?"

Sure I knew. Emeryville is a small town tacked onto the edge of Oakland, right on the Bay. Condos. Restaurants. Old homes. And the mud flats had been turned into an alfresco sculpture gallery years before. The wooden works of art had been erected by, so far, a couple of generations' worth of rogue artists—wildly imaginative airplanes, figures, animals rising out of the mud between the Bay and the freeway.

A desolate area, too. Lonely even with the statues.

I could understand Royal's feeling bad about a friend getting killed, but his grief had a taste of something else about it. "Royal, what is there about Richard you're not telling me?"

The boy wiped his eyes, but he still wouldn't look at me. "It was my fault." I could barely hear him.

"What do you mean?"

"I got kind of drunk one night, you know. And I told some guys, I don't even remember who. Red. Maybe Ebner. What Richard said about, you know, like going over to the other side. I just wanted someone to talk him out of it or something, you know? Somebody's just got to pay for this."

Someone besides himself. That was Royal's stake in stopping the Command. Not just fear for his own life, fear that they'd find out he had doubts just like Richard and kill him. But guilt, too. He was carrying a heavy load. Royal was saying something about Pete Ebner.

"Sorry. What was that?"

He looked hurt that I hadn't been listening. "I said, I got Pete Ebner to agree that you could come to a warriors' meeting tomorrow night."

"How'd you get him to agree to that?"

"Said you wanted to help."

"As a warrior?" That was all I needed.

He shrugged. "No. You're too old." For once, then, middle age was a good thing. "Anyway, first he said no. But I convinced him you could be useful."

"How?" Could Royal really convince Ebner of anything? Why was the man letting me come to the meeting?

"I said you were smart. Look, it's not that big a deal. It's just kind of a party, you know?"

A warriors' party. Just me, Ebner, skins, maybe some camp followers? Well, nothing ventured.

Then I remembered what I'd told Leslie in the bar. "Will Leslie be there? At the party?"

"Probably."

I'd have to think of some way to explain why I wasn't spending the evening with Dad.

"Speaking of Leslie…she was wearing this T-shirt, Thunderskins?" He nodded. "So that's about Thor's thunder and lightning, right? And that's how Thor's got named? Because Aryan Command is a Thunderskin group?"

He scratched his head and squinted at me. "Huh? No. Well, not exactly. Some people are like, Thunderskins, too, maybe—they've got like a website Leslie's into—but Aryan Command is, well, Aryan Command. People belong to all kinds of shit, and it's all kind of connected, and Thor was, you know, Aryan or something, so everybody's all…Thor and Odin and those guys."

Between Leslie's explanation and Royal's, I felt like I was trying to get a grip on an oil slick. And come to think of it, that was a pretty good comparison all the way around. Poison. Spreading.

It was my turn to host the poker game, so I had to run home from dinner and throw chips and dip together and make sure I had enough cold beer and wine and sodas.

Artie showed up first. He glanced at my hair. "Washing away the gray?"

"Rinsing away the genes."

"You still resemble yourself."

"Maybe not from a distance."

He looked doubtful, but dropped it. He was a lot more interested in up-to-the-minute news about the case. I didn't tell him that one of the female skins remembered Deeanne, and worse yet, remembered her first name. I did tell him about the assassination plans, leaving out the identity of the intended victim. This upset him.

"Jesus, Jake! You have to tell me! This could be big."

A big story was what he meant. In exchange for the press card he had given me, Artie expected stories for his people to pursue. He got annoyed when I wouldn't tell him things he wanted me to tell him. I got cranky if he pushed me when I wasn't ready. It was a fine friendship, nevertheless, and a good professional deal for both of us.

"Lives at stake, Art. Including maybe Deeanne's. You're going to have to let me decide when I can talk about what."

He grabbed a beer from the fridge. Ale, actually. Mount Tam pale. "When did I ever get into something before it was okay? When did I ever turn a writer loose on something prematurely? When did I ever run a story—"

"Never, never, and never. Just give me a few days to see what's really going on, okay? I don't trust anything at this point. The whole thing could be bullshit." Always the optimist.

That backed him off a little, but I knew he wouldn't stay backed off for long.

Dan Lopez arrived next. He pointed at my hair and laughed, and I told him it was for a job.

"Cool with me, Jake. It's pretty. Going to pierce something next?" He laughed some more. Dan's a freelance photographer who sometimes works for Artie. He's in his forties, a scrawny little guy who eats everything and a lot of it and never seems to add any meat to his bones. A few years back, he did a series of portraits of street people that won some kind of award. I was thinking how much he'd love a few shots of Royal and his buddies.

Rosie showed up with a friend, a handsome, stocky woman with long dark hair and a sweater the color of a clown's nose.

"Jake, this is Pauline."

"*The* Pauline?" It was. The San Rafael cop. The one whose divorce had been so drawn out and vicious that she swore off men, she'd told Rosie, for anything but the quickest of flings. The one who supplied information only through Rosie, even if it was on its way to me.

She laughed. "That's right, Jake, I'm *the* Pauline." Then she reached over and pinched my butt. I jumped away. She laughed again. But when we all sat down at the poker table with drinks, cards, chips, and attitude gripped firmly, it was Dan she sat next to. He actually looked happy about it. Maybe he was sizing her up for a portrait. Portrait of a heartbreaker. Portrait of a clown's nose. I would make a point of warning him that she hated men, although he was going to find that hard to believe, considering. Still, if she pinched him hard enough…

I'd once asked Rosie why, if Pauline hated men so much, she didn't switch to women. Rosie was patient with me. I had to know, she said, that lust and hate were not mutually exclusive. I also had to know that she, Rosie, loved me very much, which proved that love and lust could, on the other hand, be totally unconnected.

Sure. I knew all that. I wasn't so sure about the totally unconnected part, though, speaking for myself.

Before we sat down to play, I pulled Rosie into the kitchen and

quickly told her what Royal had said about Cary Frasier and about the date of the Switcher hit. She said she'd pass it on to *the* Pauline.

We drew for the deal and Rosie won it. Dealer's choice, five-card stud, nothing wild. I get the jack of hearts down, the eight of spades up, Pauline shows the king of hearts and she opens for a quarter. Dan folds. Rosie folds. By the fourth card, Artie's out, too, and Pauline is showing the king of hearts, the two of hearts, the three of clubs. I've got three high cards but nothing else. I bet another buck and she calls. Next card, she gets the queen of clubs, I get the ten of diamonds. Still no pair. I toss four more quarter chips onto the table, giving her the dead-eye. She gives it right back, and raises me a quarter. Does she have a pair of kings? Does she have a pair of anything? I refuse to back down. I raise her a dollar. She hesitates...and folds! Yes! Try bluffing me, huh? The king of bluffers? Forget it.

When it's my deal I call night baseball, just to do something different. In the stretch, it's Rosie with two kings and three cards to go against Pauline with three queens and none to go. Rosie gets a three—wild card. Three kings. And her seventh card is icing: another king.

Nice pot.

Dan deals five stud, deuces wild. I get the queen of clubs to go with my ten of clubs and my wild card in the hole. Dan deals himself the jack of spades for a pair. Another card up all around and here's the way it stands: Dan a pair of jacks and a five, Artie three hearts, Rosie showing a five and nine of spades and an ace of diamonds, Pauline a pair of eights and a wild card—three of a kind. And Dan deals me another deuce, which also gives me three of a kind, only higher than Pauline's—and I'm only showing a pair. The chip bowls are empty; I ignore them. Pauline bets on her three eights, the only three of a kind showing. Rosie folds. I've got one hell of a hand. Three queens for sure, a possible flush. Last card: Artie gets a spade to ruin the flush he's working on, Pauline gets a three that's no help. I get the king of clubs. With the two wild cards and my ten, queen and king, I've got a royal flush. Pauline bets on her three of a kind showing. I raise. Dan raises again. Artie folds. Pauline calls. I raise again and Dan and Pauline stay in.

Dan had been hanging in with three jacks, Pauline only had the three eights.

"Royal flush!" Rosie said. We looked at each other, and I knew we were both thinking about Royal, our plumber's-helper client, and how close he was to going down the toilet. Damn. Couldn't I just be happy about my poker hand?

I got up to refill the chip bowls and replenish drinks. Rosie wanted a Mount Tam, Artie switched to Coke. Dan wanted ice water. Pauline got up to pour herself another glass of merlot and took care of the ale, Coke, and ice water while I poured chips. I was surprised. Maybe she wasn't so bad, after all. She didn't pinch me again, either, but she did come a little close in the small kitchen, remarking softly that if we didn't have a professional relationship she would find me attractive. I wouldn't call what we had a professional relationship, since she'll only talk to Rosie, but I didn't correct her because I didn't want her thinking I was interested. I definitely was not. I've gone swimming with enough sharks. There comes a time in a man's life when a nice goldfish starts to look pretty good.

She went back to the table and flirted with Dan some more, but she'd already dumped him by the end of the evening.

Next morning, I cooked a breakfast of coffee, eggs, and toast, unrolled the *Chronicle*, and sat down for a slow beginning.

Unfortunately, the news made my heart beat faster than I wanted it to. Below the fold on page one was a story about a rash of vandalism the night before. A black church in Berkeley had been defaced with epithets; a Jewish cemetery in Oakland had been scrawled with swastikas, headstones tipped and broken. A gay bar in San Francisco had taken a brick through the front window and a patron had been slightly injured. In that last case, one of the vandals had been spotted roaring away on a motorcycle, and there seemed to be a pickup truck involved, too. But no one had gotten a license number.

Things like this happened from time to time, but not usually so many at once. I thought about Skink and his new motorcycle. The one he was earning. Maybe by vandalizing a cemetery? Spray-

painting a church? Putting a brick through a gay-bar window? I found myself hoping the men and boys of the Aryan Command were the ones responsible for all of it. That they had, indeed, committed all these nauseating terrorist acts.

I wanted the warriors who'd been snickering at Thor's the day before to be the guilty ones because I didn't want to believe there was more than one bunch of violent, moronic yahoos in the Bay Area.

I couldn't wait to go to their party that night.

The party was at the house in San Rafael that I'd heard about way back at the beginning of this mess. It was big, but just your basic ranch style, backing up to a wooded hill north of downtown, close enough to 101 to catch a steady freeway hum even now, hours after the northbound rush from San Francisco to Sonoma.

Rosie had offered to cut herself loose for the night and come along as my date, but Royal had made it very clear that this was more than a party, he was bringing me and I couldn't bring anyone. I wasn't in yet. I think Rosie was disappointed. She'd been planning to wear some black lace-up boots, a leather miniskirt, a blond wig, and a couple of earrings in each ear. I promised I'd take her to Thor's the next night.

The owners of the house were a couple I'd seen once before, at Thor's. Royal introduced us. Their names were Hal and Helen Harte. Hal greeted people at the door. Helen seemed to be in charge of serving chips.

Hal and Helen Harte were beyond mousy.

Helen was around five-seven and so was Hal. Her dishwater hair was teased and combed into a country-music nightmare that made her small, pinched features look even smaller. Or maybe it was a wig and her real hair looked like his—that colorless, thin, brownish stuff that never seems to comb properly, always looks dry and musty, and always seems to allow for an unwanted view of pink scalp.

They both should have shaved their heads, but the look would not have gone with their wardrobes. Their clothes had no holes, no mends, but managed nevertheless to look shabby and cheap—and tacky.

Hal was at least fifteen years older than Helen, around fifty, I

guessed. As on that first night at the bar, he was wearing suit pants, a dress shirt with a frayed collar, and a thin tie. She was in a pastel blue skirt and a white blouse with a ruffled front. The kind of outfits that would have been considered appropriate office wear in 1963.

The house was mousy, too. Pale pink walls. Sheer white curtains that looked like Helen's blouse, blue shag carpeting the color of her skirt, a plaid Early American couch, and a glass-topped coffee table.

I trailed Royal to his first stop, the food. Very cosmopolitan. Good old American potato chips, undoubtedly from Idaho. Pretzels, by way of Germany. And tortilla chips. Maybe they thought Davy Crockett invented those at the Alamo.

Several of the warriors were there, including Royal's buddy Zack and the two friends he'd been with the day before, Skink and Washburn. A couple of teenage girls, too. Unfortunately, one of them was Leslie. She either didn't notice us come in or was playing it cool.

Pete Ebner was there, too, of course, since this was a party for his warriors. He was sitting on a folding chair next to Red. Floyd was deep in conversation with Karl, who was, once again, dressed all in black.

I was trying to get a fix on the size of the whole group. There were the ones I'd met more or less formally—Pete, Red, Floyd, Karl, Hal and Helen, Steve, Zack and his pals Washburn and Skink, Leslie—and a dozen or so I'd seen hanging around. Some of those, including Leslie's friends, were there at the party. Was that the size of the entire Bay Area Command? A couple dozen? Were there other Bay Area groups, say in San Francisco or down on the Peninsula? Was this two dozen just the tip of the iceberg or the whole shebang? Were they one cell in a national network? International? Royal seemed to think they had big-time bad-ass connections all over the place. Maybe they did, but I wasn't sure they could get it together to make a long-distance phone call.

I had a sudden image: guys like Steve, half a dozen of them in as many cities, running secret idiot-societies, e-mailing each other at night, and pretending to make plans for world domination they

couldn't possibly carry out with the personnel they attracted. I thought I'd hold onto that image.

Pete Ebner was watching me.

He got up from his folding chair and marched over to where I stood with Royal.

"Royal knows he's supposed to pick his guests carefully. I hope that's the case with you?"

I curled my lip, Elvis-style.

"Listen, Royal mentioned there was this party, and you said I could come, so I came. I like you guys' ideas. I think it's time we turned things around a little." Was I protesting too much? Should I keep the political proclamations down?

"Yeah? How far are you willing to go personally to do that?"

"Far as I need to. Time we stopped the bastards before they stop us." Any old bastards; fill in the blanks. "Support the Command any way I can. Do what's needed. That's what I'm willing to do."

Talk about getting in character.

He quirked a fuzzy blond eyebrow and lifted half his mouth in an unpleasant smile.

"You want to cook us supper?"

Royal laughed. I didn't. Ebner probably insulted the warriors by calling them "girls."

"Whatever it takes. But there are things I'm better at."

"Maybe we'll talk about that later."

By this time, the room had filled up. A few more adults, six or seven kids who were either warriors or hangers-on. Did they allow hangers-on? Technically, I thought, I was one.

"You want to sit in, here, that's okay. As long as you know that everything—everything—we say stays in this room. Royal—" he pointed a finger at the kid's chest "—Jason messes up, you pay for it." Ebner turned away.

Tough. Scary. But if he was worried about tales being told, that could mean I'd actually hear something useful during this impressive social event.

Royal got busy with his friends, punching shoulders and looking masculine; Pete had returned to his seat beside Red. Floyd saw me, gave me an index-finger salute, but kept on talking to Karl. Hal

and Helen, our hosts, were taking a break from their duties, standing side by side in the doorway of the kitchen. So pale, so colorless, so quiet. Suddenly the lyrics to "St. James Infirmary" started running through my head. I joined them.

"Nice turnout."

Helen nodded. They both looked at me as if we hadn't been introduced fifteen minutes before.

"My name's Jason? Jason Dormeister. Royal's cousin?"

"Yeah, we know," Hal said, flickering a quick smile my way.

"You host a lot of these soirees?"

Helen frowned. Maybe she disapproved of the foreign word.

"We all have our ways of contributing. We feel that it's our duty to entertain the warriors. Show them we care about them."

"Sure, I can understand that. Do you have other kinds of meetings here, too?"

"What do you mean?"

"Oh, I don't know—just besides parties for the warriors."

"We do whatever we can."

"I was kind of surprised," Hal said abruptly, "to see you here tonight."

"Why's that?"

He shook his head. "Well, we're real careful about who gets to come to things. But Pete seems to think you're okay."

My take on this was that Pete did not at all think I was okay, but had decided to try me out, or Steve and Red had decided that after our chat at Thor's. This could be some kind of test, or maybe they just needed new members badly enough to take a chance. Once again, I went with the possibility I liked the best. They needed members. Desperately.

"So does Floyd. Think you're okay. And Leslie likes you, too." This contribution came from Helen, with a half smile on her thin lips.

I smiled back. "Well, I think Floyd's a great guy. Pete, too, of course. I think—" I gazed fondly out at the assembled crowd "—they're all great guys. I can't believe my good luck at finding you people—that my own cousin would know you. I got to say, it's a thrill."

A bit of color rose to Helen's cheeks.

"Yes, it is exciting, isn't it?"

"Yeah. So you're members then? Of the Aryan Command?" I put as much reverence as I could into the name.

"Oh, yes."

"Wow. Listen, I really want to get into the group, but how do you join?"

Helen opened her mouth to answer, but Hal broke in. "When people get to know you, they invite you."

"I see. Well, I hope that happens to me soon. I really want to do my part. Do you have to be invited by a member of the Inner Circle?"

"No, but they have to approve the invitation. We have to know you feel the way we do about things."

"Well, how exactly do you feel about things? I mean…"

Hal held out his hand and began ticking off points on his fingers. "We are white people. We are proud of being white people, the creators of all decent civilizations, all noble causes." I thought the Egyptians and the Chinese would get a laugh out of that. "We feel that white people have a right to be proud and to maintain themselves separately from nonwhites like Jews and Mexicans and Africans. We feel that our U.S. government has been taken over by the forces of the nonwhites, by the evil ZOG, and that the government is attempting to dilute our noble European blood and destroy the country we love. Which would, of course, destroy the world. It is our duty to prevent that from happening. To do anything we must to protect and defend our white honor." He was on his second set of fingers by this time, but I was still back at "the evil zog." What in the name of God was *zog*? "We have a sacred duty to fight the forces of darkness and raise the banner of white people to sovereignty."

He stopped and dropped his hands to his sides.

"Wow," I said, before I remembered I'd already used that one. Should have gone for "zowie." "Did you memorize that? That's really amazing. I can't tell you how excited I get just hearing that, you know, hearing the things I been thinking all these years set out so clear and true." This was too easy. Maybe my future was in the theater.

Hal seemed exhausted by his recitation. He nodded vaguely, mumbled something about chips, and wandered away.

Helen watched him go, then turned back to me. "Yes, well, you know you can't say those things everywhere. The world has been made unsafe for white people. And we're going to take back the world."

"Yes," I said. "Yes, we are." I smiled at her. "With women like you." Helen smiled and blushed."Very exciting. Very." Yeah. The group was as exciting as a grenade and she was as exciting as heartburn. "How many members do we have, now, anyway? Here in the Bay Area? And wherever?"

She smiled. "That's a secret." I should have guessed.

"Have you been in the Command long?"

Helen nodded, her eyes moving slowly over the crowd in her living room. "A few years. Not from the very beginning, but soon after. Right after I saw the black helicopter." There it was again. I'd heard Leslie refer to black helicopters.

"I'm ashamed to admit I don't know about those helicopters, Helen."

"Don't be ashamed. They're part of a government conspiracy. They belong to the UN." A slightly confused look crossed her pinched face. "Or to a secret faction of our own federal tyranny. There are secret underground hangars all over Napa County. They've been seen in other places, too."

Conspiracy. Always possible, I guess. But I tend to think the kinds of control freaks who'd be into world domination couldn't manage to share a house, let alone a plan. They'd be killing each other off after about a week.

I wanted to ask her which of the members had, actually, been in at the very beginning, but thought that might be pushing it. Maybe the information would just slip out if we kept on talking.

"I was wondering, I never heard of this *zog* thing Hal mentioned. The evil *zog*? What is that?"

"The Zionist Occupational Government. The secret Jew government that is ruling our country."

Uh-huh. Just my luck. My own relatives were ruling the country and no one was letting me in on it. I looked thoughtful. "Yeah. You

know, that makes a lot of sense. More and more of them…" I nodded, scowling.

"I can see you'd appreciate our newest work of art." She grabbed my hand and hauled me into the kitchen, to the far wall. There, above the kitchen table, was a framed full-color print of a lamp with the words TURN THE LIGHTS OUT ON WORLD JEWRY printed in black below it. The lampshade was made of sections stitched together. I couldn't tell what it was supposed to be until I saw faint suggestions of human features on a couple of the pieces. I felt the heat flush my face. I clenched my shaking hands together so I wouldn't reach up and rip the damned thing off the wall and break it over her lunatic head. Fortunately, she was looking at the print, not at me.

"Of course, that was all a lie, you know." She was talking again. I struggled to focus on her words. "There were no lampshades made of Jewskin. There was no Holocaust." She took my hand, unclenching my fist, and led me back out of the kitchen, stopping again just outside the doorway.

"I can see you're overcome by what I've shown you," she said.

I took a few deep breaths. "Yes. I am." I had to change the subject, quick. "So tell me, are you…" I hesitated, as if with awe. "Inner Circle?"

"Yes, indeed."

I breathed deeply, looking at her nasty little face as if she'd just said she'd won a Nobel Prize.

Pete Ebner reappeared, heading our way.

"Having a good time, Jase?"

"A great time, Pete."

"And what are you two talking about?"

"He wanted to know if Hal and me were Inner Circle."

Pete narrowed his eyes.

"Kind of a personal question."

"Just making conversation, Pete, getting my bearings. You know."

"I *don't* know. But I plan to find out." He smirked, and I decided not to let him get away with what sounded like a threat.

"What's that supposed to mean? Find out what? I swear—" I

turned to Helen "—this man just keeps on saying things I don't understand." I laughed in a good-natured, tolerant, isn't-he-funny kind of way. Helen shook her head and smiled.

I could tell Pete wasn't having any, though, so I tried another approach.

"I want you to know, Pete, that I'm grateful for the opportunity to come here tonight."

He shrugged. "Glad to hear that. Maybe you'll get a real opportunity one of these days to do something for the Command. I mean, besides cooking dinner." There was that smirk again. Was I supposed to hit him? Defend my manhood?

"I'd like that."

He studied my face. "Helen, why don't you explain to the new guy here how far he might have to go to serve the Command?" And he was off across the room again, on some other mission of intimidation.

Okay, so maybe Pete had gotten me here to impress me with something, something that he thought Helen could tell me. I turned toward her, expectant, trying to get a burning and dedicated look in my eyes while retaining Jason's basic stupidity.

"Maybe he doesn't trust you so much after all, Jason."

"What makes you say that?"

"It just sounded like he was warning you about something." Her eyes didn't look quite so flat now. There was something hot in back of them.

"Well, I guess he feels he has to do that. I don't mind."

"Good." She relaxed a millimeter. "Sounds like he wants me to talk to you some more, hmm?" She made it sound vaguely racy.

"Guess so. I'm ready and willing to hear whatever you have to say, Helen."

"What do you know about Adolf Hitler?"

"Not a heck of a lot." I chuckled. "You know, I got to admit I feel a little lost when people start talking about, you know, that history stuff. But I know he was a great leader. I know we could maybe use someone like him in the U.S. today, get some of the garbage and criminals off the streets, know what I mean? He was all for white people, I know that."

"Yes. He was. And he was willing to die for his beliefs."

I nodded appreciatively—that part wasn't hard, appreciating his death.

"He was ready to kill for them, too, Jason. Are you?"

She was leaning toward me, staring intensely into my eyes as if she were trying to read my mind. I tried to wipe it blank.

"If I had to, I guess I could. Never thought about it much, but there's been a time or two…" I gazed into the middle distance, thinking about some of the scummier characters I'd met on cases before, getting a look of distaste and anger and maybe even hate on my face.

"Kind of an exciting thought, isn't it?" Her face was no longer pale, but flushed and shining as if she were on the verge of orgasm.

I thought about sex—not with her—trying to create the same effect on my face. "Yeah, you know, it is.…"

"See, what Pete was saying, I think, was that if you really belong in the Command we'll find out. That you'll be tested. That if you pass the test you'll be in. And if you don't…" She raised her hand to her throat, forefinger extended, and ran it across in the familiar throat-slitting motion. She was grinning. She was having a really good time.

"Jeez, this is getting more and more exciting." I lowered my voice and widened my eyes. "You think this test is going to happen soon?"

She leaned back against the wall and smiled slyly at me. A high-pitched giggle bubbled up.

"That's for me to know," she said in a little-girl treble, "and you to find out." Then she turned and ran into the kitchen, toward the refrigerator. She even skipped once or twice along the way.

Helen Harte, I was now sure, was completely insane.

I glanced across the room and saw Floyd looking at me. He waved me over to where he stood with Red.

Still recovering from the conversation with Helen, I walked slowly toward Floyd and Red. Before I got halfway there, the beautiful woman I'd met at the bar approached me. Gilly. She must have arrived while I was getting Hal's fifty-cent lecture or watching Helen's weird performance.

"Jason. Royal's cousin. Nice to see you again." Her hazel eyes were deep and flecked with gold. Was there a hard, cold light back in there somewhere, or was it my imagination? Her smile was warm. When she looked at me I felt nervous, attracted, and disgusted that I could be attracted to one of these mutants. I did not like the way she made me feel. Correction. I did not want her making me feel that way.

"Nice to see you, too, Gilly."

She hovered right at the edge of my personal space, threatening to break through and into it. I backed away, smiled, and told her I had to go talk to Floyd about something, and that I would see her later.

Turning away from Gilly, I damn near crashed into Leslie.

"Hey, Jase. Thought you were spending the evening with your dad."

"Oh, just dinner. Then Royal invited me along to this great party—he asked Pete Ebner if he could bring me, and Ebner said okay." Ebner was talking to Zack. They looked very serious.

"Really? Well, that's pretty quick. Listen, I was thinking. I got some great websites you might want to check out."

I shrugged and grinned. "Not too sharp in that department, Leslie. Got to go talk to Floyd. Catch you later?"

She sneered. "How fast can you run?"

Pretty damned fast, in the other direction. But I slowed down a little as I passed Ebner and Zack, trying to hear a few words. I caught two—Farrier's and something-busting. Farrier's was an upscale shop in north Berkeley. What was that about? I'd have to ask Royal.

Red and Floyd gave me the one of the standard greetings: a strong, silent nod.

"Floyd. How ya doing, Red?"

"Good, Jase." Red's nod got more energetic. "Real good. Hey, the couch is empty, let's go sit over there." He burped.

The three of us, Floyd, Red and me, sat and drank beer—I drank mine very slowly—and watched the party drag on.

Ebner was all over the place, backslapping and looking intense. The warriors did a lot of arm-punching and haw-hawing and drank

huge quantities of beer. Leslie hung around their fringes, along with a couple of other young females similarly dressed and buzz-cut. I wondered if they wanted to be warriors. I wondered if it was ever allowed. Always a cheerleader?

I heard the words "ZOG" and "Thunderskin" a few times, "KKK" once. Hal walked by with Karl at one point, raving about the IRS.

I poked Floyd in the ribs to get his attention. "I'll bet that Ebner's been in this group a long time, huh?"

Floyd nodded. "Yeah. A while. I been in two years, he was in before me." He muttered something beery about "takin' a leak," heaved himself to his feet, and ambled away.

Just me and Red now. Ebner, circulating closer to us, caught Red's eye and looked at his watch.

"Think it's time, huh, Red?"

"Yeah. I do."

Ebner squared his shoulders and marched over to the rear wall of the living room. I hadn't noticed it before: a roll of fabric up near the ceiling, with a rope hanging down from it. Ebner put out his hands, palms up, asking for quiet. Group by group, one by one, people turned to look at him and went silent.

"We have Hal and Helen to thank for this historic moment. They designed this flag and they made it. Let's give them a big hand." Flag? We were going to see a flag? Enthusiastic applause tailing off to a quiet tension, waiting, excitement ready to bust loose.

Ebner went on, his voice soft but building. "I'm really happy to see you all here tonight, to look around this room and see all you brave, clean young men, ready to go out and do battle for the white race." He stifled an outburst of cheers with his raised hands. "Save it. Save it for the flag." Then, louder: "Together, we'll get the job done, and we'll march across this country and across the world carrying this flag—thousands of these flags! The sacred banner of the Aryan Command!" He raised a fist, then in a single movement, grabbed the rope and pulled. The flag unrolled. The room exploded in cheers and roars and screams and foot-stomping joy.

At first glance I thought it was the stars and stripes. It had the right stripes, red and white, but where the blue field of white stars

should have been was a black field with a white swastika.

The beer threatened to erupt from my clenched stomach. I covered my mouth, tears spilling from my eyes. Red was staring at me.

I caught my breath, forced the beer back where it belonged, and smashed my fist down on the coffee table. "Incredible," I said. "So incredible. It damn near makes me cry."

I invited Cousin Royal for a short stroll outside.

"I'm going to leave in a little while, Royal. You staying?"

"I guess I have to. It's for us. For the warriors. They'd think it was strange if I left early. I never did before."

"Can you get a ride?"

"Sure. Zack or maybe Skink. No problem."

"I heard something. About Farrier's. Tomorrow. Do you know what that's about?"

"Oh, yeah—tomorrow. Nothing much. Some lefties are going to protest something, I forget what, and some of the guys are going to break it up."

"Why didn't you tell me?"

He shrugged, looking a little sullen. "I said it was no big deal. Not a secret or anything. A lot of guys are going."

"Are you?"

"I guess so. I told Zack I would."

We had walked down the street a couple hundred yards. I stopped, under a huge eucalyptus, and pulled Royal to a halt with me.

"Listen, Cousin—I need to be kept informed and you need to let me know what the hell's going on. Maybe you don't think this is important—and maybe it isn't—but I'll decide. Got that? And get that damned beeper so I can call you!"

His eyes narrowed, his lip curled. "Shit, man, pull that stick out of your ass."

That was a lot more than I was willing to take from this punk. I grabbed the neck of his T-shirt and twisted. "If I do I'll apply it to yours. You're my mole, remember that. You let me know what's going on. You don't make decisions about what I know and don't

know. That's dangerous for me and for you and Deeanne, too. Let me do the thinking, Royal."

His gaze shifted away from me and dropped. His shoulders sagged. I let go of his shirt. It was all stretched out.

"Okay, Jake. I'm sorry, okay? I, like, forgot about it. It's not like that's where they're going to kill someone or something, like we talked about. Don't be all, Royal's trying to hide shit. I'm not, okay?" I believed him. What a dummy. "I'll try to remember to tell you everything I hear, okay? And I will get a beeper. Some of the guys have got 'em. It won't look bad or nothing."

"Good. What time is this protest?"

"I think morning, like ten."

"Find out for sure and call me if it's another time."

He nodded and started walking away.

"One more thing," I said. He stopped and turned his face toward me, his body still in escape mode.

"The paper said there was some trouble last night—a cemetery, a church, a gay bar—anyone I know responsible?"

"Yeah." He looked at his boots. "Zack and Skink."

Big surprise. "On their own?"

"Course not. Red put it together."

"Was it part of this big plan you told me about, with Switcher, and—"

"Nah. Just a Red Run."

"A what?"

"A Red Run. Just practice. Games. Maneuvers. Red sets 'em up sometimes."

So Red got his kicks by setting up war games. Nothing that counted for much. Maybe a bone Ebner threw him to keep him in line. Or Steve.

"And this thing tomorrow? At Farrier's? Is that just a Red Run?"

"Not exactly. I think it's a little bigger than that. I think it's connected with the plan. Some way."

Clear as mud. We started walking back, but I stopped him again. "Leslie mentioned those Thunderskin websites. Maybe I should take a look at those."

"Maybe. I did, once. They're all, like, 'Odin,' and 'Thor,' and

those guys. Leslie says this Odin's the big god of warriors, but they talk about Thor a lot, too. Some of them even, like, worship them, I mean they're not even Christians or anything."

"But the Command isn't Thunderskin?" I was still trying without much success to get a handle on how everything tied together, if it did—Nazis, KKK, survivalists, Thunderskins…

"Well, like I said, not part of it. You know, people check it out. Different groups, you know." I didn't. And neither, obviously, did he. Lots of splinter groups, no solid core? I hoped.

I went back to the party with Royal, just so it wouldn't look like the flag had chased me away, but it was still hanging there and it still made me sick, so half an hour later I made a big show of being really tired and a little drunk and took off.

When I got home I fired up my slow 486, got on Netscape, and searched the word "Thunderskin." There were a bunch of sites listed, one in Germany, one in Britain, and one called "Thunderskin Warlord." Most of the headings I clicked on led nowhere. A couple gave e-mail addresses for further contact. Some led to warnings that I was about to be offended, but I could go ahead and enter if I was not homosexual, Jewish, drugged out, or nonwhite. A couple of them led to elaborately graphic home pages with various emblems—burning shields with crossed lightning, stars with crossed lightning, Confederate flags with crossed lightning. One of the elaborate ones included an apology that said its creators wanted to make it "Members Only" but were "having trouble" getting set up. Another promised to "return" at some unspecified time. An "international list of addresses" came with the disclaimer: "Don't complain here if you don't get no answers."

I was, certainly, offended. I was also a little relieved by their lack of organization. Prospective members would have to be a lot more motivated than I was to make contact. The original Nazis were a lot more efficient.

Royal didn't call me that night or early the next morning, so I assumed—hoped, anyway—that ten was the hour, and let Rosie know what was up. She offered to come along for the ride.

I wasn't sure how I wanted to go, as Jason or as myself. This was

not an easy decision. Royal had said this thing, whatever it was, was no secret in the group, but that didn't mean that it would be okay if he told someone on the fringes, like Cousin Jase. And I didn't want them seeing me there and testing my loyalty by inviting me in on whatever they were doing. Which meant I should put on the curly wig and wear normal clothes. But with a bunch of warriors around, I was worried that someone might recognize me as Jason anyway, and wonder what I was playing at.

Rosie came in on the side of the wig and tipped the scale. This would be the rug's first major public appearance.

I picked up Rosie and Alice B. The poodle loved riding in my convertible. Rosie's dark hair was covered by a straw sun hat and she was wearing her baggiest overalls.

"You going for the Iowa cornfield look?"

She explained that she hadn't wanted to look like her real self but was saving her more complete disguise for her "Thor's drag." Which was going to include a blond wig, she said. It was all getting very complicated.

We got to north Berkeley by 9:30, and as close to Farrier's as Shattuck and Vine, when we heard the sound of voices raised in that old familiar, Vietnam-era chant—"Hell no, we won't go!" I wondered, where was it they would not go?

I figured some of them had just gotten their records stuck in 1968 and couldn't say anything else.

I grabbed the first parking place I came to, Rosie slipped the leash onto Alice's collar, and we jumped out of the car, looking for the source of the noise. We weren't the only ones; lots of heads were turning. North Berkeley was not that often the site of demonstrations, certainly not these days; most protestors still seemed to enjoy doing it at Sproul Plaza, right on campus, in the traditional fashion.

About a block away, we could see a dozen or so people marching and waving signs. They were heading in the direction of Farrier's, a yuppie clothing shop that specializes in imports. When we got close enough to read their signs, I began to get a glimmer of what they were protesting. Overseas child labor. BOYCOTT THE CHILD-KILLERS! one sign read. Another: THIRD-WORLD CHILDREN DIED TO

MAKE FARRIER'S RICH. Printed in large red letters across the bottom of each sign was the name of Frasier's group—ThePeople. At the head of the parade was someone I recognized from newspaper photos, a tall, gaunt man with red hair, the curly orange kind, that stuck out all over his head. Not like a perm, more like a foaming fountain. And lots of big freckles on his face and arms. Cary Frasier. I pointed him out to Rosie.

I had mentioned to her that Royal had a vague idea that maybe the left-leaning target slated for the Command's grand plan was—possibly, not necessarily—Cary Frasier.

"They're planning to kill the lefty after the righty, isn't that so?" she asked me.

"That's what Royal said."

"But if he's wrong…"

"This could be a hit."

"Okay. Just in case, then." Like Superman, she ducked inside a phone booth. Unlike Superman, she didn't undress. She just made a quick call.

"Couldn't reach Hank or Pauline—I think the cop I talked to was humoring me."

"Great."

We caught up with the action in time to see ThePeople march right up to Farrier's door and plant themselves in front of it. A couple of customers who had been about to go inside backed away. One guy turned around and damned near ran down the street. Maybe he'd OD'd on protests in the Sixties and thought he was having a flashback. Alice, who's a really tough watchdog, was looking pretty tense and standing pressed against Rosie's side.

The owner of the store, a small, thin woman with platinum hair, burst out of the door waving her arms, red-faced, and began pushing at the protestors, screaming shrilly at them to go away and leave her shop alone. They didn't argue with her, but they didn't move, either.

"So that's where hell-no-they-won't-go," I said to Rosie. "Away from the door." She rolled her eyes—at them or at me, I couldn't tell.

"It's a lie!" the owner shouted, but her cries were drowned out

by their chants: "Boycott the child-killers," and, still, "Hell no, we won't go!"

"I'm calling the police!" the owner screamed, but nobody cared.

ThePeople had actually brought a wooden crate with them, not a soapbox but a reasonable facsimile, and Frasier climbed onto it and held up his hands, asking the chanters to stop. He started shouting something about dead children and slave labor. The store owner had given up and gone back inside, presumably to alert the law. That was good; another call couldn't hurt. The demonstrators began walking in a circle. A few passersby stopped to listen.

Frasier had just gotten to the part about Farrier's participation in the exploitation of the third world when a light blue pickup truck screeched to a stop at the curb and several yelling warriors leaped out. Alice started barking. Rosie hushed her. We were looking at the truck's passenger side, and without getting closer, I couldn't tell who was behind the wheel.

Royal wasn't with them.

There was Zack. Skink. Washburn. A couple of kids I'd seen around but didn't know. They were all wearing leather jackets and boots and carrying what looked like police nightsticks. I didn't see any guns.

Just to be sure none of the boys saw me, even though my wig, khakis, and striped shirt created a pretty good non-Jason effect, I touched Rosie's arm and shuffled sideways to hide myself behind a clump of retreating spectators. She shuffled with me.

The warriors swarmed through the demonstrators, waving their nightsticks and chanting, "Two-six-oh-five Barclay Street!" over and over again. I heard the sound of hard wood hitting muscle and bone. Frasier's people scattered, cursing and screaming. Skink, still chanting, shoved Frasier off his box, and three protestors rushed to his side to help him up.

Our little knot of concerned citizens was moving and splitting up at the same time. Our thin shelter was evaporating. As I looked around for new cover, I caught a glimpse of one of the skin-chicks who'd been at the party with Leslie the night before, leaning against the window of the store next to Farrier's. Buzz-cut black hair, bony body. She'd been looking my way, and I couldn't tell

from her sulky expression if she'd recognized me or even seen me.

Rosie was pulling at me with one hand and at Alice, who was straining at the leash, woofing in her deepest voice, with the other. I followed her into a nearby recessed doorway. We tucked ourselves in and kept on watching.

The warriors fought the protestors for their signs, won, and smashed the wood and cardboard against the sidewalk, against the fire hydrant, against the front wall of Farrier's. A woman standing near us began crying. The warriors kept on smashing. And over and over again, they shouted those words: "Two-six-oh-five Barclay Street!"

Then, as suddenly as they had come, they were back in the bed of the truck and the truck was roaring up the street. I noticed there was an Aryan Command flag tied to the tailgate over the license plate, a foot-long version of the monstrosity Ebner had unfurled the night before. I couldn't help but wonder if Helen had spent the night sewing it.

The crying woman mumbled something about "poor Cary," who was, in any case, still alive, and I asked her if she knew what the Barclay-Street chant meant.

"Of course," she said. "That's Cary Frasier's home address."

The police arrived a few seconds later, responding to somebody's call, and seemed surprised to find the protest already shattered and some of the picketers slightly injured. One man sat against the store wall holding his bleeding nose. A woman was nursing a wrist that seemed to hurt a lot.

Frasier, wearing a red abrasion on his cheek, accosted one of the cops, yelling, "This is what happens, when—" but the cop managed to quiet him down.

I was shaken by the suddenly-there, suddenly-over blitzkrieg attack, by the violence, and by the powerful intimidation tactic the Command had used—shouting the man's own address at him. I also had a minute's worry that the driver of the truck might have spotted me. The warriors had been busy pillaging, but he'd just sat there waiting, and would have had time to look the crowd over.

Ah, what the hell, I told myself. Different hair, different clothes, and somehow, I didn't think that the driver, whoever he was, would

be all that interested in crowd-watching. Chances were better that he'd have been eyeballing the warriors and rating their performance.

All of the injured seemed to be more or less okay, on their feet or getting there. The store owner was talking to one of the cops. I heard Cary Frasier telling the other cop that he didn't need an ambulance.

The show was over, but the people still left on the street were stunned, immobile, babbling to each other. Three words were being spoken over and over again: Nazi, flag, and skinheads. A van from Channel 2 News pulled up at the curb and a crew spilled out, including one of their hotshot on-air reporters.

On the drive home, we rehashed the show.

"It was quite a performance," Rosie said. "But I think it was a simple enough statement: break up the left protest, make a public appearance, wave their flag."

I'd been thinking: This wasn't just another Red Run. It was something more significant—the first big announcement of their presence. A show of strength. The first public display of their new flag.

"But they made Frasier a hero today. Nobody would have noticed this little protest if they hadn't turned it into a war. They're getting him big coverage, making him a martyr to a strong and emotional cause. Why would they want to do that?" Odd bits of conspiracy theory were trickling through my brain.

"Know what I think?"

"What do you think, Rosie?"

"I think there's no point in wondering why they do things. I think they're just stupid little bullies who get a kick out of this kind of crap. And stupid little bullies tend to self-destruct."

Just as she was saying that, we were crossing the Richmond–San Rafael Bridge, the bridge with the big tan troll: San Quentin. Yeah. Sometimes bullies self-destruct; sometimes they rule their worlds.

S o tell me, Leslie, besides coming here and going to Hal and Helen's, what else do these guys do? Where do they go for fun? I mean this is a nice bar, but, you know, it's a bar...."

She looked at me appraisingly, and I wondered what she was thinking.

Friday night. Getting right back on the Thor's horse after I'd watched it biting people. And this was a very big night, Rosie's first visit to the Command's watering hole. She was wearing a blond wig, short and straight, black jeans, a tight red T-shirt, two earrings in each ear and a cuff on her nose. She really did look like a different woman from the one who'd been in north Berkeley that morning, and she certainly looked different from the Rosie I know and love, who leans a bit to the preppy side when she's being herself. I had introduced her around as my friend, Rosie Van Dyke.

After the protest-bash, we'd headed back to Marin, Rosie to the office and I to meet with Sally and make an offer on the house on Scenic. Sally was also moving right along on the hoped-for sale of my house. A prospective buyer was coming early Saturday evening and an open house was scheduled for Sunday.

Working on Rosie's theory that Sally thought I was pretty hot, I made sure our conversation didn't end with business this time. I asked her to go out to dinner with me after the next day's meeting with the buyer. She said yes.

Which made sitting in Thor's and talking to Leslie just about the last thing I was in the mood for.

Leslie had come into the bar a few minutes after we got there, looked around, and plunked herself down next to me. I introduced Rosie; Leslie squinted at her and mumbled hello. Karl had come in with Floyd a few minutes after her and they sat down on Rosie's

other side. They introduced themselves and this time I heard that Karl's last name was Tullis.

Zack and Pete Ebner were sitting at a table across the room. The pal of Leslie's I'd also seen at the lefty-bashing was there, too, the skinny one with the buzz cut. I hadn't seen anything in any of their faces, not so far anyway, that told me they'd spotted me on the street as Jason wearing a wig.

I was hanging out, trying to relax, breathe easy, and blend in. I was also wondering about Floyd. Zack was a kid. Ebner was a lunatic. Red was a slob. Karl was a gnome. But Floyd—I could guess that women might not find him too ugly. He was broad, solid, and tall. His nose wasn't smashed in, and although his eyes didn't exactly sparkle with intelligence, they weren't crossed or anything.

So why was he always in Thor's, and never with a woman?

And why couldn't I manage to avoid him for even one day?

Leslie had finished her study of my face, and took a long, slow draught of her cheap beer. "We go lots of places, Jase honey." She flicked a smug look at Rosie. Trying to make her jealous? "We go out to dinner, we go to movies. We go to ball games. You like movies? You like ball games?"

"Of course I do." Hey, I'm an American kind of guy.

Floyd spoke up. "What about you, Rosie—you like ball games?"

"Sure."

"Well, that's good. A pretty lady like you would want to do something with your time besides sit around a dark bar with a buncha beer-soaked guys." He grinned at me. Were these people trying to break us up? Did Floyd not have a girlfriend because he always went after lesbians?

Karl snorted. He was wearing a black shirt over a black T-shirt, black jeans, and black boots that looked more like combat boots than Docs.

"Beer-soaked guys," he muttered. "Speak for yourself, Floyd."

"Hey Karl, climb down off it, okay? I was just trying to explain to Rosie here that we have interests that might, well, interest her. Social stuff, you know?"

"Ball games? Jesus, Floyd. She's a woman." Karl leered at her. "Bet you'd like to go hear some really good music, though, huh?"

Floyd swung his head around to face Karl. I couldn't see his expression, but I could hear his words. "Back off, Karl. If she wants to hear some music, she don't want to hear it with a skinny pervert like you."

Karl snorted again; beer spurted out of his mouth and dripped off his chin. Beer-soaked, yeah. Floyd laughed and turned back to Rosie. He was still chuckling, but his eyes were cold.

"Pervert?" I asked.

"He's a vegetarian! For Christ's sake."

"Hey, man, I got medical problems."

"Okay, a skinny, sickly pervert."

"You're getting less funny every minute, Floyd."

"Then go sit somewhere else, celery-sucker."

"Hold on, Floyd." Steve leaned over the bar and touched Floyd's arm. Floyd shrugged and swung all the way around, his back to Karl. Tullis shook his head, climbed down off his bar stool, and wandered over to Ebner's table. Ebner and Zack didn't look all that happy to see him, either.

For a macho guy, Floyd had done a quick stand-down. Steve really did carry a lot of authority with these people. Maybe it was only the kind of power that goes with wielding the beer spigot. Maybe something more.

Gorgeous Gilly strolled in, gave me a lazy smile, and sat down on the stool Karl had just vacated. I had two thoughts: first, like Floyd, she was always alone; and second, I was really grateful that Sally had accepted a date with me. Save me, Sally.

Ebner hoisted himself to his feet and strolled casually over to the bar, placing himself between me and Leslie and giving Rosie a cool gaze. I introduced her to him. He nodded, but all he said was "Give me another beer, Steve." Steve did and Ebner walked away without looking at either of us again.

Floyd picked up the conversation where we'd left off. "I believe we were talking about a ball game, isn't that right, Rosie? And Jase?" He added my name as an obvious afterthought. Cute.

Rosie nodded and sipped at her red wine. "I believe we were."

"Who do you like, the A's or the Giants?"

He was talking to Rosie, but I answered before she could.

"Who you got tickets to?"

"A's. For tomorrow. Whole block of 'em. And we got a tailgate party happening. Eleven A.M." He sneered. "You can come, too, Jase." Eleven would work. I could be back home by six, take a quick shower and change clothes, meet the prospective buyer by seven, go out with Sally at eight.

If Rosie and I had to go somewhere with this guy to work our way deeper into the group, a ball game sounded pretty harmless. Lots of people around, sunlight, hot dogs... I like the Oakland A's. Of course, I really loved the '89 A's, saw every game I could. Carney Lansford. José Canseco. Rickey Henderson. Dave Stewart, Mark McGwire. Some of them were still around, some were back again, some were hitting them over the fence for other teams. McGwire— well, hitting them over the fence is, of course, putting it mildly. But together, way back then, they'd been the greatest.

They'd even caused a major earthquake.

Rosie smiled at Floyd. "A tailgate party. Sounds like fun."

Right. A Nazi tailgate party in the heart of Oakland. Sounded like suicide.

I wanted to be sure it wasn't just going to be me, Floyd, Rosie, and maybe Leslie. "Who'll be there?"

"Well, I think Pete Ebner's coming." Wonderful. "And Gilly? What about you?"

Gilly shrugged. "Not sure."

"I'm sure old Karl will be there. He don't miss anything. And Leslie. She loves tailgate parties, don't you, Leslie?"

"Love 'em." She drooped her damned lashes at me again.

"And your cousin—he'd probably like to come."

"I'll mention it to him."

"So I guess we just made a date, huh? Right, Rosie?" Again, that sly look toward me. I was having some trouble with this. If I declared that Rosie was my girlfriend it would limit my, well, movements around, well...Gilly. That was probably a good thing, but it would also limit Rosie's movements in the group. We should have made a plan. For now, we'd have to play it kind of ambiguous.

I tossed him a sneer and a warning squint he could take any way he wanted to.

Floyd slid down off his stool. "Gotta go to the little boys' room." He headed for the back of the bar. Ebner was moving that way, too, now.

Just as they were disappearing, Royal came in, nodded to me, said, "Hi" to Leslie, who flashed him the biggest smile I'd ever seen on her, must have moved her lips a quarter of an inch, and stopped at Zack's table. He and Zack exchanged a few words. Royal nodded, dug out his wallet, and handed Zack a wad of bills. A few more words, and he headed toward me. I noticed that Leslie was following all his movements.

Steve drew him a beer and he stood between me and Leslie, chugging it. I told him about the tailgate party.

"Yeah," he said between swallows. "Zack mentioned it." He glanced at Rosie.

"You've met my friend, Rose."

He almost said no, but caught himself and nodded.

"Why don't we ride to the game together?"

"Yeah. I got to go. Talk to you tomorrow." He swallowed the last of his beer, like it was medicine.

Leslie seemed to be watching his butt when he walked out.

She swung back around and stared at her beer. "You think Royal will come to the tailgate party?"

"Sounds like it."

"Good. See you." She glanced at Rosie and gave her the droopy lashes this time. "You, too." With that she took off, wandering in the direction of the jukebox.

Gilly looked over at me and smiled. A gorgeous smile. Just as I was about to start a conversation with her, she finished her wine and got up.

"Can't stop to chat now, Jase, but I sure would like to another time." There were those damned gold-flecked eyes again. I forced myself not to watch her go. I forced myself to think of the Aryan Command flag. I thought very hard about it.

Rosie broke into my thoughts by whispering in my ear, but not tenderly. "What's that about? That woman? I've seen that look on your face before. I know what it means. Are you completely out of your mind?"

"Hasn't got anything to do with my mind. Don't worry. I'm cool."

"She's spectacular. Take care that you stay cool."

Half an hour later, Floyd had not returned and neither had Pete Ebner. Caught up in some backroom business, I supposed. Maybe a postmortem on the fight that morning.

We were walking to my car when I heard a voice behind me. "Hey, Jase—Rosie! Wait up. I'll walk with you. Streets are dangerous."

Karl. By that I assumed he meant he was scared out there at night, not that he was coming along to protect us. We stopped and waited for him.

We exchanged the usual nice-night small talk, then he looked at me, his dark eyebrows all wrinkled up with sincerity.

"You know, Jase, you seem like an intelligent man to me."

Damn. I wanted to seem stupid. Was I failing? "Thank you, Karl."

"A lot of these guys, well, they don't have much education."

"But you do?" Right. Royal had said that Karl was the brains of the group. The intellectual leader of the Aryan Command. What a distinction. I was surprised he hadn't changed his name to Karl Goebbels.

"Sure. Can't run a revolution if you don't understand how things work."

"And how do they work?"

"With great difficulty and in surprising ways."

"So you're running the revolution, right, Karl?"

"Only the mental part, Jase. I leave the physical side to the big and the strong. The warriors."

"And Ebner."

"Right. Ebner. And Red. And Floyd. Which brings up a point."

I slowed down. "And what would that point be, Karl?"

"You and Floyd seem to be buddies. And he acts like he likes Rosie—" he almost bowed in her direction "—if you don't mind my saying."

"What's your point, Karl?"

"No big point. I just think you might want to, well, be careful.

Maybe be a little bit careful and maybe not trust Floyd too much."

"Not trust him? What's that supposed to mean? Not trust him how?"

We were a few yards from my car.

"Just be careful, okay?"

"Okay." We had reached the Falcon. I unlocked the door.

"See you, then, Jase, Rosie." Karl winked, and sauntered back a couple of cars, getting into an old brown VW fastback. He got in, started the engine, and pulled away.

Now what the hell was all that about?

Saturday was a pretty day. I couldn't believe I was going to spend it watching a ball game at the Oakland Coliseum with a bunch of Nazis.

Royal was coming. He'd wanted to take his own car but I asked him to ride along with me and Rosie instead. I wanted to quiz him about the Command's attack on Frasier's ThePeople, among other things.

I picked Rosie up first. We had a lot to talk about.

"So you never heard back from Harry George?"

"Nope. But what the heck, it's only been a couple of days. He could be out busting terrorists somewhere."

"Or on vacation."

I laughed. "Impossible. Our government never rests."

"Looks like they were sound asleep on this one. I'm not looking forward to spending much more time with these jerks." And she'd only spent one evening with them so far. It didn't take much.

"Yeah. I want to turn this whole thing over to the Hairy Guy, get Royal's butt covered somehow, and watch from a safe distance while the FBI raids Thor's back room. Maybe you should check again with Pauline to make sure Hairy's the guy I was supposed to call."

"I'll do that."

From the FBI, we moved on to something that might have more immediate consequences—like today—Floyd's interest in her and how we could deal with it. We decided that we would leave our relationship a semi-mystery, hinting that we were seeing each other just enough so she could put off Floyd, Karl, and anyone else who craved her shapely body and the favor of her pretty smile. But at the same time giving the impression that both of us were keeping our

options open, in case we needed room to maneuver. I'd been happy the night before when Floyd had disappeared leaving things kind of vague, so I didn't have to make a fast choice between acting like either the pissed-off boyfriend or the casual pal. And of course Rosie had been pretty damned relieved, too.

I'd invented a sick old dad to keep people away from my house. Rosie might have to invent a psychotic mother.

Although that might not bother a member of the Aryan Command.

Royal was waiting on a street corner. I still didn't know where he lived. As he slid into the back seat he handed me a scrap of paper. He'd written "Royal's Beeper" and a number on it. At least I had that now.

"By the way, Royal, Rosie here runs the agency I work for, so she's on the case, too."

"Oh. Okay. More the better, I guess."

The three of us drove out to the Coliseum to meet the gang where Zack had told Royal they would be: in the general area of Section F, at the tailgate of Red's truck.

"Same truck they used to carry troops to the Farrier's protest? Big? Light blue?" Rosie asked.

"Yeah. Ford."

"So that was Red driving in Berkeley yesterday? Rosie and I couldn't tell."

"Nah. What I heard, Red's truck was there, but he wasn't. Ebner was all, like, I got to do this. With the truck, you know, so the guys could just all jump out." I wondered how Red felt about Ebner using his truck to take the warriors on a job.

"How come you weren't there? You were thinking you might be."

He didn't answer for nearly a full minute. "I was afraid you might call the cops, Jake." And so we had, but they hadn't gotten there soon enough to make a difference. Not soon enough to jail the warriors or keep people from getting hurt.

Rosie filled the hole my thoughts were making in the conversation by asking, "How did this protest action get put together, Royal? Who came up with the idea?"

"Red saw this article in the paper last week, that Frasier guy saying they were going to do it," he explained. "So he thought it would be fun, you know? They weren't going to hurt anybody really bad or anything. Just make them look like a bunch of fools." It had even been Red's idea. He must have been really pissed off when Pete pulled it out from under him.

"Do you think Frasier's group is a bunch of fools? About the child labor?" Rosie sounded like she was talking through her teeth. I knew she was left of neutral on that question.

"Yeah. I do. People are greedy. It's stupid to think they can change that. Everybody's got to make a buck, you know?"

What a bunch of crap. "Damn it, Royal, is that why you didn't tell me about it at first? Because you thought they were right?" Could I trust him at all?

"No! I didn't say they were right, I just mean you can't change people. And I said I was sorry, Jake. I didn't think it was worth it, to get them suspicious that someone's snitching, just for that stupid protest. Okay?"

I glanced over at him. His hands were trembling. "Let me repeat this: Next time you let me make the decision. Okay?"

"Yeah."

He didn't sound convincing. Maybe he was too scared to trust.

"Something else—I saw you giving money to Zack yesterday. What was that all about?"

"Loan."

"He borrowed money from you? How much?"

"Just a couple hundred."

Just. "Do you lend him money often?"

"I got it, I loan it."

"And he knows you've got it."

"Sure."

He was sounding defensive, so I decided to let Zack's sponging go for now and change the subject. His crap around the protest had left me feeling a little mean, so I said something I thought he might not like.

"You know, Royal, you'd better watch out if Leslie's there. Floyd said she probably would be."

"Watch out? What's that supposed to mean?"

"It means she wants your body."

He looked at me as if I'd just told him I had three wives and two husbands. He was shocked that I would say such a thing. "Don't talk like that."

"It's true."

He spat out the window.

"Don't do that. You might hit the car."

"Besides," Rosie added, "it's disgusting."

He wiped his mouth. "How do you know? About Leslie, I mean."

"She told me."

"She told you?"

"Yes. And she says she doesn't understand what you're doing with a girl who isn't a skin, a straight-edge like Deeanne."

"Well, why are you telling me all this?"

"Because I think she wanted me to."

"You going to do everything Leslie tells you to do?"

"I very much doubt it."

Rosie laughed. "Glad to hear it, pal."

I pulled into the Coliseum parking lot and began cruising the rows. The Command goons were close to where they said they'd be, in the F Section, at the big blue troop carrier. F Troop.

Karl was hunched in a faded red deck chair nursing a beer. He nodded at me. Pete Ebner and Leslie were working at the Weber, trying to get the charcoal to burn. Red was sitting behind the wheel of his truck listening to the radio. Oldies rock.

A row of bloody paper-wrapped bundles of meat was slung across the truck's open tailgate, along with some packages of hot dogs and buns. Half a dozen ice chests were squatting underneath along with several grocery sacks spilling chip bags.

Hal and Helen were there. I figured they'd probably brought the chips.

No one was wearing a Confederate flag, thank God. And most of the tattoos were covered.

Floyd was waiting for us.

"Hey, there, Rosie! You all know Jase's friend Rosie, right?"

A few mutters of "Yeah, sure," even from the ones who hadn't met her the night before.

"You going to want a burger, honey?"

Oh, boy. He'd graduated to endearments. Rosie was going to have to start thinking about blocking a pass.

"Sure. Medium rare. And Jason likes his the same way." I could almost hear the strains of "My Guy" playing an accompaniment to that remark.

Floyd sagged a little, but kept smiling. "Okay. Want a beer?"

"Little early for me, thanks."

"Not for me," I said, and accepted a Budweiser.

Royal said he'd eat hot dogs, thanks.

It occurred to me that there was something definitely wrong with Floyd's smile. It didn't include his eyes. I began to gnaw on the possibility that maybe he was flirting with Rosie for the same reason he'd befriended me. Because he didn't trust either one of us and wanted to edge in closer, and not because he truly appreciated her beauty and charm.

I took a deck chair next to Karl's. "So, Karl, tell me. What's a vegetarian eat at something like this?"

Before he could answer Floyd roared, "Not a whole hell of a lot!"

Hal and Helen laughed loudly. Pete Ebner leered. Royal helped himself to a beer. The party was in full swing.

Would Gilly Johns show up? Alone? Why did I care? Why did I have the woman on my mind at all? And why, above all, was I arguing with myself? Why not just ask Floyd the question? I mean, I didn't want to be taken by surprise.

"Is Gilly going to be here?"

"Don't know. She keeps to herself a lot. Why, you want *her*, too?" His eyes slid toward Rosie, and he was sounding a bit snappish.

Karl laughed. "Maybe he wants 'em all, Floyd. And maybe he gets what he wants. Not like you."

Floyd ignored the crack. Had Floyd gone after Gilly and—I couldn't help it, I was at the Coliseum—struck out? In any case, he and Karl were not best buddies, and Karl seemed to get a lot of fun

out of making that clear to anyone who'd pay attention.

Karl jabbed again. "How's the job hunt going, Floyd?" Floyd didn't answer. "Floyd says he had a big job in construction. Foreman. But he lost it."

Floyd couldn't let that stand. "Politics, you son of a bitch. It was because of politics."

Karl laughed. Floyd's face was looking a little pink. I was thinking Karl better knock it off.

Ebner got the charcoal going to his satisfaction and grabbed a beer, taking it to an old convertible parked next to the truck. A Chevelle. Not in good shape like my Falcon. One more reason for him to hate me.

The car was a dusty and faded black with dents in the two near fenders. He swung open the door and sat in his own driver's seat. Like Red. Their choice of semi-solitude probably said a lot about them both.

Floyd was tossing dogs and burgers onto the Weber. Karl announced to the world at large that he had to go take a leak, and hiked off in the direction of the ballpark.

Leslie was standing close to Royal, talking very earnestly— something about a flight jacket she had seen somewhere. Something about the patches on it. Royal looked mildly interested, in the jacket, anyway. She reached up and stroked his arm. He didn't pull it back, but he shifted his body slightly so he was a couple more inches away from her. She moved in closer again. I joined them.

Leslie's eyes looked me up and down quickly, dismissively, and turned back to their contemplation of Royal's face.

"Food smells good, huh?" I included them both in this brilliant remark.

Royal nodded. Leslie sneered and ignored me, whining, "Royal, I'm restless. Why don't we take a little walk?"

"Hey, good idea." He really did seem to be glad she'd suggested it. Anything to escape from the group, I guessed. The kid was not holding up well in his role as snitch. It couldn't be too wonderful spending all this time with people he was betraying—people who would just as soon kill him as look at him if they knew. Couldn't have been a warm fuzzy feeling.

Of course, I was spending a lot of time with people I was betraying, too. If you could use the word "betrayal" in a case like this.

The two teenagers stumbled off in their big bad boots and I mumbled something about "little boys' room" and wandered off myself, just to see where Karl was really headed.

He hadn't quite gotten all the way to where he'd said he was going. On my way to the toilet, I saw Karl standing near the row of public phones, so I waved, smiled, and passed right by.

When I got back, Rosie was helping Floyd flip burgers. Ebner had gotten out of his car and was waiting beside Floyd, plate in hand, eyeing a pair of teenage girls who were sauntering by. They were giggling, and seemed to like his pretty blond attention. Little jerks didn't even notice me.

Helen was putting chips in plastic bowls. Hal went to a nondescript gray Eighties sedan parked next to Ebner's convertible and pulled out a radio, which he brought back and tuned to a country-and-western station.

Red swung around and stared out his window. When he saw who had turned on the competing sound he pouted, shut off his oldies, and got out of his truck.

"Okay, Hal. We'll listen to your crappy music for a while."

Hal smiled and nodded. Helen giggled.

Floyd was slipping the first burgers onto grilled buns when Karl came back, took a beer and a bag of tortilla chips from the truck, and eased his thin butt into his deck chair again.

He was watching Floyd in an odd, concentrated way.

"Hey, Floyd?"

"What, Karl?" The tone of voice said, clearly, Leave me alone.

"Maybe you should skip lunch."

"Why's that?"

"Getting a belly."

"Man needs a little flesh to look like a man, you scrawny runt."

"You look like a fat man. No, you know what you look like? Act like one, too?"

"Jesus Christ, Karl, slow down on the beer and back off before I have to shove a burger down your throat. Or a nice raw fist." He handed Ebner a hamburger on a paper plate.

"What you look like, you look like a cop."

Floyd just shook his head and continued to flip burgers and poke hot dogs. Ebner snickered and carried his food back to his car. He sat with the driver's side door open, eating his burger and watching the two men.

Zack and Skink showed up and grunted their hellos.

Karl wouldn't let up. "That wasn't a compliment, Floyd."

Floyd glanced at the smaller man and spat on the ground. Karl jumped up, spilling tortilla chips, and lurched right through them, crunching them underfoot. He grabbed Floyd's burger-flipping arm.

"I said you're fat, Floyd, and you look like a big, dumb cop."

Floyd yanked his arm out of Karl's hand and passed his spatula to Rosie.

"And I said, back off, runt. You're too skinny and too drunk to hit."

Red and the two boys laughed and drank beer, leaning against the truck.

Karl really surprised me when he swung at Floyd. He connected, too, hard on the jaw. Floyd took a couple of faltering steps back, then jumped on the little guy, knocking him to the ground and pounding on his chest and face until blood spurted from his nose. Karl pounded back on Floyd, his mouth open and a weird screeching war cry pouring out.

People from nearby cars began rushing toward us. Someone yelled, "Fight!" Helen pushed past Rosie, who was enjoying the mayhem, pulled the meat off the grill and piled it on plates, then she and Hal moved the grill itself away from the action. The whole maneuver looked almost rehearsed. Those two geeks were efficient. Not one hunk of meat other than Karl hit the ground. Karl was getting mashed, and nobody was stopping Floyd. I was about to break the newcomer's code of let-'em-work-it-out when Ebner hauled himself up out of his car and approached the two, writhing, locked together on the ground.

"'Nough, Floyd." He said it loud enough to be heard over Karl's eardrum-splitting screeches. Floyd gave Karl one more blow, an open-handed slap to the face, and got up.

"Runt."

Floyd's jaw was red and was going to be nicely bruised. Hal and Helen helped Karl to his feet and sat him down in his deck chair. Helen picked up the fallen bag of chips and put it back in his lap.

She went to one of the ice chests and got some cubes, wrapping them in paper towels and handing one makeshift ice pack to Karl, who held it to his nose, and another to Floyd, for his jaw.

Everyone in our party was now acting like nothing had happened. Red, Ebner, and the two boys were standing around, drinking beer, laughing, talking. Helen was putting more chips in bowls. Hal poured soda and handed out beer. Karl sat staring at the ground—some of his blood was clearly visible in the dust—and icing his face.

Floyd touched his jaw with ice for about five seconds, then tossed it in the garbage and retrieved the half-cooked meat that Helen had rescued. I helped him put it back on the grill.

The crowd attracted by the brawl dispersed, probably disappointed at the dull aftermath. The place felt like a bed after bad sex. Messy, with the odor of spent emotion and spilled fluids. And like something was definitely over.

When Royal and Leslie came back half an hour later, they both looked at Karl, But Royal's eyes slid away from him quickly.

Leslie wasn't so reticent. Or compassionate.

"What happened to you, Karl?"

"Nothing. Fell on my ass."

"Yeah? Is your ass bleeding, too?" She laughed, meanly, went to the truck, shoved some raw meat to the side, and hoisted herself up on the tailgate, stubby little legs swinging.

Floyd turned a burger. "That was medium rare, Jason?"

"Uh-huh. You guys fight like that often?"

"Not often."

For the duration of the party no one else even mentioned what had happened, as if it were bad manners to talk about a fight afterwards. Food was served, drinks flowed, and finally, it was time for the ball game. We trooped into the Coliseum and found our seats, ready to see the A's trounce the Twins.

I was sitting between Floyd and Royal. Karl was right below us.

Leslie had managed to squeeze in next to Royal, who didn't seem to mind all that much. I guess that kind of attention is flattering to a teenage boy. To anyone, actually—except Rosie when it came from Floyd.

The game was mostly slow. I kept wondering who some of those people out on the field were and why so many of them had the wrong names. Where was Steinbach? Where the hell was Tony La Russa and his animal rights? Didn't baseball players use to stay with the same teams all their working lives? Or was that just a trick of middle-aged memory?

The Twins won.

Everyone wanted to go back to Thor's after the game. I had better plans and begged off, saying I had to go home and make dinner for my dad.

"Hey, I got an idea," Floyd said. "How about you and me and Rosie, we get some takeout, bring it home for your pop?"

This guy was definitely checking us out. I thought fast, and stole Rosie's unused crazy mother. I took him aside.

"Listen, Floyd, about my father. See, I haven't exactly told you all the truth about him." That was for sure. He was healthy and obnoxious and living in Chicago with my stepmother, the yenta. "He's not just sick. Well, he is sick, his heart, but he's also, well, he's also…" I waved a hand vaguely in the direction of my head.

He nodded slowly. "Crazy, huh? Well, that's okay."

"No, see, he really can't have company. It kind of, um, sets him off."

"Oh. Okay." I couldn't tell whether he believed me or not. "Well, see you tomorrow then?"

"Sure. Tomorrow."

Leslie offered to drive Royal, and he accepted the offer.

Maybe Artie wouldn't have to worry about this boyfriend much longer.

I got home fifteen minutes before Sally was due, jumped into the shower, scrubbed until the stink of hot dogs, peanuts, barbecue smoke, sweat, and stupidity was mostly gone, pulled a Mt. Tam ale from the fridge, and sat my clean jeans down on the front stoop to wait.

She pushed open the sticky gate right on time, gave me a cheery smile, plunked her briefcase down on the steps, and asked me if I had another ale. It was all I could do not to trip over my own feet jumping up to get her one. I was wishing I'd had the foresight to stick a couple of steins in the freezer, but I brought her an un-iced one anyway.

The buyer, she told me, had called her cell phone on his cell phone to say he was stuck in traffic on the Golden Gate Bridge and would be a few minutes late.

Now I understand how that kind of thing can happen, especially at the height of the tourist season. The Vista Point parking lot is full, people from Hamburg and Yokohama and Milwaukee are driving slow to get a look over the railings, and the sight of San Francisco—Babylon, Oz, Shangri-la—well, it's enough to make you gasp and it's hard to drive when you're gasping. Then of course there's the additional sight of all the other tourists from Hamburg, Yokohama, and Milwaukee strolling across the bridge, smiling like lunatics, taking each other's pictures.

But I really hate it when people are late. It's not just a matter of cranky middle age, either. I've always hated it. I hate waiting. I can never think of anything to do that will fill the time in any reasonable way, so I just wait, life on hold.

It should have helped that I was drinking ale with a gorgeous, leggy redhead—she wasn't wearing hiking shorts today, but the

skirt was short enough and the sandals showed off pink-painted toenails and a red rose—I guess they were decals?—on each big toe. Made me wonder if she had a tattoo somewhere and if I'd ever get to see it. Anyway, being there with her should have helped, and it did, a little, but the thing was, I wanted to concentrate on Sally and on the evening together. I didn't want to be interrupted by the guy showing up in the middle of telling her a great story or making meaningful eye contact.

So we talked about the buyer. He was a stockbroker, she said, worked in The City, wanted a house in Marin. He was ready to buy, easy to qualify, and didn't want to spend the extra bucks to live a quarter hour closer to the bridge in Sausalito or Mill Valley.

He showed up half an hour late, and he was driving a BMW, which I thought was not a good sign. Sally had left the gate open, but he hesitated a minute anyway, taking a squinty look at the front of the house, eyeing the perfectly good roof, shooting a speculative glance my way. Oh good, I thought, he was going to play Shrewd Businessman. I took a breath and began pretending I didn't care whether he bought the place or not.

After that little pause, he marched up the walk. Assertion. Confidence. No-nonsense kind of guy. I stood up. So did Sally. We all shook hands. Well, I didn't shake hands with Sally, but I wanted to. His name was Mark David. Figured. He looked like a Mark. He was wearing Dockers and Top-Siders without socks and a green T-shirt that said BAY TO BREAKERS. His teeth were perfect. He was shorter than me but in better shape. It was clear he liked looking at Sally. I snarled internally and asked a silent question: "Think you can fix a gate, asshole?"

Sally pulled a stack of flyers from her briefcase and handed one to Mark and one to me. She also gave him a copy of the termite report. I already had one of those. There was a picture of the house, the asking price—$250,000—and a description. Potential, potential, potential. Charming two-bedroom fixer in the heart of Marin, bring your hammer. We walked into the house. Sally put the rest of the flyers on my coffee table.

"For the open house tomorrow, Jake."

Oh, yeah, the open house. Once, in Oakland, I'd made the

mistake of sticking around for that. Four hours of listening to people whine about my home. One woman sat in the living room for twenty minutes looking sad, then angry, and finally said she couldn't buy the place because my furniture suited the house so well she could never compete. Then there was the guy who sneered, giggled, and offered me $100,000 under asking. I'd find something else to do on Sunday.

Mark didn't giggle. On the contrary, he was one serious thirty-year-old. He pulled a little notepad out of his pants pocket and asked questions about the age of the appliances. He studied the termite report and said he wanted to inspect every spot it mentioned. Hey, a little rot here. A little beetle damage there. Big deal. This was, after all, the urban forest. I decided to watch TV and leave Sally to it.

At one point I saw the two of them walk by the living room window. He was shaking his perfectly clipped head.

Half an hour later, he stuck that same obnoxious head in the front door.

"Just wanted to get another look at, you know, how it is when you walk in."

"Sure, Mark."

I watched through the open door as Sally escorted him to the gate. He couldn't let it be, oh no, not Mark. He tried to close it behind him. It balked. It dragged on the ground. It squealed. He shook his head again, said something to Sally, got in his tan Beamer, and eased off down the street.

"What do you think?" I asked her when she came back in the house.

"I think he likes it."

I didn't want to tell the woman her business, so I changed the subject. "What do you feel like eating?"

I've dated a lot of women. I've gone out with the ones whose only answer to that question is "expensively," although they never use that exact word. I've gone out with strict vegans, and with those who won't settle for anything more conventional than East Cumquat fried ants, or anything less trendy than whatever's *nouvelle* at the moment.

This one took another little chunk of my heart by saying, "I've been craving Chinese lately, although I'd go for Thai if you'd rather."

Fairfax has both, along with the requisite Marin Italian, a couple of diners, a brew pub, and two places where you can get falafel, salads, herb tea, live native musicians, and the lowdown on the latest local political issue.

I said I'd drive, and she climbed into my Falcon.

"A classic," she said.

"You're amazing," I said. We settled on one of the two Chinese places on Bolinas Avenue, the dark one that occupies its own little house.

We'd started the evening with ale, but red wine seemed like a better idea now. She suggested merlot. They didn't have any, but they had a decent cabernet and we ordered that. No, I'm not a wine maven. But you can't live in Northern California without learning something. Even people who live here wander around the wine country sometimes on a free afternoon. Which was one thought for a second date, if we had one. Maybe we'd see a black helicopter scoping out the grapes.

"So, Jake—where are you from?" This is a pretty standard question for one Californian to ask another. Sometimes someone says, "California," or even "Marin County," where people seem to go on for generations. But more often the answer is someplace far away.

She was born in Minneapolis, grew up there, moved to the Bay Area right out of college. She knew Chicago. I'd been to her town once or twice.

"Minneapolis is a great place, Sally. Why'd you leave?"

She laughed. "Chicago's great, too, Jake; why did you leave?"

"I came here in 1970. Everyone was coming here then, so I did it, too."

"Well, they were still coming in 1978, and you could still buy a house."

I topped off our glasses. "Did you get into real estate right away?"

"Just one house, then, but that was all it took."

"Yeah. Me, too." I knew about that. If you bought the right house in the Bay Area in 1978, and I had by pure dumb luck, you'd

have made a $200,000 profit by 1990. Of course, it was all play money, because if you wanted to buy a house again you'd have to spend it all. Some people took the money, ran back to Ohio, bought for $80,000, and held onto the rest. But some of us had fallen in love with Oz and couldn't leave for anything. "Ever think about going somewhere else?"

She smiled. "No. And now the market's soaring again."

I smiled back at her. It sure was. But I figured she was still talking about real estate.

Then we played "what do you miss about your home town." She missed all the pretty little parks, the lakes, Minnehaha Falls, she said.

Chicago was known for something else. "I miss the smell of corruption in the morning."

Sally laughed. "Funny. *Apocalypse Now*, right? Only that was napalm?"

"Got it in one. I don't miss the cold and the heat, and if I want snow I can drive a few hours and find it. But I miss a few things. There's a smell and feel of summer you carry with you from childhood that's never the same somewhere else."

She brightened, nodding. "Yes! That midwest humidity, the greenness in the heat. Here, when it's hot, it's not green, usually."

Exactly. Our food came. She'd ordered something with tofu and eggplant and garlic. I'd ordered something with green beans and prawns. We each took a bite. Good? Good.

"And," I said, "I miss Midwestern chow mein."

She put down her chopsticks and positively glowed at me. "There's nothing here like it. Did you ever actually try to order chow mein in California?"

"Noodles," I said with disdain. "Pale noodles and things." I hate West Coast chow mein.

She made a face. "Awful. I've always thought of the good stuff as Minneapolis chow mein, but I guess you had in in Chicago, too."

"Oh, yeah. If I were a rich man—"

"*Fiddler on the Roof*."

"Uh-huh. Anyway, if I were, I'd have it flown out here once a week."

"You could make it yourself. I do. Not as good as the old Nankin in Minneapolis, but I wing it."

Oh, God, was I dreaming? Had I died? "How. How do you make it?"

"The key ingredients are celery—lots of celery—onion, mushrooms, some kind of protein—beef, chicken, whatever—lots of soy sauce. And then there's the one thing that makes it right, the ingredient you might never guess is there. Molasses."

"Molasses? Really?" Of course. See, the sauce just has to be brown.

"Really. And it should be cooked in a cast-iron Dutch oven and served only over crispy fried noodles."

The kind you buy in a bag at the supermarket.

My prawns and green beans dish was tasty. We get great Chinese food in the Bay Area. But it was all ashes in my mouth, as memories of takeout from that place on Diversey drifted in out of the past to haunt my taste buds. I slugged down more wine.

I wanted to say, "Will you make it for me?" But I knew that was sexist and presumptuous and she'd probably hate me. So instead, I said, "How about helping me make it some time?"

"Sure." Just like that. Sure. And we had a second date. Between that reality and the thought of the chow mein, I was a very happy man.

As we picked at our food, we talked about her work, about the open house the next day, about my current and future houses. Then came the question I never quite knew how to answer: "And what exactly is it that you do, Jake?"

I tend to lead up to it slow and easy. "I used to be a cop. In Chicago."

"That's some place to be a cop." No shit. "And what do you do now?"

"I do things for people. Help them out."

"Like a consultant, or like a hit man?" She was kidding, but she looked a little nervous.

"I do investigative work."

"You're a private investigator?"

"Yes." I didn't tell her I'm unlicensed. I figured she could wait

until the second date to hear my political philosophy. Or whatever the hell it is.

"That's amazing. What are you working on now?"

I don't usually talk about current cases much, but I wanted to talk to her. I thought about it, looking into her gorgeous blue eyes.

"I don't know if I want to tell you."

"Now I'm even more interested."

Those eyes. Hypnotic. But I was working undercover. What if she was connected with someone who was connected with the Command? What if…? Oh, horseshit, I thought. She couldn't be.

She stared into my eyes, I stared into hers. Finally, I shook my head, reluctantly.

"I'm dealing with some nasty people, Sally. I will tell you, but not yet. Not until I know you better."

Her glance fell and she looked into her wine. We sat silent. When she looked up again, I saw the mix I'd dreaded seeing: Distrust. Skepticism. Disinterest. She thought I was bullshitting. A loser with a big story.

"Sally, I'm telling you the truth. You met Rosie."

"Yes."

"She has an agency. We work together."

"She does? You do?"

"She does and we do. Ask her. Really."

"Will you tell me what you're working on if I make the chow mein for you and only ask you to chop celery?"

Things were good and warm and connected, and I could breathe again.

"I think for now I'll do all the chopping and keep my options open."

"If you must." The words were harsh, but the look was sweet.

So was the brief kiss she gave me when I dropped her at her car in front of my house.

The date had ended pretty early, and rather than obsess about Sally, I tended to a couple of chores. I moved the breakfast dishes from the sink to the dishwasher, fed the cats, and made a phone call. Harry George still hadn't called back, so I punched in his number and left another message, repeating everything I'd said before. Then I popped a can of Diet Pepsi and tuned in Preston Switcher's Saturday night show.

He was already blathering, had apparently been blathering for some time. The topic was once again jobs, and affirmative action, briefly. Gross discrimination, he called it, and he warned his listeners that enemies of America were trying to get it back on the ballot. That lasted for a few minutes. Feminism. That took him another five, followed by a commercial for a brand of soup I would never buy again.

The gays. Wow, he really got swinging on that one. I wondered how anyone could live in the Bay Area and stay so stupid about a big chunk of the population. My mind wandered, tuning him out. Then I heard something that made me tune back in real fast.

"It has come to my attention, ladies and gentlemen, that there are some people who are going to make an attempt on my life, or so they say. Or so the police tell me." Uh-oh. This was bad. Very bad. "And who are these people? Are they left-wing terrorists? Radical homosexuals? Inner-city hoodlums? Militant unionists? No, according to the report I heard, they are supposed to be a right-wing, white-power organization. Or so they say.

"Now should I believe that? Should I believe, my friends, that the right is out to get me?

"No, I won't believe that. What I will believe, though, is that this threat is real, and that it comes from someone else. Someone,

something, some group on the far, far left that wants the world to believe they are what they are not. So I'm going to say to you people, you who say you are going to kill me, right here and now— I am not afraid of you. You are liars. And you are cowards. And I have soldiers of my own, friends who will catch you in your vicious lies, protect my life, and send you back to the welfare rolls, or the unemployment lines, or the AIDS clinic.

"Preston Switcher has enemies, there's no doubt of that. And I am proud of the enemies I've made.

"But Preston Switcher relies on his friends. Friends like all of you out there. And the right, my friends, knows right from wrong."

I hadn't made Royal get a beeper any too soon. He had to know, right now, that the plan had leaked in a big, public way. The Aryan Command would be spinning in its boots. And Pete Ebner would be looking hard at everyone who knew about it—including the warriors who were supposed to do the killing. Royal. And by extension, maybe Royal's cousin, Jase.

After I'd beeped the kid, I left a quick message on Rosie's home machine. She needed to know and she needed to call Pauline. If the cops had made it clear to Switcher that broadcasting their warning to him would endanger our lives, he'd somehow failed to listen.

I waited up, hoping Royal would call. An hour later I was worried enough to call Artie's place, late as it was. I woke him up; he woke up Deeanne. I didn't want to worry her, so I told her it was no big deal, I just had to make a plan with Royal for the next day. She yawned a couple of times and offered to call his house.

Five minutes later, she got back to me. Royal wasn't home. His dad didn't know where he was and told her he didn't give a damn, either. Somehow, that wasn't a big surprise.

I stuck around the house all morning, and paged Royal a couple more times. Finally, he got back to me. He sounded weird but he said he was okay, that he knew about Switcher and wanted me to meet him at a hot dog and burger place in San Rafael at noon.

That worked for me. Noon to four was a hole in the day. There would be a stream—I hoped—of strangers trooping through my

house counting beetle holes. And after that was over, Rosie, Sally, and I had a date to go to the cottage-and-cottage on Scenic and negotiate with the sellers.

I dressed in my Thor's clothes, so if anyone who knew Royal saw me with him I'd be good old Cousin Jase.

It took me ten minutes to get to Frank's Franks. Royal sat slouched at a table, unchewed burger in hand, staring down at the fries in the cardboard boat beside his paper plate. When I walked in, his glance shot to the doorway like he was a deer expecting a pack of dogs, focused on me, and slid from panicky to pitiful as I crossed the room.

He looked bad, pale and bruised. His clothes were wrinkled and dirty, and I noticed a small spot of blood on the front of his shirt. Not his usual almost compulsive and ironed tidiness. Not at all.

I sat down and thought about getting some food, but the burger looked gray, the tomato pale pink, and the fries were shiny with grease and underdone.

He didn't seem to notice that the food wasn't good. He shoved down a few large bites, quickly, like it was the first food he'd seen in a while.

I decided not to order anything. "Tell me," I said.

He swallowed and rubbed his eyes. "Spent the night being questioned. By Ebner. And by Red." Inner Circle business. Big time. "Me and Zack. I swore that I didn't tell nobody nothing. Swore that I didn't know how Switcher found out. Said what's true—maybe not everybody knew there was a plan, but a lot of guys did, even if they didn't know exactly when it was going down. I was, like, did he say Wednesday on his radio show? They said, no, and I was all, see? I even said, yeah, there must be a ringer in the group—but it isn't me. Ebner didn't believe me. He said maybe I don't want to do the job, you know, the killing. Said I been acting funny about it. He hit me a few times, son of a bitch. Once in the face." He touched a bruise on his cheek. "And a bunch of times in the gut. Till I threw up."

"I tried to call you."

"Yeah. I know. I was at Thor's. I went for the phone to call you, but that was when Pete grabbed me, took me to the back room."

I'd been worried about Royal's ability to play this game convincingly. Looked like I'd had good reason to worry. "Okay, so he didn't believe you. Or seemed like he didn't, anyway. He may be pulling that with everyone. But how'd they leave it—what did they say when they stopped pushing you around?"

"They said they'd find out who it was, but they acted like they really thought it was me. They're gonna be testing people, you know? Loyalty tests."

"What does that mean?"

"Means they could, like, give me a really bad assignment and see if I do it. Or they could just tell me bullshit, maybe tell other people bullshit, and then see if it goes anywhere. Now they're all, 'Hey, the hit on Switcher's off,' you know? But I don't know whether that's true or not, like if they're just trying to pass on a bogus message."

"Probably true, at least for the moment. But the police will cover the original day." At least I hoped so. I was feeling just a tad out of the loop at the moment.

"So I'm not gonna hear nothing about nothing until they trust me again. There's meetings and stuff they won't let me near."

This was very bad. I was losing my major access to information about their plans. But it was hard to tell from Royal's story whether they really suspected him or were just leaning on everyone in sight.

"Do you think you're in any real danger? Will they try to kill you?"

"You mean like poor old Rich? I asked Zack what he thought. He said no. 'Cause they don't know it's me. And 'cause they'll want to see if anyone else is in it with me. Better believe you're not going to be trusted now, either, not for a while anyway." He hesitated, and the anger seemed to drain out of him, making him look small and slumped. "I'm really sorry this happened, Jake." He turned sad, damp blue eyes on me. "I would understand if you wanted to just, like, dump the whole thing."

I wanted to, but I wouldn't. "Do they suspect Zack at all?"

"Nobody hit Zack. And he says we're not friends anymore till this is settled."

I didn't ask if Zack had returned the $200 loan. Somehow, I doubted it. "Well, lie low for a few days. Act normal, like you're still in the group, but try to stay out of their way."

"What about you?"

What about me? I thought for a minute. There seemed only one way to go. "I'm not supposed to know anything about the Switcher hit. So I'm going to act like I know you got beat up, but that it doesn't involve me and I don't know what it's about."

He sighed and rubbed his eyes. "Thanks."

"Go home and go to bed, Royal."

"Yeah."

I, unfortunately, could not go home. I didn't know who would be around the bar midafternoon, but I needed to start re-establishing my credentials somewhere and sometime, and I had a few hours to kill.

Steve was, as usual, behind the bar. He gave me a dead look that could have meant, "You ringer, me kill ringers." Then again, it could have meant, "You're turning into a lush. Get a life."

A boy and girl were sitting at a table. He was wearing red braces. That's what they call their suspenders in skinhead-speak, probably because the Brits seem to be the ones who started all this skin stuff—at least according to one of the web pages I'd checked out. Both the kids were wearing boots, jeans, and leather jackets. He was bald, she had a little hair. Kind of reminded me of the old days, when straights would joke about the hippies—"Can't tell one sex from the other."

Then it was because everybody's hair was long. Everything changes and everything stays the same.

I don't know, hairy, hairless, whatever, I didn't have a lot of trouble telling the difference between girls and boys. Not then, not now.

I didn't remember seeing the boy before, but the girl was the friend of Leslie's who'd been hanging around the protest in Berkeley. I felt pretty sure she'd never made me as the brown-haired guy in the crowd, but I turned away anyhow. As I sat there watching Steve wash glasses and thinking about hair, Preston Switcher, and Cousin Royal, Floyd came strolling out of the back of the place and sat down next to me. Along came a spider....

"What's up, Jason?"

"Not much, Floyd. What's up with you?"

"Heard your cousin got himself in a little trouble."

"You mean Royal?"

"You got a lot of cousins in trouble?"

"Sure. All of 'em. The kid got beat up. Happens to kids all the time." I laughed.

Floyd stared at me for a minute, then he decided to laugh, too. Har-har. "Listened to Preston Switcher lately?"

I gave him a "what's that got to do with anything" look. "Off and on, yeah."

"Did you hear him say the cops told him someone was trying to kill him?"

I let my jaw drop. "Jesus. Who'd want to do that?"

"Jews. Niggers. Lefties."

It was hard to listen to the names that came so easy out of Floyd's mouth. I shook my head and let my attention drift back to the kids at the table. They were kissing. Interesting sight. Kind of like being in one of those science fiction movies where the space crews hang out in weird multiplanetary bars.

Steve was watching the couple, scowling. Floyd was watching them, too, but he was smirking. I concentrated on my beer. A few seconds later, something the pair did pushed Steve over the edge.

"Okay, you two. Get a room. This is a clean, decent place."

I kept my eyes on Steve.

The boy spoke up. "Hey, man, we're customers."

"Yeah? I never seen you before. And this ain't no house of prostitution."

"Listen, man…"

Steve got a cold and scary look on his face. He flipped the end of the bar up and moved toward them.

"Whoa," Floyd said, punching me on the arm. "Watch this. Steve's in no mood today, man. You're gonna see him in action." I shifted my face halfway toward the kids. Halfway interested. Halfway scornful, cold. What would I do if Steve really hurt the boy? I couldn't do anything. The damnfool girl had picked a bad day to bring in a stranger.

The kids stood their ground. Steve grabbed the boy by his jacket collar and shoved his own jowly face in close.

"My customers are the kind of people who know how to behave. And they know how to take orders. My customers are not whiny

little kids who dress up, shave their heads, come for a visit, and pretend to be something they're not."

"He's a skin, just like me. And I'm here all the time!" the girl protested.

"Yeah, little girl? Maryanne, isn't that your name? And what kind of skins are you? SHARPS, maybe? Druggies?"

I whispered to Floyd, "What are sharps?"

He snickered. "Skinheads Against Racial Prejudice."

"I ain't no druggie and I ain't no SHARP," the boy said. "I don't do politics."

Floyd snorted. "College kid." No. I didn't think he was that old. Neither was she. They weren't old enough to be in a bar. When this was over, at the very least I was going to make sure Thor's lost its liquor license.

Steve was still holding the boy's collar, laughing. His laugh—I'd never heard it before—was a creepy and probably calculated "Heh-heh-heh." He let go of the boy's collar.

"No politics. No brains. Go on home, little no-brains."

The boy swung at him. Floyd jumped off his bar stool and shoved the kid away from Steve. Maybe he was trying to protect Steve, but the kid was the one who needed protecting, so I was glad to see Floyd separate them.

Then Floyd pushed the kid, hard, toward the door. He stumbled, fell to his knees, and jumped up again, his face red with rage and probably embarrassment.

Floyd put his hands on his hips and stared the kid down. "Get out."

"Come on, Jay, let's get out of this hole." The girl had had enough. Her friend shrugged, sneered, and followed her out the door.

Steve moved back behind the bar and began lining the clean glasses up on a towel. Floyd came and sat beside me again.

"That Maryanne," Steve said. "That's the last time she gets let in here." He tossed a significant look toward Floyd. "I don't trust her."

Floyd stared back at him. "You think she's a ringer, maybe?"

"Bet she is," I said, grabbing my chance to spread the suspicion around a little. "You got a lot of loose ends around here, public place, people come in, how can you tell…"

Steve pointed a glass at me like it was a gun. "We don't got a lot of loose ends. Someone, some *one*, is a traitor."

"What's this about, Steve? Why you looking at me?"

"We got a problem, Jason. Someone's been telling stories to the police." I let the tiniest bit of light dawn in Jason's dumb eyes, and turned to Floyd.

"What kind of stories?"

He shot a glance toward Steve, and must have gotten the okay. "Someone told the cops we wanted to kill Switcher."

"Us? They said it was us? Did he believe it?"

"No."

"Who would lie about us like that?" I figured that Jason, not knowing about the hit plan, would automatically assume it was a lie. And that Steve and Floyd would not hurry to correct him.

Floyd shrugged. "Maybe Royal, huh?" I turned back to Steve.

"Is that why Royal got beat up? Someone thinks he's a liar? A traitor?"

We stared, eye to eye, like a pair of dogs. "You want me to leave?" I asked him.

Steve grinned. I was beginning to think this guy was as loopy as Helen. "No. You stick around, Jase. I want you where I can keep an eye on you." He moved off toward the other end of the bar and picked up a magazine.

I turned back toward Floyd. He finished his beer and hauled his belly over the bar, leaning far enough to get his glass under one of the spigots, drawing himself a fresh one. Steve didn't object.

When he sat back down again, I smeared an earnest look on my face. "Listen, Floyd, you got me a little worried about Royal. Nobody really thinks he's a traitor, do they?"

"Maybe. They think maybe you are, too. Or that Royal shouldn't have trusted you. Lots of people think lots of things."

"What do you think?"

"I think you should watch your step."

I laughed. "I always watch where I step."

"Good. So—where's that hot girlfriend of yours today?" For a second, I thought he was talking about Sally and wondered how he knew she existed. Then I realized. Rosie.

"You think she's hot?"

"Yeah, I do."

He didn't ask me what our status was and I didn't volunteer. In some ways, Floyd had me more worried than Steve did. Floyd thought Rosie was hot, but he wasn't pushing, not me, not her.

How did that fit in with his image of the tough guy who seemed to like waving his manhood around? I couldn't help but think we were some kind of assignment. Keep an eye on Jase. Scope him out.

"Hey, Floyd?"

"Yeah, buddy?" Uh-oh. He'd never called me that before.

"I want you to know that I'm real grateful for your friendship. New to the group, got my dad to worry about—you've welcomed me. I thank you for that."

He grinned at me. "But leave your girlfriend alone, is that what you're saying? I ain't no fool, Jase. I can see something's not quite right between you. But don't you worry about me. Never push a woman, that's my motto. She'll come to you when she's ready." He jabbed me in the arm with his elbow. "Or maybe she'll come to me."

Yeah. Neanderthal with a Valentine card. It didn't scan.

Still, I decided to just go along with the gag, whatever it was, and convince this guy that he was my pal and I was everything he wanted in a best buddy—stupid, northern European, loyal, and fascist.

Gilly strolled in, said hello to Floyd, and nodded at me, taking a stool halfway down the bar.

Floyd stood up and clapped me on the back. "See ya later, Jase?"

"Yeah. See ya later."

He swaggered out of the bar.

Gilly was watching me. "How are you, Jason?"

"Okay, I guess."

"How's Royal doing?"

"He's just fine."

"Glad to hear it." How did she manage to make those words sound like an invitation to bed?

This would be a good time, I decided, for me to take a bathroom break. I headed for the back of the bar. But Gilly fell into step beside me.

"Where's your girlfriend?" Why was everyone so interested in where Rosie was?

"Busy."

"You look good together." I shrugged modestly. "Seems to me, though, that there's something going on between you and me."

I shrugged again, totally noncommittal, smiled, and slipped inside the bathroom. I stayed in there for a full five minutes, trying to decide whether to get away from Gilly by going home, or stay for a while and try to pitch Royal's innocence to Gilly and Steve.

Gilly was leaning against the wall, waiting, when I came out again. She took my arm and led me toward the door to the back room I'd never seen.

I didn't know what to do. A perfect opportunity, a perfect excuse, to go somewhere where the Aryan Command probably thought I had no business going. To do some reconnoitering. But oh boy...

I let her guide me through the door, and we were in.

And alone. There were a lot of folding chairs stacked against the walls. At the other side of the room, about thirty feet away, there was a makeshift stage—a plywood box about eight feet long and two feet high. A podium stood beside it. Hanging on the back wall was one of those swastika-and-stripes Aryan Command flags. Courtesy of Hal and Helen. Next to the flag was a door. Another exit? A closet?

"Impressive, isn't it?" Gilly said, looking at the flag.

"Very." Big, anyway. As wide as the stage. Okay, I'd seen the room. It was for meetings. Speeches. And with that flag glaring down at us, there was nothing attractive about Gilly Johns. I reached for the doorknob.

But then I couldn't see the flag anymore because Gilly was pressing me against the door, her hands on my shoulders, kissing my neck. From there, she navigated up to my ear. I couldn't seem to move.

When she shifted her head to go for my lips, I got another look

at that flag. What was I, a collaborator? What was this, a World War
II movie? And the more important question, how easy was Jason,
anyway?

I put my hands on her shoulders and moved her gently but
firmly backward.

She was smiling at me. Rejected, perhaps, but still not con-
vinced. "Who are you, Jason?"

"Just a man looking for his life." I thought she might like that,
but she wasn't smiling anymore.

"Be careful where you look."

I opened the door and escaped back to my stool. She followed
in a few seconds, but didn't sit down. She said she'd see me later,
and left the bar.

No one else came in. I stuck around for half an hour longer,
nursing a beer, trying to make small talk with Steve. He wouldn't
talk.

As I walked past him on my way out, I saw that the magazine he
was reading was a gun catalog.

I had more time to kill before I could go home. It was one of those bright blue, hot-sun days we get in September, with a light so strong and deep it gets inside you and paints pictures on your soul. A Mediterranean light, I'm told, although never having been to the Mediterranean, I can only take it on faith.

The open house had a while to go; I was dressed, still, in my Thor's clothes, and while the jeans, Docs, and T-shirt were normal enough for West Marin—no reason to change—Sally might wonder a bit about the boots she'd never seen me in. So all in all, it seemed right to keep the brown wig in the dash compartment and pass right through Fairfax, staying on Sir Francis Drake, heading west to the farm country and the coast. Past the stables and the dairy cows and the ranch, hidden among the hills, where George Lucas makes his magic movies.

I kept going to Olema, a town with one store and one great restaurant, and turned right and left again, heading toward the Point Reyes National Seashore. Still sunny, still clear. No fog. Some Sunday traffic. The side road to Limantour Nature Area wasn't as deserted as I like, either. Weekdays are better. And the parking lot was pretty full. I pulled in next to a minivan that was spitting out children, and started walking toward the beach, trying to look at the birds in the marsh and clear my mind. It stayed pretty clear until I actually slogged up onto the dunes, pulled off my boots, and looked out at the Pacific, smelling the rotting seaweed, squinting toward China. Some days, the waves are big and act like they want to knock you down. Today, they were smooth and easy, and people were playing carelessly in the cold water.

I walked ten minutes along the sand until I got to a place where no one had laid a blanket or planted an umbrella for a hundred

yards around. I sat down on a big chunk of driftwood, and the people I'd been spending my time with started wandering around my mind.

The weird thing was, none of them seemed real. Floyd acted like he wanted to be my pal, flirted with my "girlfriend," and watched me like a high-school hall monitor. Karl had tried, in a not-so-subtle way, to warn me about Floyd, but I couldn't tell what the warning was about, and even though it was clear Karl and Floyd didn't like each other, I sure didn't have any idea why Karl would want to be on my side.

Steve? Well, I'd thought he was this totally in-control guy, but suddenly, after the Switcher leak, he was edgy enough to get paranoid about a couple of teenagers and toss them out of the bar. He seemed like he was under pressure to keep out subversives and recruit at the same time. Tough job.

And Gilly! I wanted to ask some questions about her. Sure, I'm irresistible, but that scene in the back room felt a little cold. And she'd warned me about something, too. What? The fury of a woman scorned?

Helen and Hal. She was just a garden-variety lunatic, I was pretty sure. And Hal was a blank. Nothing too puzzling about them. Or Ebner, for that matter. He was consistent. A consistent son of a bitch. And Red just seemed to be Red.

Ebner, I thought, was in it for the power. Leslie, I figured, was in it for the boys. And the boys were in it for the motorcycles.

I got home half an hour after the open house was supposed to end, and found a note from Sally scribbled on the back of one of her flyers.

"Just a couple bites," the note said. "But I think we've got some interest. Rosie called—she'll meet us here at 7:00 to go over to Scenic Avenue to negotiate. See you then."

Not exactly a love note, but it would do until something better came along. I felt a quick flashback: Gilly's lips on my earlobe. I thought I'd worked that one out of my system, but maybe not. See, my problem is, I'm too vulnerable. Just a peeled nerve when it comes to beautiful women.

I didn't see the cats anywhere, so I gave a yell. "Tigris? Euphrates?" They crawled out from under the bed, looking dusty and pissed off. Too many strangers passing through their house that day. I fed them a can of Super Supper, fed myself a can of chili, and stretched out on the couch with the Sunday paper.

Rosie got there first, and I ran down some of my thoughts on the inhabitants of our little nightmare world. She listened, and she nodded, and she sat there quiet for a minute.

"Losers and misfits," she said finally. "Why do you think they should make sense?"

"I can't think of Gilly as a loser or a misfit. She's gorgeous."

Rosie gave me her "idiot man" look. "Listen, Jake, one of the craziest, most vicious, most sadistic women I ever knew was gorgeous. At least she was for a while."

"Was she a loser?"

"Eventually. Tell you which one of those guys scares me the most—Pete Ebner. I watched him in the bar, I watched him at that tailgate party. Evil. There's a piece of him missing."

Right about then Sally knocked on the door, and we drove off in the Falcon to the other side of Fairfax. Which took all of three minutes.

The people who were selling the cottage-and-cottage lived in the first house and let their teenage son live in the other one. They reminded me of Dharma's parents on that TV show, "Dharma and Greg," old, unreconstructed hippies. He had a long ponytail dripping down from the bald spot at the top of his head; she had a lot of hair and floppy flowered pants. Their realtor, a guy in chinos and white polo shirt, was with them.

They offered us wine, which we accepted. They looked like pushovers but they were not.

"Hey," the homeowner said, after we'd been dipping into the wine and the real estate conversation for five minutes. "I can see where you're coming from. You want to sell your house and buy this one."

I admitted that was where I was coming from.

"But hey, we can't go along with a contingency deal, man. Sorry,

but we just can't. Whoever comes up with the money first, that's the guy we have to sell to."

They were moving up to Oregon and they wanted to go now. They did admit that they had no other offers, but said if they got one, they'd take it, that they couldn't wait around on the off chance that I would sell my house. No contingency deal, no way, no chance.

But hey, you have a nice day.

Back in the car, Sally reassured us that my house, being somewhat more conventional, might sell faster than the cottage-and-cottage. She put a little icing on that cake by asking me to join her for chow mein at her house later in the week—right there in front of Rosie, who jabbed me in the ribs. I set it up for Thursday, just in case Switcher's Wednesday hit wasn't really off. So all in all, even though Thursday was four days away, I wasn't as depressed as I might have been.

Except for a couple of locals I'd seen before, sitting around stupefied as usual, no one but Steve was in the bar when Rosie and I got there later that night. Not one other ranking member of the Aryan Command. But Steve had a message for me from one of the missing: Floyd.

"Wanted to talk to you about something but won't have a chance tonight. Leave your phone number with Steve so I can call you. Thanks. Floyd."

As I stood there trying to focus on the note, thinking fast about my phone number and the answering machine that identified me as Jake Samson, Gilly came rushing through on her way to the now-no-longer-mysterious back room. She glanced at me, and jerked her head in a kind of nod, but didn't stop or say a word. Red came in, ignored me entirely, and strutted toward the back, too.

I ordered beers. Steve just looked at us for a minute, then he decided to serve us.

I pushed my luck. "What's going on back there tonight?"

"Go on home, Jase. Members only."

"Some kind of Inner Circle meeting or something?"

He gave me that blank stare again and shook his head. "All the

members. Which you are not." *Charming guy.* But I consoled myself: he didn't seem any more suspicious of me than he'd been before The Leak, and he wasn't really any ruder now than he'd ever been. Which made me wonder if he had a better suspect than Royal, better than me. It wasn't like I'd seen him being pals with anyone else. He didn't seem to socialize much with the group, hadn't showed up at the ball game or the warriors' party.

That afternoon, though, he had allowed Floyd to come between him and the skin kid. That meant he either liked him, respected him, or feared him.

I didn't want to go home. I wanted to stick around and wait to see who else came in. I gave Steve a blank look of my own, stuck Floyd's note in my pocket and asked Rosie if her beer was cold enough. Just to say something. She didn't have a chance to answer.

"Don't matter if it's cold enough, it's the only one she's getting. You got five minutes to drink and go."

I drank slowly. Halfway through the beer, he reached out with both hands and yanked our glasses off the bar.

"Bar's closed. I'm gonna lock up now." Then, louder, for the benefit of the neighborhood guys in the corner, "Finish up! Bar's closing." They lurched to their feet.

I put up a token fight. "Hey, listen, Steve…" He jerked a thumb toward the door. "Ah, for Christ's sake, come on, Rosie." I jumped down off my bar stool, grabbed her arm, and started for the door.

"Wait a minute, Jase. Don't you want to leave an answer for Floyd?"

No, I didn't. He'd asked for my phone number. I was hoping getting pissed off would be a good enough excuse for blowing it off.

"Hey, I'm leaving. You tell Floyd I'll see him here tomorrow."

There was no way I was going to follow Steve's orders and go home, though. Something was going on, and if Steve wouldn't let us watch from inside the bar, we were damned well going to watch from outside. I pulled my car farther down the block and we kept our eyes on the entrance. Karl arrived. He looked furtive, but he always did. Zack. Hal and Helen. Zack was clearly agitated, walking stiffly, talking to Karl and pounding his fist into his palm. No sign of Royal.

I waited a while longer. No Ebner. He and Floyd were probably already in the back room.

Were they planning some mayhem? This seemed to be a very important meeting, and everyone who didn't look angry looked solemn. Damn, I wanted to know what was going on.

Another fifteen minutes. No one else showed up.

On the drive home, I thought of calling Royal's pager but I got a sudden fit of paranoia about it. He might be in that back room right now, with all the others. I didn't want anyone ripping the beeper out of his hand and taking down my number. Instead, I phoned Deeanne and told her to have him call me. Rosie said she'd get hold of Pauline and let her know about the big meeting. We called it a day, and a night.

Over coffee the next morning, I obsessed over the meeting at Thor's. Was it about The Leak? Probably. But what, exactly, about it? Steve had said all the members were going to be there, so the chances were good it was no strategy session. Maybe just a rally? A flag-waving? A little rousing of the rabble to get their morale back up to a goose step? The leak had to be devastating to a bunch of people who believed they had all the answers and were going to make the world theirs.

The speculation led where it almost always does: nowhere in particular. As far as I knew, Royal was still a member. So unless the Command made a distinction between members and members in good standing, he could have been at the meeting. If he was, I'd find out from him what happened there, if anything. And I had other things to obsess about, anyway.

Like the two kids Steve had tossed out of the bar the day before. As nasty as the scene had been, I realized I should be glad it had happened. I'd been nervous about the girl ever since I'd seen her at the Frasier protest. Better not to have her hanging around. The last thing I needed was another iffy teenager who could blow my cover. Royal was more than enough. Besides, I kept remembering that her boyfriend didn't "do" politics. Maybe they'd both stay out of trouble from now on.

Royal. I still hadn't heard from him. I paged him.

Then I started thinking about Preston Switcher.

It had occurred to me that maybe the silly son of a bitch needed to hear he'd screwed up, but I was afraid if I followed through with that thought, his next show would feature the news flash that a PI, an infiltrator of the group that wanted to kill him, had paid him a call to criticize his judgment. He'd probably accuse me of

being a left-wing unemployed faggot malcontent, too. Or a transexual welfare mother.

The thing that bothered me most about what he'd done was that his motivation was unclear. How dumb could he be? The more I hung around with the Command the more I wondered who was doing what to who. And why. For all I knew, the whole thing, including the broadcast, was part of an elaborate plot to expose Royal as a turncoat and me as a ringer. For all I knew, Preston Switcher was a member of the Aryan Command. That would not be surprising, considering his attitudes. But somehow I really didn't think so. The Command was way outside the law, and held an element of danger a successful radio hero would have to be crazy to go near. I could see him lending them his support from time to time, but I couldn't see him being an actual member.

Running the plot idea to its logical fantasy conclusion: The group hadn't been sure about trusting Royal for a long time, because the turncoat Richard was his friend and it probably wasn't too hard to see that Richard's murder upset Royal. When I came along, they got even more suspicious, maybe even found out something about me, for all I knew. Then they set up a plot that led to Switcher's broadcast and was going to end with Royal and me and Rosie getting scraped off the rocks under that gorgeous orange bridge we all love so much.

Well, it was possible.

Then again, were these people capable of such an elaborate scheme? I was getting fuzzy in the head. It was that old "lie down with dogs, get up with fleas" thing. I was lying down, so to speak, with Nazis, and I was getting up with a head full of plot and counter-plot. I reminded myself that I didn't believe in conspiracy.

Switcher was probably just plain stupid or unbelievably vicious or overwhelmingly ambitious—maybe he'd seen a chance to get some publicity by getting a snitch killed.

I took my third cup of coffee outside, sat on my garden bench, and had another chat with the tomato hornworms. I told them that I hoped someone new would be moving in soon, and I wanted to warn them that not everyone was as merciful as I. They didn't look scared. When I went back into the house I discovered I'd gotten

two phone calls; neither of the messages was from Royal. Rosie had called to check in with me, and my father had called from Chicago. We try to talk once a week or so. I punched in the number.

"Hi, Pa, how's it going?"

"Going good, Jakie. And you?"

"Good. How's Eva?"

My stepmother had the constitution and strength of an ox. I got the answer I expected.

"Good. Wonderful." She would live to be a hundred. Which was terrific because I didn't think my father could make it through the death of another wife. He almost hadn't lived through my mother's, and that was a long time ago.

I heard her call out something in the background.

"She wants to know, you're working? I want to know, too. You got a case?" I'd managed to hide my job from them for a few years, but he'd figured it out. And he worried. So I sure as hell wasn't going to tell him I'd joined the Nazis.

"Just a little divorce thing. Nothing interesting."

He repeated my words to Eva, and the next thing I knew, he'd lost possession of the phone. "Gimme the phone, Isaac." Whoosh—just like that, I was talking to her.

"And it's not dangerous, this divorce?"

"No. Not dangerous."

"And how is Rosie?"

"She's good."

"Such a shame, such a wonderful Italian girl and she won't marry you."

"Eva…"

"I know, I know…you met anyone else?" She was terrified I'd slide into old age with no woman to take care of me. So was I, come to think about it.

I told them I was going out with a nice real estate woman who was selling my house. We jabbered about houses for a while and then my dad got back on the line, and as abruptly as always:

"Okay. So we'll talk next week. Good-bye, Jake." Clunk.

A while later, when I was in the middle of a very delicate omelette operation, and pondering again the motives of Preston

Switcher, the phone purred. I let the machine take it, but I listened as the caller left a brief message. And damned near burned the omelette. Speak of the devil, as my mother used to say. Or in this case, think of the devil... The call was from Preston Switcher.

He said he wanted me to phone him at a San Francisco number, "about Royal Subic."

Now I was scared. Why was he calling me? If he wasn't part of a plot, how would he even know I existed? My head was beginning to hurt. I would have to play dumb, which at this point was not so hard to do. I split the omelette with Tigris and Euphrates and returned the call.

Someone who might or might not carry the title of administrative assistant, someone whose boss probably still preferred the word "secretary," informed me that Mr. Switcher would like to see me in his office as soon as possible—and when would be convenient?

The word was out of my mouth before I could catch it. "Never." Quickly, I patched the damage. "I would be happy to talk to Mr. Switcher on the telephone."

"He said if you were reluctant, to tell you he knows all about your undercover work and is not your enemy."

Wiping cold sweat off my upper lip, I caught my breath and groped for an answer. Okay, playing dumb wouldn't work. And maybe there was something here I needed to know.

"I don't know what you're talking about, but I'll meet him. But not at his office. That place where the tourists go to look at the San Francisco view, on the Marin side of the Golden Gate Bridge. Vista Point. There's a parking lot. I can be there by noon." Maybe the lot wouldn't be full on a Monday.

The secretarial person advised me to do so. Had I ever seen Mr. Switcher?

I'd seen only one or two photos of the great man, mug shots, but I thought I'd recognize him when he appeared. He wore black-framed glasses and a gray crew cut. As for the rest of him, he was known to be muscular, a workout freak who had once said something about the body being "a church." That's right. Not a temple,

a church. By way of further identification, the secretary told me he would be dressed in a blue suit and a red tie.

And, I presumed, a shirt with fifty white stars on it.

I described myself to the secretary. Then I got in the Falcon and drove to 101 and south to the bridge, parked, and began strolling around, looking casual and annoyed. What the hell was this Switcher guy yammering about, anyway? Sounded like a lunatic, with his crazy talk about my being undercover…and on and on until I was so deep into the role I believed it myself.

The point was fairly crowded. Several dozen tourists were wandering around in shorts. They do that in June and July, too, and freeze their butts.

I wasn't wearing shorts, but I was wearing my brown wig. I had been called to this meeting as Jake Samson, not as Jason Dormeister.

There he was, getting out of a large car, undoubtedly American…no! There was that distinctive hood ornament. It was a Mercedes. Blue suit, red tie, white shirt, no stars, glasses, muscles, bland and nondescript face. I walked toward him. When I got close enough, I raised my hand. For a moment, he looked alarmed, then his chunky facial muscles relaxed. The description I'd given his secretary had kicked in.

"Mr. Samson?"

I admitted it.

We strolled together to the wall, looking across the Bay at San Francisco, a sight way too pretty, in the noon sunlight, for this mean-spirited twerp.

I started at the beginning. "Where did you get my name?"

"From Royal Subic. He called me and told me what had happened after my show. He wanted me to know that there were people trying to keep me safe, that I'd put those people in danger." He smirked and shook his head.

Oh, Lord. Royal had exposed us both to the plain view of someone who might be one of the enemy. Well, was one of the enemy, as far as I was concerned, but could also be one of the Aryan Command.

Carefully, coolly, my face expressionless: "What else did he tell you?"

"He told me that you were working for him, trying to keep the Command from carrying out some of their plans, including my murder. That you had infiltrated the group as his cousin."

Nice going, Royal. Now maybe we're both dead.

Switcher was studying my face. He laughed. Apparently expressionless is too hard for me.

"Oh, don't worry, I'm not a member of that group of idiots and I have no interest in blowing your cover."

"No interest? Why did you talk about the plot on your show? Do you know—"

"I'm sorry that the group suspects you now, or at least suspects the Subic boy." He didn't look sorry. Didn't sound that way, either. "I'm sorry, but he's a pretty foolish young man, don't you think?"

Sure. But that was the point, wasn't it? Royal was just a foolish kid. And this guy didn't care what happened to him. "He's been trying to keep you from getting killed."

"Yes, he said he was an admirer of mine and wanted me to know what was happening to him because I mentioned this nonsense on the radio."

"Nonsense?" He thought death threats were nonsense?

"That bunch of losers can't hit the cup with the coffee. I'm not afraid of them."

I glared at the man. "I am. And I'm afraid for Royal, too. He may be stupid, but his heart seems to be in the right place."

"Meaning that mine is not? Royal and I, I'm sure, agree on most things. Especially now that he sees that group for what they are."

"Losers."

"Exactly."

"Maybe they're more than that."

"I don't believe so. And you obviously don't understand. It was important that they know I'm aware of their plans. I had to send a threat right back at them. They're frauds."

I hoped he was right, half believed it myself, but what was his stake in believing they were no more than incompetent clowns?

"Maybe the Holocaust was a fraud, too?"

He smiled. "I think you've got me confused with someone else, Mr. Samson. I'm a conservative, not a fascist."

"Right. I've heard your show. You're an inch to the right of Mussolini."

"You're very emotional, aren't you, Mr. Samson?"

I stared at San Francisco. Why wasn't I there now? "All us Jews are."

He laughed and shook his head.

I'd had enough. "Look, Switcher, I don't understand why you wanted to talk to me. So far you haven't said anything."

The lunch hour crowd was beginning to fill the lot, local brown-baggers and tourists stopping by on their way to Marin, a bed and breakfast on the coast, a few days in Mendocino, or a tour of the Sonoma or Napa wineries. I needed a vacation.

The sun blazed down on us. In a couple of hours the fog would start threading its way through the Gate and the tourists would be pawing through their bags trying to find the sweatpants.

"I'm curious about why this bunch might want to kill me. The Subic boy told an incomprehensibly wild tale. Doesn't it all seem a little strange to you?"

I shrugged. "Part of a master plan."

"You don't trust me, do you?"

"No. Why should I?"

"Because I'm an honest man. Ask anyone who knows me." For some reason, he began flexing his right bicep. Nervous habit?

My patience, what there had been of it, was gone. "I'm tired of standing here talking to you, Switcher. Get to the point, if you have one. What do you want?"

"All right, here it is. Yes, I think these people are idiots who will most likely stumble over their own feet no matter what they try to do, and that any plan they come up with will be as full of holes as a liberal's argument." Wow. When I think of holes I think of bumpy roads. But then, I'm a practical kind of guy. He was still talking. "But at the same time, I wanted to be sure there's nothing you know that I need to know to protect myself. Something you might, as you liberals like to say, share."

"If I hear of another plan to kill you, with details, the police will know and they'll warn you. Again. I would like it, though, if this time you could manage to keep your mouth shut."

"Tough guy, huh? Maybe you act this way to cover a limp wrist."

I started to walk away.

He grabbed my arm. "No, wait. I did have a purpose in calling you."

I yanked my arm out of his fist. "Then maybe you'd like to stop wasting my time and tell me?"

"I want you to pass on everything you find out about the Command's plans to me."

"Why should I do that?"

He laughed. "For the reason everyone does everything, Jake. Money."

"You want me to work for you?"

He nodded.

"I do things for reasons other than money, Switcher."

"I'm sure you do."

"And don't call me Jake."

"All right. Mr. Samson."

"I have a client on this case already, Switcher. I don't need another one."

"Yes, but all you have to do for me is pass on whatever you learn working for the other client. Everything you find out. I think these people are harmful to the conservative cause. I want to know who they are and what they're up to and how dangerous they are. This is a war of words, too, and we were hurt by that bomb in Oklahoma City. We'd need ten Ruby Ridges to outweigh—"

"Well, I don't want to work for you. And I don't understand why you'd want to hire me. I'm a Democrat. Maybe even a Green. Isn't that against your religion?"

"I'm a pragmatist. You're on the case. Talking to you now, you seem competent."

"Thank you so much."

"And despite the fact that you obviously don't like my views—" he flexed the bicep again "—I think you wouldn't mind taking my money."

What a disgusting twit. He turned around and hoisted himself up on the stone wall, facing away from Babylon across the Bay, getting his nice blue suit all dusty, flexing his calf muscles.

"I don't want your money. I don't want to work for you. I don't even want to be standing here talking to you. As far as I know the plot to kill you is on hold. Stay in touch with the police. Have a nice day."

Once again, I started to walk. Once again, he stopped me, catching up, getting in my way. I kept moving, but he didn't grab my arm again.

He walked along beside me, brushing off the seat of his suit pants. "Five hundred dollars a day."

"No."

"What exactly is it about me you find so offensive? My views on welfare? Health care? Religion? Women? Gays?"

"Yes. But I wouldn't find your views nearly so offensive if you kept them to yourself. You're a rabble-rouser. And the rabble you rouse is violent. You don't just want to 'prune the tree of liberal government,' as you like to say. You want to eliminate the constitutional protections of everyone you don't understand or like, make sure that welfare goes to business only. That jobs go to heterosexual men. Only. That the schools teach fundamentalist propaganda and don't teach anything that goes against it. You're not just a bigot, Switcher—I heard you say one night that you're a creationist. There's just so much I can stand."

He was staring at me, his mouth open. Then he burst out laughing.

"Well, at least you've got convictions. Look, I'll be out of town for a day or two, but I will be back Wednesday, as planned." He smirked. "If you change your mind, give me a call."

"I won't change my mind. My grandparents were immigrants who could barely speak English, and I had family on welfare during the Depression. We were poor when I was a kid. Fundamentalists called me names and tried to beat me up. I know enough about history to know how dangerous pricks like you really are. And my best friend's a dyke who's lived with as much crap in this enlightened damned day and age as my parents lived with in the Fifties. Because people like you make it okay to harass her. And that college kid in Wyoming? The one who was beaten to death because he maybe—maybe!—flirted with a man? Take your money and your

red white and blue suit and your smug little ego and—"

"Why are you so angry with me? What have I ever done to you? Do you want them to kill me?" He let out a weird giggle.

We were at my car. I climbed inside, slammed the door in his face, and turned the key. He was still standing there, looking amused, and puzzled, and patronizing, when I roared out of the lot and headed north. I wanted to drive through the Marin landscape for a little while. Maybe take a back road or two. Maybe stop for lunch somewhere. Get the taste of Preston Switcher out of my mouth.

No, I didn't want them to kill him. I just wanted all of them to go away and leave decent people alone.

I turned off Route 101 at the Sir Francis Drake exit, and once again, drove west. Past Fairfax, and Woodacre, and took the Nicasio turnoff. By the time I got to Rancho Nicasio I was ready for a meal and a glass of wine. On a bench outside the restaurant there was a copy of that day's Marin *Independent Journal*. Good. Something to read with lunch.

Halfway through my fried oysters, I found a story about a murder victim found early Sunday evening at the Berkeley Marina. A man dressed in jeans and boots and a leather jacket, the story said, with a Confederate flag on the back. A friend had ID'd him but the name was being withheld pending notification of relatives.

He'd been stabbed in the back.

I called Royal one more time and left the number of the restaurant pay phone. I was just about finished with my meal when he called me back.

"Listen, Jake, we got to talk."

"I know. That's why I've been trying to reach you. Where have you been? I just saw Preston Switcher. And who is this guy they found at the Marina? Anyone I know?"

"Meet me somewhere? Where are you now?" I told him. "That's kind of far. Let me think a minute." I let him think. "Okay, I got it. There's a good place in San Rafael."

I agreed to meet him at an upscale pool hall on the west side of downtown. He said none of the skins or Command guys ever went there. It was a yuppie spot.

"The corpse, Royal?" I didn't feel like waiting until I saw him to get an answer to that. "Who was it?"

"It was Pete Ebner."

Ebner. Who would kill Pete Ebner? I didn't think Red was too crazy about him, but suddenly, I wondered: Was this the way Royal was getting out of trouble with the Command? By killing his boss?

I decided to ask him straight out. "Royal, did you have anything to do with it?"

"Jesus, no! Why would I kill Pete? Just because he beat me up?"

"Seems like a reason to me."

"Well, not to me. Jesus. I wouldn't kill nobody. Not ever. Look, what I want is, you just meet me, okay? Me and Deeanne. I'm picking her up at school. I can be in San Rafael in an hour."

"Okay. We're going to talk more about Ebner and we're going to talk about Switcher, too—and why you opened your mouth to him."

"Yeah. Okay. Yeah. 'Bye."

I drank another cup of very good coffee and got back on the road.

Nice pool hall.

I got there after Royal and Deeanne, and they were playing a game. Deeanne was standing, leaning on her stick like an old woman, watching Royal drift around the table, settle on a shot, and almost forget to watch the ball not go in. His walk was missing nearly all its swagger. He looked worse than he had the day before, and he had a five-o'clock shadow on his head.

Deeanne patted his arm and aimed her stick at the cue ball; I stopped a few feet away to let her shoot. The stick slipped, she ticked the cue ball, and it wiggled a couple of feet in the direction of the five.

That made it Royal's turn again, but he wasn't paying attention. He was staring at his boots, his forehead all wrinkled like he saw a sad, scary movie playing across the surface of the leather.

I sat down beside him.

"Murder, Royal. The police are in this now big-time. Whether you like it or not."

"Yeah. I know."

Deeanne sat down on his other side and took his hand.

"That meeting at the bar last night—it was about Ebner, wasn't it? He'd been found by then, right?"

"I don't know about a meeting. I been hiding out at a motel. Zack beeped me, I called him, he asked me did I kill Pete. I said no. He said I was lying."

"You answered Zack's call but not mine?"

"He called first. I didn't want to talk about it."

"Uh-huh. Well, you didn't mind talking to Preston Switcher either. What the hell was that all about? Are you out of your mind?"

"I thought he should know what he did, so he wouldn't do it

again. I've always thought he was okay. I wanted to tell him I was looking out for him, but he had to look out for me, too."

"He doesn't care about you."

The kid shot me a hot look. "I don't believe you."

"He betrayed us. And then you gave him my name."

"He said he'd keep it off the air now, and he said he wanted to talk to you." Stubborn, sullen, like a five-year-old.

"Yeah. He called and we met. Fat waste of time. The man had nothing to say I wanted to hear. Listen, Royal, I'm saying this only one more time. You tell me everything you know every time you know something. You answer my calls. You don't talk to anyone else about anything. You don't jeopardize me and Rosie. Or we're gone and you're on your own. You got that?"

For a second I thought he was going to argue. Then he nodded and started to cry, silently. Deeanne leaned over, twisting in her chair, and rubbed his broad, rock-tense shoulders.

"Who killed Ebner?"

"I don't know, Jake. Maybe the same guy that killed Richard."

Richard. The kid who'd gone looking for new causes. "But why?"

"I don't know."

"You have to do better than that. Ebner had to have some enemies. In or out of the group." To say the least. He must have walked through the world pissing people off.

When I'd called Rosie to tell her to check out the story in the paper, told her who the corpse was, she hadn't said much. Just, "Could have been anybody, creep like that."

"Even if he did have enemies," Deeanne said, "it doesn't matter. Everyone's like, what just happened was Royal." I must have looked confused. She went on a little more clearly. "Everyone thinks it's Royal because it just happened, him beating on Royal and accusing him of being the snitch."

"Does Zack think you killed Pete?"

"Well, yeah, he's all, well, he kind of thinks so. I mean, he was there when Ebner beat on me. But he's my friend, still. I think."

Sure. "He ever give you back the money you loaned him?"

The kid shot me a hurt look. "He needed it for tools. He's trying to like, make something of himself."

"Tools?" Wires? Timers? Explosives? "What kind of tools?"

"He's learning to be a locksmith."

Great. Just what the world needed. Zack knowing how to pick locks.

"Okay. So Zack kind of thinks maybe you did Ebner. Do all the others think so, too?" I was wondering how long it would take the cops to hear about this and come looking for the Command's most popular murder suspect.

"I don't know who-all else. Steve, he told Zack that people are wondering. He goes, everybody's pissed and a lot of them are looking at me, you know? But Zack, he says Steve wouldn't say who, exactly, is looking at me, or maybe Zack won't say. But we were, like, followed when we came here today. By Floyd. I recognized his shitty-looking car."

"Followed!"

"Don't worry. We lost him on Fourth Street."

"Are you sure?"

"Positive. Unless he changed cars or something." That didn't seem likely, but with this group, who knew?

Nothing we could do about it now. And why shouldn't Royal be meeting his cousin? I decided to get back to Floyd in a minute. There was something else I wanted to know right now.

"The paper said a friend ID'd the body. Who was that?"

"Oh, yeah. Well, Pete had, like, Steve's name and Thor's phone number on him, so the cops called and Steve went."

"Zack told you that, too?" He nodded. Zack had been pretty damned chatty with the guy he thought killed Pete Ebner. The kid had a mouth as big as Royal's. But Steve's ID sounded okay—it wasn't like the cops found him hiding in the bushes and asked him to look at the body.

"Okay. Tell me why you think Richard's death is connected to Pete Ebner's murder. There must be something that makes you think they're related. Richard was shot, right?" He nodded. "And Ebner was stabbed. So that's not it. Not the same M.O."

Royal just shrugged.

"Look, pal, you're going to have to be more willing to help, more willing to talk, more willing to take a little responsibility for your own life."

"I am willing. I just don't know anything. It just seems like there must be someone in the Command that had a reason to kill Richard and had a reason, like maybe the same reason, to kill Pete. But that doesn't make a lot of sense. See, Rich was killed because he was pulling out. I can't see Pete pulling out. Not ever. It was his whole life, man."

"Pulling out. Yes, you said Richard was trying to leave the group and that was when he got killed. But I've been wondering about that. Why would they bother? Did he know too much?" And about what?

"Hey, he didn't have to know nothing. He was just a warrior. But some of these guys don't think killing's such a big deal, you know? And loyalty is. A big deal."

I thought of Red. Survivalist. Weapons expert.

"Okay. Think about it. Right now. Who do you think, who do you remember, was maybe especially mad at Richard for wanting to leave? Anyone. A warrior, Inner Circle. Whoever."

"Well, Leslie found out, and she was real pissed. She and him, you know, for a while, but he backed off and you could tell he was on his way out of the Command, and she was real pissed."

"Who else?"

"Pete didn't like it. Pete was real mad at him." He looked up, his brow furrowed. "Hey, maybe Pete killed Richard and some friend of Richard's killed Pete?"

"You were a friend of Richard's."

"Yeah. See? No matter where you go with this, it looks like me!"

I got up and walked over to the pool table, thinking. "Okay if I take your shot, Royal?"

He shrugged again. Once I finished with this mess, I hoped I'd never see another shrug. I aimed and shot, sank the six. Tried a bank shot on the eight and blew it. Deeanne didn't get up to take her turn. She was still rubbing Royal's shoulders. Why can't I ever find a woman like that? Should I shave my head? Learn to look sullen and dangerous?

I stayed standing, leaning against the table. "Let's look at it another way. Who would benefit from Pete's death? Who wanted his Command job or something else that he had?" Job. That brought up another question. I'd ask it when we finished this line of thought. Didn't want to confuse the kid.

"Red did. Red benefited. He wanted to run the warriors. He told me that once."

"Yeah. I was thinking along those lines, too. And who else? Who else stood to gain in some way? Or had some kind of special grudge going against him?"

"Nothing real big, but Gilly. Her and Pete, they seemed to not exactly like each other—but it was hard to tell. They tried to hide it. And Karl didn't like him, I thought sometimes, but if Karl killed anybody, I think it would be Floyd."

Back to Floyd, then. "So you think Floyd tried to follow you today?"

"I know he did. It was that old green Camaro of his." I thought I'd seen one of those parked near Thor's, and near Red's truck at the tailgate party, but I hadn't known it was Floyd's and hadn't paid much attention to it. It looked pretty much like every other old Camaro I'd ever seen. Every green one, anyway.

"You think he followed you from your motel, or did he pick up on you along the way?"

"I don't know."

"Better find another motel."

He just closed his eyes. Deeanne was working on his neck muscles now.

Gilly and Red.

And Karl. And Floyd. Following Royal? With what in mind?

"Royal, I know Steve hands out presents, but is there any other money floating around? I mean does anyone actually get paid for working for the Command? For Command jobs?"

"I don't think so. People mostly work."

"Even Ebner?"

"Yeah. He sold, like, car parts or something." His eyes were still closed.

That was good. An army without pay is an army of deserters. Of

course, Royal might not really know what was going on.

I thought I'd better be sure he'd heard me about finding a new place to hide. "Royal, go get another motel room and stay there. Do you hear me?" He opened his eyes, focused on me, and nodded. "And Deeanne, you go home."

Royal jumped up, grabbed his cue stick and bashed a couple of balls. Neither one of them went in. Then he swung around, legs spread as if he needed to work to keep his balance.

"I been thinking. I think I can't do that. I think it was wrong to run away and hide out. I got to change my, you know, approach. I got to act normal, go back home. Go back to Thor's. I got to act like what everybody's saying isn't true—just like you're doing. I got to be around the guys and make them believe I didn't snitch and I didn't kill Pete." He finished the longest speech I'd ever heard him make, turned back around, and bashed another ball. This one went in the side pocket.

For a kid with a minimum of smarts, Royal did a lot of thinking, most of it skewed. In this case, though, it was possible he was right. That was the way Cousin Jase had been playing it all along. I couldn't keep Royal away, I couldn't protect him by making him look guilty.

I gave in. It was his life. "All right, then. But understand you're really risking your neck now. And Deeanne—you stay away from him until we see how this is going to fall."

She didn't say yes and she didn't say no.

I left the two of them there, playing pool, and called Rosie from my car, leaving a message that I was headed toward Thor's but I'd turn around and pick her up if she called before I got to the Richmond Bridge.

She didn't. All the way to Berkeley, the possible killers and the possible reasons for the killing ran through my mind. Royal was absolutely the best suspect, if you weren't in the mood to suspect Red. What did that make me? Anything different in the way I should be playing the game now? No. I was still innocent Cousin Jase. Ebner's death didn't change that.

There were a couple of motorcycles parked outside. Skink and two of his no-name warrior pals were sitting at a table drinking

beer. All of them glared at me when I walked in.

Steve was wiping the bar, or maybe spit-shining it.

"You again, huh?"

"Steve, you could make me feel more welcome."

"Guess I could. Don't think I will, though." There was that half smile again.

He didn't seem to be mourning Ebner's death. Except for closing the bar and tossing everyone out the night before, he didn't seem to be affected by it at all. He served me the beer I ordered without another word, and this time he didn't rip the stein out of my hand before I'd emptied it.

I waited to see who came in and what happened. Every time I glanced toward the warriors' table, they were staring at me. Except once, when only two of them were staring at me and they both had to elbow the fat kid so he'd look up from his beer and help them.

Gilly showed up. She was wearing jeans, boots, and a tight black T-shirt. Her hazel eyes crinkled at me and she sat down on the next bar stool. She was looking friendlier than she had since I'd turned away her pass. Did I have the strength to do it more than once?

"Well, Jason, how's it going?"

"Okay, I guess. Sorry to hear about Pete Ebner. That's bad news."

"Yes. It is. Can't imagine who'd do a thing like that." She was watching me slyly. "Some Jew. Someone from ZOG maybe." She ordered a cola. ZOG. The secret Zionist Occupational Government. Imagine how these guys must have felt when the secretary of state found out she was Jewish. Bet they thought she knew it all along.

At least Gilly hadn't said she was betting on my cousin Royal.

"There seem to be a lot of bad things happening to this group lately, you know, Jason? Kind of odd, all at once." A sidelong look.

"Well, it seems like this group is doing some stuff all at once, too. Really good stuff. Maybe there's a connection."

"You mean the church and the cemetery and ThePeople?"

"Yes, I do." I flashed an excited smile at her. Lust for vandalism. I hoped she didn't mistake it for anything else.

"What makes you think we did all that?" She smiled at me.

"Just hoping, I guess." That was true. Hoping this was the only group of fascist assholes in the Bay Area.

She laughed, but, like Deeanne, she didn't say yes and she didn't say no. Then she changed the subject abruptly and threw me off balance.

"I suppose you're still seeing Rosie?"

"I wouldn't say seeing, exactly." No, I sure wouldn't.

"Find some time for me, all right?" There was that gorgeous grin again. Her teeth were perfect, her lips full. I kept repeating over and over in my mind—Nazi, Nazi, Nazi.

Steve was standing at the end of the bar watching our little love scene with a sardonic eye and a sour twist of the mouth.

Floyd appeared in the doorway, taking in the view. Then he pasted on his own version of Steve's half smile and sauntered over.

"You didn't leave a number last night, Jase. Wanted to ask you something."

Gilly swung around to face Steve, backing off for the moment. Guess she figured it was Floyd's turn to interrogate me.

"Ask away, Floyd." Cool, unconcerned. Was he going to ask me when Royal murdered Ebner? Was he going to ask if I helped him do it? Was he going to ask why I'd met Royal and Deeanne at the pool hall and what we talked about?

Floyd dropped his arm down on my shoulder. A heavy, heavy arm. "There's a show I wanted to take in tonight. Skink's band, they got a gig. And how about we grab some dinner first? You, me, Rosie? She here?"

So Skink had a band. Wow. And Floyd was still my pal. Or even more interested in checking me out. I couldn't say no. Not now. I was innocent. Royal was innocent. No reason to say no.

"No, she's not here. The music sounds great. Dinner, too. Tell you what. I been running all day. Need to take care of some things first. How about I give Rosie a call, go back, take a shower, bring her along?"

"Yeah. Do that. How about I see you here in an hour, hour and a half?"

I looked at my watch. Four-thirty. "Make it two hours?"

He nodded, took his arm off my shoulder, and headed for the back of the bar. Not a word about Ebner. He hadn't even left an opening for me to say anything about him. Maybe that would all come later.

Turned out it was a good thing I'd given myself some extra time. When I got home I discovered that Harry George, the FBI connection, had finally called me back. He had a slow, quiet voice. He wanted me to get back to him right away. First I called Rosie. She couldn't wait to go to the show, said she wondered what kind of music these guys would play.

"Maybe," she said, "It'll be a tribute to Pete Ebner."

"That ought to be fun."

After we hung up, I started trying to call Harry George. I tried the number for half an hour. First it was busy. Then nobody answered.

T hor's was jammed. Floyd was there waiting for us at a table near the jukebox, a long way from the door. As we walked through the place I heard Ebner's name spoken several times, and a stir of tension and suspicion followed us. Rosie must have felt it, too, because she took my arm. Not something she usually does.

Skink and his buddies were still there, or had gone and come back, and now Zack and Leslie and a couple of other skin-kids— not Maryanne, the one who'd gotten tossed out with her boyfriend—were with them. Leslie, who I now knew was a former girlfriend of the murdered Richard.

The warriors had been busy working themselves up. One after the other, they turned and glared at me. When it was Zack's turn to glare, I noticed he had a black eye. Well, fighting is a warrior's job.

Rosie had found out a few things about Ebner's murder. The cops had gotten a no-name public-phone call around 7:30 Sunday night, found his car, found his body behind a bunch of shrubs, found the Thor's number, and called Steve. They didn't find the murder weapon anywhere in the neighborhood. We'd gotten to the bar around 9:30, maybe 10:00, and Steve had the meeting all set up by then.

She didn't have anything on what kind of knife had done the job or the exact time of death, but her Berkeley cop friend Hank had told her the body was "real fresh."

We sat down with Floyd, who acted like he wasn't noticing the atmosphere. He offered to go get us a couple beers, though, so maybe he thought we should just sit where we were for a while. The next time I glanced toward the bar, wondering what had happened to our drinks, I saw that Floyd had struck up a conversation with Red.

"Looks like Floyd's going to keep us waiting," I told Rosie.

She followed my gaze and rolled her eyes. "Maybe it's supposed to be some kind of torture."

We were both pretty nervous. It was hard, sitting there and pretending to be totally innocent, trying to outstrut and outbluff, with nothing to lubricate the dryness in our mouths, nothing in our hands but air. Times like these I really miss cigarettes. So I was about to get up and go to the bar myself when Leslie stumped over to our table.

"Didn't think I'd see you in here again, Jase."

She stood too close, hands on hips, glaring.

"Why not?" I acted like I really didn't know what she meant.

She snickered, but there was no laughter in her eyes. "Maybe you two really don't know what's going on." She turned her head to look at her buddies, who were watching and sneering, and barked, "Not!"

"Listen, Leslie, I don't know what you mean by 'what's going on.' I know about what that Switcher guy said on his radio show. And a couple people seem to think Royal had something to do with that. And then I hear some people even think he's got something to do with Ebner's murder, which is pure bullshit. Why don't you tell me what you're talking about?"

"Yeah. That's right. People think Royal had something to do with what Switcher said on the radio. And with Pete Ebner's murder, too."

"I'm real sorry about Ebner, and—"

Rosie broke in. "Royal's loyal to the Command, Leslie. Even I know that, and I don't know him very well." Sure. Loyal Royal. "It makes me kind of mad that some people don't get that, you know?"

"Yeah, well, I don't think he's loyal. I think he totally rolled on the Command. Or maybe he told you some garbage, and you rolled on us." She was facing Rosie, but she was talking to both of us. I wondered: Did she know the Switcher plot was real? Hard to tell. But dumb Cousin Jase wasn't touching that question. He had other fish to fry. A fish named Leslie.

I cranked my voice as loud as it would go without yelling. Her change of heart toward Royal gave me some idea of what might

have happened between them in the last couple of days. I had to land on her and land hard. No more Mr. Nice Guy, no more Gentleman Jase. "Look, little girl, I know you're pissed off at Royal because he didn't go for it when you came on to him. That's no reason to be bad-mouthing him."

"Yeah," Rosie picked it up. "Or maybe it is, huh? Maybe you want him blamed because he turned you down. Maybe none of this has anything to do with Switcher's program at all."

I noticed Floyd coming toward us, holding a beer in each hand. Then, with no warning that I caught, Leslie jumped Rosie, pummeling her shoulders and chest. Her chair fell backward and she was on the floor.

Leslie had managed to catch both of us by surprise, I don't know why. Too into our acts, I guess.

Rosie let out a roar and rolled to a crouch. I tried to get between the two women, and was just reaching for the boot that was coming at my face—Leslie's—when Floyd lifted Leslie off her feet and put her down again several feet away.

"I'll stomp that bitch!" she screamed.

"No, no you won't. Nobody's gonna stomp anybody in Steve's bar, and nobody's gonna stomp anybody until we find out where Switcher got his story, and who killed Pete. You got that, little girl?"

She went at Floyd, fists pumping, and managed to plant a good kick on his shin before Steve came around the bar and grabbed her, marched her back to her table and sat her down, hard.

Floyd's shin was bleeding. There was a dark stain on his jeans leg.

"Thanks, Steve," I yelled, picking up Rosie's chair and patting her on the shoulder. She was steaming, gritting her teeth, red-faced, but she sat. I was really glad she wasn't mad at me.

Steve just glared at me. I laughed and dropped into my own chair. Floyd had managed to set our glasses on the table before he'd stopped the fight. I slid Rosie's beer in her direction and took a long swallow of my own.

"Hey, Floyd, maybe you can tell me this—does Steve hate everybody or is it just me?"

"Steve don't hate nobody, Jase, he's just got a suspicious mind."

Steve went back behind the bar. Not a word to Leslie. No 86 for her. I figured that was either because of how Steve felt about her or how he felt about us.

I stared at the blood on Floyd's pants leg. There was a lot of it. Floyd followed my look.

"Leslie's got steel-tipped boots," he said.

Thinking about that, and wondering where she'd used them before, I glanced across at the warriors' table in time to see Zack lean over and say something to Leslie. Then he got up and approached us.

He kept his eyes fastened on me while he made it clear he was speaking only to Floyd. "You know, Floyd, maybe you shouldn't have stopped the fight."

Floyd waited for the rest.

"Leslie's right. And I don't want no one who supports Pete's killer in my bar." So much for Zack's friendship with Royal. I remembered what Red had said, that these guys would kill for each other. If they weren't too busy knifing each other in the back.

Floyd shook his head. "Not your bar, Zack. Cool down. We'll get to the bottom of this." Zack shot me an Elvis sneer. He wasn't finished yet. He had been Royal's friend, friend of the snitch. That made him look bad, and now he had something to prove.

"Hey, Floyd, you sure you're not sitting with a traitor?"

Floyd didn't answer.

"We think Royal killed Pete Ebner, that's what we think. The warriors, I mean. And we think he needs to be punished for it. What do you think of that, Jase?" I didn't like the sound of the way he said my name.

Floyd didn't say anything. He didn't even blink. I decided to pretend he had spoken up, had blinked, to keep the fantasy going that he was my pal.

"It's okay, Floyd. I can understand where the man's coming from." Like I thought Zack was a man. "Listen, Zack, if I thought Royal killed anyone in this group, I'd turn him over to you myself."

The kid sneered at me again. "Bullshit, that's—"

"That's enough, now," Floyd told him. "We're gonna find out who did Pete, you can be sure of that. Now just take it easy."

"I'm a warrior, Floyd." The kid raised his voice. "Warriors don't
take it easy." With that, he swaggered back to his table of friends.
Red was just pulling a chair up to the warriors' table. He was wear-
ing his buck knife.

Like the conversation had never happened, Floyd leaned back,
totally relaxed, and looked at Rosie's breasts. "What kind of food
you two like? Dago? Chink? Jap? Steak? I can eat anything."

Floyd was talking loudly enough so that everyone at the bar
could hear his epithets and catch the meaning of his last statement.
Several people laughed every step of the way, which at least served
to lower the tension level in the room. Leslie laughed the loudest.

"Steak's fine," Rosie said, ignoring his carnivorous fix on her
body. She's not much of a steak-eater. Maybe she didn't want to
inflict Floyd on an ethnic restaurant.

I nodded. "Yeah. That's fine. I wanted to ask you, Floyd—Royal
says Gilly and Pete didn't get along in some way. Is that true?"

"Huh. Kind of funny, about those two. Always had this edge, you
know? Couldn't tell what it was about. Didn't ask, either. Personal
stuff. Sex, probably." I could believe that about Gilly, but Ebner?
I'd expected him to be saving himself for the second coming of Eva
Braun. "It was really Karl who didn't like Pete, but Karl don't like
me either, and I'm still alive. Have another beer."

I'd had enough for one night. Enough beer, enough Aryan
Command, enough Floyd. Unfortunately, it was time for dinner.
Floyd insisted we go in his Camaro.

He took us to a decent place in Berkeley. I wanted the sole, but
I didn't want Floyd doubting my manhood, so I ordered steak.
Rosie, not having that problem, got the salmon. Floyd, as expected,
opted for their biggest steak, very rare.

"I like 'em so they're still walking." Big surprise.

"Floyd, I'm glad we're getting this chance to talk about what's
going on. It's real bad for the Command to lose Pete this way. And
I'm worried about Royal."

"Yeah. Yeah, it stinks, all right. Good guy, Ebner. Helluvan
Aryan. Hey, how long's it been since you had a martini?"

About three years. "Don't remember."

"You, Rose?"

"A while, Floyd."

"Maybe it's time. I hear they make real good ones here. Let's give it a try."

"Well, maybe just one." Rosie sounded doubtful. I was with her on that. We didn't want to relax that much. Floyd stood up and waved at the waiter, who was there in ten seconds. He ordered three jumbo martinis.

I wasn't going to let him cut me off about Royal. I put on my best earnest, serious face.

"Floyd, you're a member in good standing. Royal—"

"Yeah. Listen, there's not much I can do."

"Royal's a good kid. Maybe someone lied, and for sure someone killed Pete, but going after an innocent, loyal warrior—that's not gonna do anybody any good at all."

Floyd shrugged. I needed to try to pull him into this.

"Listen, I know he didn't kill Pete. I know where he was Sunday night."

"Yeah, where?"

"At my place. See he was worried about some of the guys threatening him, calling him a traitor. So I said, Hey, come over for dinner and sleep on my couch tonight if you're scared. He did. But he made me swear not to tell, embarrassed about being scared, you know? He probably still won't admit it." I threw that in just in case anyone asked him and he was dumb enough to tell the truth. Then, remembering that Floyd had followed Royal the next day: "He left sometime real early in the morning. Don't know when. Went to a motel, I think."

"No kidding?"

"No kidding."

He looked thoughtful. "Maybe Pete was killed before dinner-time."

"Broad daylight?"

"Didn't you come by Thor's on Sunday?"

"Early and late. And by the time we got to Thor's Sunday night you guys were already having your meeting. What time do the cops think he was killed?"

Floyd looked thoughtful again, but he kept that information, if

he had it, to himself. The waiter came back with our unwanted martinis, breaking some kind of record. The damned things were bigger than margaritas.

"And Royal's not a traitor, either. That kid, he's real serious, real true blue, Floyd."

"Yeah? And how about you, Jase?"

"Jesus, Floyd, is that why you invited us to have dinner with you tonight? To ask me if I'm a traitor?"

"No, but I sure would like to know. You're a sharp guy, Jase. You could be useful to the Command. But we got to be careful."

"Hey, I can understand that. I don't know how I can make you feel okay about me, though."

"Or me," Rosie interjected.

He leered at her. "Well, we'll just have to see, won't we?"

She ignored the leer and turned the conversation back where we wanted it. "Floyd, I don't get it, how those kids can blame Royal for all this. Isn't Zack supposed to be his friend?"

He shrugged. "Who else they going to blame? Switcher found something out from someone. A snitch who knew about some plans. Pete thought it might be Royal. Now Pete's dead, right?" Floyd was looking at her with a glimmer of a smile. The smile gave me the creeps. "Was it Royal? Or was it you, Rosie?"

Even Cousin Jase wouldn't miss the implication of what Floyd had just said. I slapped the table, getting his attention back on me. "Wait a minute." I wrinkled up my forehead, all stupid-looking. "You said a snitch knew about some plans. Does that mean it's true? That what this guy said about the Command wasn't a lie?"

He scowled at me. Maybe he hadn't meant to let the truth slip out that way. "How the hell would I know? I'm just sayin'…" Casually, he took a slug of his martini.

"But if everyone says a snitch told the cops…" Come on, Floyd, admit it.

Floyd just shrugged.

"Maybe I'm stupid, but I don't get it. Why would the Command want to kill Switcher? I thought you guys liked him."

"I guess it's kind of complicated then, huh? Anyway, I don't know."

The food came and Floyd acted like he was too hungry to talk, swallowing his salad, shoving four pats of butter into his baked potato, and attacking his steak like he didn't want it to attack him first. Rosie and I managed to eat most of what we'd ordered and drink about half the Godzilla-sized martini before it was time to leave for the show.

Rosie had been careful to sit in the back seat, as far out of Floyd's reach as she could get. "Hey, Floyd—what's the name of this group?" she wanted to know.

"The Killer B's," Floyd said.

"Bees? As in little striped bugs?"

"No, *B*'s as in letters of the alphabet."

"And who are they again?"

"It's Skink's group."

"Isn't he one of the warriors?"

"Yeah. A good one."

I'd mentioned Skink to Rosie as the kid who'd earned the motorcycle, and pointed him out: Skink, brave warrior, friend of Zack.

"Why are they called B's?"

Floyd looked blank. Apparently he hadn't wondered about that. Then he shrugged. "I don't know. Maybe they're all from Berkeley. Maybe they all work out and it stands for buff. Anyway, they're supposed to be really good and the Command likes to support its own. So we're going."

I nodded with all the enthusiasm I could dredge up. "Can't give enough support to our warriors!"

"Thought you'd say that."

Was it my imagination or was there a subtle shift in Floyd's tone with me? A touch of sarcasm? Was my acting not quite the star-quality stuff I'd been imagining? Truth was, I was a little worried about going to a public place that wasn't Thor's. The Bay Area is like a small town. We'd taken a chance when we'd gone to the ball game at the Coliseum, but I've never in my life run into anyone I know at a ballpark. I don't know why. But this was music. An East Bay club. Rosie and I both knew a lot of people in the East Bay,

and we were only half an hour from both San Francisco and Marin County, too. We could run into someone who recognized us even in white-trash drag with the wrong hair.

But nervous or not, we had to be willing to go out in public. All we could do was hope this would not be the night our own act laid an egg.

I tried again, using a little less cheerleader, a little more Clint Eastwood. "Who else is going to be there?"

"Gilly, Red, Leslie, buncha warriors, don't know who else. Maybe Karl, but probably not."

The ride took only ten minutes, and that was about all the conversation, thank God, that we had time for.

"Are they going to maybe dedicate the show to Pete?" I asked as we got out of the car, like I thought it would be a good idea.

"Nobody said. "

The club occupied a warehouse down in west Oakland, between a film company I'd never heard of and a welding business.

Its scabby gray façade was decorated with messy, unreadable, dirty-mouth tagging. Not one piece of decent graffiti on the whole front wall. The interior had been cut into one large room and one small one. The small one, a lobby of sorts, was brightly lighted. It was crammed mostly with young and youngish people milling around a snack bar and a ticket taker. Leslie and her pals were already there, looking sullen and cool. The large room, which I could see through the doorway, was pretty dim.

Tickets were ten dollars, and a couple of muscular and hairless teenagers with rings in more places than I could count, or wanted to count, stood near the ticket taker looking menacing. In case anyone didn't like the music? What would they do if a critic showed up?

Floyd insisted on paying our way. "Want a candy bar or a soda or something? Place doesn't sell alcohol, 'cause they want to get kids in here."

"Steve doesn't seem to worry about legal age, down at Thor's."

"Steve doesn't believe in that law."

"Can't it get him closed down?"

"He don't need to worry about that."

"Well, let's hope it stays that way. Payoffs?"

"Nah. Other towns, sure, but not in this neck of the woods. Why do you care?"

"Hey, whatever." Maybe Steve had other sources of income, and losing a liquor license just meant setting up somewhere else. Maybe, in the case of Thor's, the alcohol was a deliberate attraction.

I accepted a soda. Rosie got a bottled water.

Gilly showed up while we were buying our tickets. She was alone, and walked over to Leslie. So there she was again, this beautiful woman, on her own, at a club. I amused myself for a minute or so imagining she was alone because I belonged to Rosie. Or had Pete Ebner broken her heart?

Red lumbered in, nodded to us, and went to talk to the bouncers, or whatever they were. He wasn't wearing his knife. Zack came in with the little guy who looked swamped in his tough jacket, the one who'd been admiring the motorcycle with Zack and Skink. Washburn, that was his name.

A lot of the people showing up for the performance looked like ordinary kids, ordinary adults out for the evening. One group of middle-class music-lovers, in particular, looked like they didn't have a clue what they were in for, trying to be cool and avoid the eyes of the scowling skins. Tourists, maybe out to scare themselves or prove there was nothing to be scared of.

I saw someone I recognized as a checker from the supermarket in my old Oakland neighborhood, a young woman in her twenties who'd never really noticed me before and wasn't looking at me now. Turning toward Gilly again—what the hell, no harm in looking—I came face to face with Maryanne and her boyfriend, the kids who'd been tossed out of Thor's. She stared hard, straight into my eyes, before she moved away.

Leslie and a friend were whispering to each other and looking at me. Gilly wasn't with them anymore. Red was still talking to the bouncer.

Royal showed up, with Deeanne. I'd been afraid he would come. I'd been even more afraid she'd be with him. He'd insisted that he had to hang, to act like he was innocent and try to be part of the group, and here he was. And Deeanne had not agreed when I'd told her to avoid him. But they couldn't understand how bad things

had gotten, or they would have stayed away. They hadn't heard what I'd heard in the bar that night.

I pulled them aside, trying to look casual.

"You don't have any friends here, Royal. I think you'd better go."

"Can't. If I run it's as good as admitting—"

"That you have a brain."

He shook his head, placed his hand lightly on the back of Deeanne's neck, and steered her into the large room. The kid was a fool, but I had to admire his stubborn courage.

I managed to maneuver Floyd to a table up front, close to them.

Keeping an eye on Royal and Deeanne, I was waiting for a fight to break out, waiting for Zack or a bunch of the warriors to swagger in their direction, to challenge Royal, to start shoving him around. It didn't happen. Although there were some nasty looks, no one seemed to want to start anything, at least not here in the club. This was Skink's big night, after all. A fight might scare away the crowd. I caught sight of Gilly again, sitting at Leslie's table. She saw me looking and blew me a kiss.

The show opened loudly and abruptly with Skink riding his motorcycle out on the stage. It roared and backfired and the crowd roared and probably backfired, too. Skink jumped off his hog and turned away from the screaming audience, showing the skull and crossbones on the back of his black sleeveless T-shirt.

Also showing the crowd his tight little ass in its tight little jeans. Leslie and her friends jumped up and down and cheered. Whether it was for Skink the man, Skink the skull-wearer, or Skink the buns, I couldn't tell. Maybe they didn't know, either.

While he stood there, his back to the audience in what struck me as a hostile or at least contemptuous statement, three more shaven-headed adolescents ran out on the stage, one of them pushing a platform with a drum set on it to the middle of the stage behind Skink and his hog, the others carrying a bass, a guitar, and a keyboard. Skink jumped up on the platform and began to batter the drums while the other guys fiddled with their instruments, plugging in the bass, setting the keyboard up on a table. The band members arranged themselves around the motorcycle, and began to join in with Skink's bashing.

I was beginning to regret not sitting at the back of the room, but our seats gave us a good view of the group, and of their various decorations. They all had tattoos. Snakes. Crosses. Double lightning streaks. On their arms and their foreheads.

After a few seconds of heavy metal noise, they started singing. I tried to hear the lyrics—obviously some people either could hear them or knew them, because applause and cheers rose from the audience from time to time. I heard the words "kill," "stomp," "death," and the phrase, "We're gonna make 'em pay with blood," which the kids in the audience, at least, seemed to like.

About halfway through the first number, the bassist, who seemed to be the lead singer, took off his shirt and flexed his muscles. He also flexed a newly revealed swastika tattoo on his right pec. I heard a few hisses, but they were weak. A few yells of approval, too. Two people near the back got up and left, to the hoots and laughter of their neighbors. I got the feeling that, mostly, the people who had come to see Skink's band knew what to expect.

After the second song, which seemed to consist mostly of the line, "All the soldiers, all the warriors, gone to battle in the streets," Skink stood up and made an announcement: "That one was for a great soldier, a great hero, who died on the front lines—Pete Ebner!" Then he took off his shirt to reveal a big clavicles-to-abs tattoo on his chest: crossed lightning on the red and black shield of the Thunderskins, the shield roasting in red and yellow flames rising from the blue words that underscored them: WHITE POWER. A few big roars for that one, and suddenly someone—a bald black teenage boy—was rushing the stage, shrieking.

Two of the bouncers I'd seen out in the lobby were there before he got to the musicians, lifting him off his feet and carrying him out the door, earning some laughter, several shouts of protest, a few untranslatable yells, and a big cheer. But mostly people seemed to be just rocking with the music and trying to ignore the graphics.

Maybe there wouldn't be a riot outside later.

Actually, the band wasn't bad. A heavy beat, a lot of sweat, muscle, and macho posturing, and some very dangerous messages—I could see how the right audience might find the show enthralling. It was loud and it was rousing, and if I'd been stupid enough, and

hadn't understood the message, I might have gotten swept up in it myself.

Floyd grinned at me. "Good group, huh?"

"Great. Really great."

Leslie was bouncing up and down in her chair and crying. Gilly sat watching, an odd little smile on her gorgeous full lips. Maybe the boys turned her on, too, but I somehow doubted it.

After an hour, we staggered, exhausted, out to the lobby for the break between sets. Floyd, Red, Rosie, and I. Royal and Deeanne joined us. Gilly walked over, and much to my amazement, so did Leslie. Keeping an eye on us?

"Is the show over," I asked, "or is this an intermission?"

"They'll do another hour after this, and that's the show," Leslie told me, flaunting her familiarity with the group. Flaunting it for whom, I wondered. Deeanne, the rival? Royal, the traitor? Rosie, her recent sparring partner? There seemed to be some kind of truce in effect here, although I didn't know why, how long it would last, or what it meant. Just more erratic crap from the terminally nuts, I thought.

We were standing there, drinking sodas, chatting about the Killer B's—yes, Leslie said, the *B* did stand for buff. That was why they took off their shirts. Well. Silly me. Here I'd been thinking they'd undressed to show their politics.

I was picking up bits of a quiet conversation nearby, between a man and woman in their thirties, in ordinary, casual clothes. He was saying he wanted to get the hell out of there, it was making him sick. She was objecting. She said something about, yes, it was disgusting, but she was enjoying the sense of danger, the excitement, the "alienness." They mumbled some more, and finally she seemed to agree to leave. As they walked past us, the woman—pretty, darkhaired, athletic-looking—did a double take at Gilly, and swung back around, squinting at her.

"Milly?"

She didn't respond, but I noticed a flicker of hesitation in her chat with Leslie.

"Milly Levine?" The woman was smiling. She touched Gilly's arm.

Gilly turned toward her. "Got me confused with someone else,

I'm afraid." She smiled. Was that sweat on her perfect pale forehead?

"No! You're not Milly Levine, Jody's older sister? From L.A.?"

"I'm not from L.A. I don't know them." Gilly stopped smiling and turned away to continue her talk with Leslie.

"But—" The woman's companion took her arm and led her off, glancing nervously at our little group of Nazis.

Leslie had backed away from Gilly.

Red, on the other hand, moved toward her.

"Milly Levine?"

"Oh, come on, Red, she made a mistake. Nobody ever thought I looked like a Jew before." She laughed, but I could see she was shaken.

"Maybe she didn't. Make a mistake, that is." He reached out and gripped Gilly's arm.

Floyd moved in and put his hand on Red's wrist. "Hey, Red, lighten up—Gilly's no Jew. Kind of funny, though, huh?"

Red's flushed, sweaty face was right up in Gilly's pale, sweaty one. Floyd was trying to pull Red away.

One of the bouncers noticed and came over. "Take it outside, please. Then you're welcome to come back in for the second half."

"Good idea," Red said. "Let's go out and talk, Gilly."

All of us went outside, following Red down the block and around the corner, out of sight of the club. Dark warehouses, no cars, no people.

"You know, Gilly—" Red pronounced the name as if he no longer believed it "—I always wondered how come you disappeared sometimes. When shit was going down."

"I don't know what you're talking about. I was right there with you and the boys in that cemetery."

"Yeah. Dead people. That's the only time you ever came along. No live ones, though. I'm trying to remember, but I don't think no live ones."

"Bullshit. The bitch mistook me for some Jew. I can't help that."

"Royal, help Gilly take down her pants."

Royal stepped back, shaking his head. "What the hell you doing, Red? What kind of crap is this? You can't pull down the woman's pants!"

"She told me once she had a swastika tattooed on her right cheek. We was all talking about tattoos and how we wore what we fought for. She said she did, too. I always wondered about you, Gilly, or Milly, or whatever the hell your name is. Cold bitch, nose in the air. Too good for anybody. Pull 'em down, Milly, or we'll do it for you."

She didn't move. Was there any way I could help her? Floyd led the way.

"She shouldn't have to do it out here in front of all these men. It's wrong, Red. What if she's not a Jew after all?"

"And maybe she is. And if she is, maybe she's JDO."

"What's JDO?" I asked.

Floyd, his eyes still on Red and Gilly, answered loudly. "Jew Defense Organization or something like that. They're not like most Jews. They like to fight. They've even been known to assassinate their enemies. Almost like real people. Almost like white men. See, they're the military arm of the ZOG."

Oh, right. There was that secret Jewish government again.

Gilly shook her head and laughed. "You're crazy, Red. JDO!"

I jumped right in. "How about a couple of the women take her back to the club, into the rest room, and check out this tattoo thing? Rosie? Leslie?" If there was no tattoo, Rosie could take Leslie down and Gilly could run.

Red shook his head. "Here. Now. Take off your pants." He was really into it. He couldn't wait. He was practically licking his lips.

"Fuck you."

Red lunged at Gilly and fell with her to the sidewalk, turning his fat gut into dead weight and pinning her down with it. Gilly struggled, bucking, and Leslie ran to help Red hold her down. Between them, they had her overpowered, and Leslie managed to unzip her pants. I noticed Red had his groin pressed hard against her rump. He caught his breath and wheezed, "Royal!"

"Yeah?"

"Royal—you get your ass over here and you pull off this bitch's pants."

Royal hesitated. Deeanne was clinging to him, her mouth open.

"Now!" Red yelled. Royal pushed Deeanne away and did as he

was told. Red, the horny bastard, slid upward, wriggling, and straddled Gilly's back, holding her arms. Royal yanked her pants down to her ankles.

Gilly didn't have a tattoo. Rosie and I caught each other's eye. How long should we wait before we blew our cover and started kicking ass? What if Gilly was just a Nazi who lied about tattoos?

Red heaved himself to his feet. "Get up, Gilly. We're gonna go someplace and talk now."

She stood, glared at Red, turned her back, and yanked up her pants again. She also dipped a hand into her jacket pocket.

And turned around pointing a small handgun at Red.

"I ought to kill you right here."

He stared at her. You could see that dull brain spinning behind the piggy little eyes, trying to decide how to handle this. He went with contempt—a choice I would not have made.

"You won't shoot. You'll turn around and run like a Jew, won't you?"

Gilly licked her lips, as if she were tasting blood.

I was a mass of ambivalence. Was she or wasn't she? If Gilly was a ringer, that might take some of the suspicion off Royal and me. On the other hand, if Gilly was a ringer, I wanted her to get away. In any case, I might enjoy seeing her shoot Red.

Just as I was juggling all those feelings, Leslie jumped Gilly, who fell to one knee. She was still holding her pistol but was distracted long enough for Red to get to her and disarm her, beating Floyd by a yard or two. I ran toward them, hoping to get in the way, but Royal was there at the same instant, stumbling, colliding with Red. At which point, Gilly sprang to her feet, kicking out and scattering Red, Leslie, and Royal, and ran. Floyd ran after her.

"I'm going to find you, Jew-bitch, and I'm gonna kill you!" Red screamed in rage and frustration, nursing what appeared to be an injured ankle.

"Come on, Red, let's get you inside and have a look at that, get some ice on it," I said. Whoever she was, I was glad Gilly had gotten away. And I was feeling a lot better about my attraction to her, too. I kept remembering what she'd said about how she balanced books: credits, debits, credits, debits…

"Nice try, Leslie," Red muttered. "You did better than Royal."

"Yeah." She gave Royal a nasty, scary smile. "You kinda got in the way, didn't you?"

"I tripped."

I cut loose. "For Christ's sake, lay off him. You know who the spy is now—Gilly. Not Royal! You got JDO in the Command, it shouldn't be too hard to figure out who's been making trouble."

Red was shaking his head. "I don't think Gilly knew about Switcher."

"I thought almost everyone knew."

"No. Warriors. Inner Circle. A few other people. But not Gilly. Pete didn't trust her."

Shit. I didn't know whether Royal had interfered purposely or had just been clumsy in a try at winning back some approval. But either way, it was obvious he wasn't going to be winning any Warrior of the Month plaques any time soon.

Royal and I helped Red through the door and back to his chair. Leslie fetched some ice in a plastic bag. Red crossed his injured ankle over his knee and plopped the ice bag on it, wincing.

A few minutes later, after the entire scene had been gone over at least twice with grievances, Floyd came back.

"She got away."

"Shit." Red spat on the floor.

Floyd shook his head, glowering. "Guess you were right. Guess she was a ringer."

"Shit. I coulda had her."

Floyd sighed. "I thought I did. But someone got in the way. You. Like playing the outfield. You got to call the ball."

Red pulled a flask out of his jacket pocket and took a long swallow. "This ain't baseball, you dumb fuck. This is war."

Which just happened to be the theme of several more of the songs performed by the Killer B's that night.

We sat through another hour of the Killer B's, although Floyd was pretty antsy and Red and the warriors seemed to be doing as much huddling as listening. Gilly was going around and around in my head, and all I really wanted to do was get the hell out of there and talk to Rosie. Finally, it was over.

"Well, that was sure enough excitement for one night," I told Floyd as we left the club. "Great music, though."

He grunted.

Out on the sidewalk, Royal and Deeanne said good night to everyone. Only Rosie and I answered. A group of five kids standing near the door—Zack, Skink, Washburn, Leslie, and one of her friends—watched them walk to their car, muttering among themselves, looking dangerous. Leslie had accused Royal of getting "in the way" when they were trying to recapture Gilly, and I guessed she'd gnaw on that bone for a while. The others seemed only too willing to gnaw it with her.

Royal's current disfavor was like a rock rolling downhill with no one in the Command willing to step in its way. It didn't seem to matter that he was still acting like one of the boys. It didn't seem to matter that they'd just unmasked a spy. That even if they couldn't necessarily suspect Gilly of the Switcher leak, they could suspect her of killing Ebner.

ZOG. JDO. RSVP.

Maybe, once they had time to cool down and think it through, they'd take some of the heat off Royal. But they were acting like they just wanted to punish someone. Gilly had escaped and he was the next best choice.

At least I could console myself that I hadn't been lusting for a

Nazi, after all. That was a relief. Of course, it was also possible I'd been lusting for a killer, but Ebner probably really needed killing, and if she did the job, I wasn't so sure I should hold it against her.

Floyd, still silent and tense, dropped us off at my car where I'd left it outside Thor's.

Rosie and I piled in, happy to be on home turf, even rolling home turf. We could hardly get the words out fast enough.

"Do you think she really was JDO, Jake?"

"I hope so. Makes me feel like less of an asshole—do you think Royal got in the way on purpose?"

"Yeah. I do. I'm almost positive he didn't trip by accident." I thought so, too. Which meant I was not a total fool on two counts—Gilly was not a Nazi and Royal was worth saving.

My car phone gurgled. I picked it up, expecting Royal to be on the other end.

"Hello. This is Harry George." There was that slow, pleasant voice again.

"George! I'm glad you got back to me."

"Tell me what you're doing. What's going on." I noticed he didn't bother to give a reason for his delay in calling back. Was it an FBI motto? Never apologize, never explain…

I filled him in on our infiltration of the group, and brought him up to date—all the way to Gilly's discovery and escape.

Then, a question he probably wouldn't answer: "What about this Gilly Johns or Milly Levine? Do you know anything about her?"

"I couldn't tell you if we did, Mr. Samson."

"Was she your agent?"

No answer.

"Do you have an agent in the group?"

"Mr. Samson, we cannot infiltrate any political group unless we have proof of criminal activity. It's frowned upon. It's not in the budget."

Uh-huh. It was frowned upon in the Sixties and Seventies, too. But not by the FBI.

"Are you saying you didn't and you don't? Have anyone in there?"

"Our policy is clear." Double-talk.

"What about the plot to kill Preston Switcher? Isn't that criminal?"

"No one has done anything."

"What about the murder of Pete Ebner?"

"I'm sure the police are involved now, since there's been a homicide. And I expect you to keep me informed of your activities."

"My activities?"

"Be careful, Mr. Samson. These people are dangerous." He rang off.

Thanks a lot, Hairy George, you stuffed monkey.

"He didn't tell you anything, did he?"

"Nothing. Which makes me think there's something to tell."

"I'll talk to Pauline about Gilly. Johns? Was that the last name she was using?" I nodded. "And Milly Levine. Maybe she can check on those names. Maybe she can find out something about her. If she's JDO, the cops might know that. It's a pretty militant group."

I dropped her off and drove home, feeling jangled and exhausted all at once. Questions plagued my mind, but my mind was just too tired to answer them. I took a couple of aspirins and a warm glass of milk and fell onto the sheets, shedding underwear. I slept hard for a whole hour. Then the bedside phone rang.

"Jake! You've got to come!"

The words were slurred and wet with hysteria, but I recognized Deeanne's voice. "He's hurt. They really did him."

Where are you, Deeanne?"

"Marin General. Emergency."

"I'll be right there."

Before I put my clothes back on, I made a quick call to Rosie, who said she'd meet me at the hospital, and another one to Art.

"Thought you'd want to know—Deeanne's boyfriend is hurt. He's in the hospital."

"Don't call him her boyfriend. And the way I look at it, you play with fire, you get burned."

"Artie, she's with him, and she sounds like she needs a shoulder. Yours is better than mine."

He was silent for a moment. "What happened?"

"I don't know that yet. Sounds like someone beat him up."

"Big surprise. Okay. Where is she?"

I told him and dressed quickly. The hospital was only ten minutes away, and only a little more than half an hour elapsed between Deeanne's call and my arrival at Emergency.

I asked the nurse at the desk where I would find Royal Subic. She told me to wait in an ugly, uncomfortable, blue plastic chair. I did as I was told. Nurses intimidate me. She went into one of the little side rooms—examining? treatment? The rooms where they take you when you've just fainted in a gourmet restaurant or gotten shot on a street corner. While I was waiting, Rosie came in.

"Your T-shirt's on inside out," I told her, pointing at the label hanging off the collar. It was a union label.

"Good. Why are we sitting here?" I told her we were waiting.

In a couple of minutes, Deeanne came out. Her eyes were red and her nose was running, but I didn't see any marks on her, at least. She came to me and huddled in my arms like a six-year-old,

crying again. I patted her shoulder and said, "There, there" several times before I sat her down on one of the plastic chairs, said Artie was on his way, and demanded that she pull herself together and tell me what was going on.

Before she had a chance, the nurse returned. "If you're James, he wants to see you."

"Jake?"

"Maybe. He's having a little trouble talking." She held out an arm to bar Rosie. "Wait a minute. Who are you?"

"I'm his sister." The nurse dropped her arm.

A doctor was working in the room. He was just putting a suture needle down on a tray. Royal was smeared with blood, mostly around his mouth and down his chest. His lips looked like hamburger. His right cheekbone was purple. Blood spotted the floor and the paper cover on the table where he lay.

Deeanne had followed us in.

"James?" the doctor asked.

"Sure." James, Jason, Jake—they all started with *J*, anyway.

"He says he wants to talk to you, but I don't know how he expects to do that."

Royal opened his mouth and blood trickled out. He mumbled something and a piece of tooth fell off his chin.

"Don't try to talk," I told him. "Just nod. Or Deeanne can answer."

"I'm going to have to keep working on him." The doctor pointed at a note sitting on the counter top. "He wrote this, by the way. You might try to convince him to tell the truth."

The note, written on a hospital memo pad, said, in shaky capital letters, "I fell."

I'd caught something in the young doc's voice and looked at him closely for the first time. He was pissed off, his jaw rigid. His eyes slid toward the unbandaged swastika on Royal's arm, then back up to meet mine. I didn't know what to say. I'd forgotten the thing was there. This doctor probably should have tried to forget about it, but couldn't seem to. Then he took a breath and he was back to business, asking Royal to open his mouth for another look.

"The kid's okay," I said lamely. The doctor didn't look up. Then to Deeanne I said, "How did you get him here?"

"Drove him. In his car."

"So you didn't call 911?"

"He wouldn't let me."

"Uh-huh." The no-cops rule. I turned to Royal. "Who did it, Royal, your buddies or someone who didn't like your political affiliation? Wink once for buddies, twice for violent liberals."

The doctor's head only partly obstructed my view of Royal's face. He winked once, or maybe he just closed his eyes.

The doctor straightened up and stepped away from the table. "Going to need major dentistry, too. I'll be right back." He slid a wad of packing into Royal's mouth and left the room. I took the opportunity to open a couple of cabinet drawers, find gauze and tape, and slap a cover on the tattoo. The last thing Royal needed right now was to have a pack of pissed-off doctors messing around inside his mouth.

The kid looked groggy and unfocused, his eyelids drooping. I didn't know whether the disorientation was caused by painkillers or concussion, but decided to abandon the answer-me-with-a-wink idea for the time being.

"Deeanne, were you with him when this happened?"

"Yes." She started crying again. "They were all—"

"They who?"

"Some of the guys from the Command. Zack was there. A couple of others."

"Just the kids?" Not Red? Not Floyd?

"Yeah. Just the warriors."

Warriors. Cannon fodder. Pawns. Hit men for cheap.

"What did they say to him while they did it? I mean, were they yelling stuff like, 'You killed Ebner!' or were they just calling him a traitor all the way around, or what?" She shrugged and looked at Royal. He grunted and looked frustrated.

"Did they say anything about me? Or Rosie?"

"I don't think so." Clearly, Deeanne had not been listening to the warriors, or registering what she heard. She had probably been screaming. But I kept trying.

"Did they say anything about Gilly?"

Deeanne pounded at her temples with both fists. "I'm so sorry, Jake. I just don't know. I was so scared." Rosie put her arm around

the girl's shoulder and gave her a hug and a pat. That just made her cry more.

Royal gurgled. I turned back to him. "Let's try something else, Royal. Raise your right hand for yes, left for no." Maybe grosser movements would work better. "Did they say something about Gilly?"

He raised his right hand.

"Oh, yeah," Deeanne said. "Now I remember that part. I remember. They were all, 'That Jew killed Pete Ebner and you helped her get away!' And they said maybe he helped Gilly do the killing, too."

Royal raised his right hand again. Artie stuck his head in the door and Deeanne wailed and ran to him. I was glad I'd gotten the bandage on Royal's arm before Artie saw the tattoo.

Rosie continued my yes-and-no interrogation, which Royal seemed able to handle.

"Are you being kicked out of the organization?" He raised both hands.

"Does that mean you don't know?" Right hand.

Through a series of questions, we learned that they had beaten him up for probably being the snitch, maybe killing Ebner or helping Gilly do it. Maybe working with Gilly the whole time. But they weren't sure about any of it.

His friends had just wanted to beat him up for something. Anything. If not for killing Ebner, then for helping Gilly do it. If not for aiding and abetting, then maybe for ratting about the group's plans for Switcher. And if not that, maybe just in case he was thinking of doing something wrong.

A little skirmish among buddies. A disciplinary action.

Rosie asked: "Did they threaten to kill you?"

He raised his right hand. Yes. But here he was, more or less in one piece. So they weren't ready to kill him. They wanted to hurt him and scare him and maybe scare someone else. Whether he did any of those things or not, he was a good scapegoat, an example for whoever might have done them. At least that seemed like what might be going on, but with these people, who the hell knew? I looked at Royal's red and purple face and felt cold, disoriented, and depressed, like when you fall asleep in the tub and wake up an

hour later. How could we figure any of this out? How could we have any idea of what they were going to do next and who they were going to do it to? They were nuts and they were stupid, and rational, reasonably bright people couldn't hope to make sense of what they did.

The doctor came back with a friend. "I'm going to ask you all to leave for a while, okay?"

"Is he going to be all right?" Artie wanted to know. The doctor nodded.

"He'll live, if that's what you mean." From his tone of voice, he made it clear he wasn't sure if that was a good thing.

We trooped out to the waiting area. I put a hand on Deeanne's shoulder, and she turned toward me.

"Dee, how did they do so much damage?" He looked like he'd been beaten with crowbars.

"They curb-stomped him, Jake."

"What's that?"

"It's a skin thing."

We waited.

"What they do, see, is they lay a guy down and make him open his mouth and bite the curb." A fresh burst of tears. We waited. A moment later, she'd recovered enough to say, "Then they kick him in the head."

I must have closed my eyes, because the image was printed in my mind in red, on a black background. All my teeth ached.

That would certainly explain the damage to the inside of his mouth.

Rosie had closed her eyes, too, but she hadn't opened them again. Artie was whiter than usual.

"He bit his tongue," Deeanne wailed, "and a bunch of his teeth are gone, and…"

The doctor came out to the waiting room.

"I've got him all stitched up now. Any of you a parent?" The way he said it, cold, tight, wary, someone was responsible for raising a Nazi.

"No," I said. "But that's a good point. Deeanne, give us his parents' number. They should be called."

"I'm going to have to keep him here tonight, under observation—he got a pretty substantial kick to the head. I think he'll be okay, though. If he stops hanging out with the wrong crowd." The doctor looked at me sternly.

I wanted to tell the man not to be so smug and self-righteous, to clean up his own medical corner of the world and go fight the HMOs, and the doctors who keep scared patients waiting for an hour while they talk to their brokers on the phone, and the ones who are in such a hurry to make another buck they cut off the wrong leg. But I really couldn't blame him for his attitude, under the circumstances, even if I wanted to.

"I'm not his father, remember? Deeanne?"

"He lives with his dad and stepmom. But Royal doesn't want anyone having their number."

"Deeanne, they have to know where he is." Rosie spoke quietly, but her authority was clear, and Deeanne caved in and wrote down the number.

There was a pay phone in the hall. It was a good ten rings before someone answered. This was, after all, two in the morning, and not everybody leaps out of bed at the sound of the phone like I do. Or like I think I do. The voice was sleepy and female.

"What!" it demanded.

"Mrs. Subic?"

"Yeah. What?" She was a bit more awake, and sounded worried.

"Mrs. Subic, I'm a friend of your son's—"

"Why are you calling us? I don't want to talk to you." Now she sounded scared.

"Wait! He's in the hospital. Emergency room. He's been beaten up pretty badly and he'll be in here at least through the night. I thought you should know. He's at Marin General."

"I think you better talk to his father."

This time, the sleepy voice was hoarse and male.

"What's going on?"

I repeated what I'd told his wife.

"I'm a sick man. I can't take much more of this. He's going to be all right, you say?"

"Looks that way. Much more of what?" Had Royal gotten beaten

up before? Had they been awakened before at two in the morning?

"Damned kid. He's crazy. Always up to some kind of trouble. He didn't steal a car or anything, did he?"

"No."

"And he's going to be okay, he's just beat up?"

"Yes. But pretty bad. He's here for the night, at least."

"Well, then, I guess we'll see him tomorrow. Tell him to call if he needs a ride home." And the man hung up.

I wanted to give the message to Royal himself, but the nurse said he was resting, whatever that meant. She took down the information.

"Okay, Deeanne," Artie said, "Time to go home."

"I want to stay here. I can take him home when he's ready."

Artie sighed, and thought about it. "How many days of school you missed lately?"

"Artie!"

"I think you better stay away from him for a while."

"Artie!"

He grunted. "Okay, you call here first thing in the morning, early, and if he can go home you call Jake or Rosie and they go with you to take him home. That way you'll be protected. Then you can go right to school. Okay with you guys?" Rosie and I said it was. "Early, though, Deeanne. So you can get to school on time."

She nodded, then abruptly, awkwardly, kissed Artie on the cheek.

Before we all went to our separate cars, we told Artie some of what had been happening. He was especially interested in the story about Gilly.

"Be a real kick in the pants," he said, "if half the people in the Command are Jewish spies."

Rosie laughed and shook her head. "I don't think we're that lucky."

Driving home, I thought about Royal's parents and their reaction to the news that their son had been beaten. They'd sounded mostly nervous, maybe even scared, and only half-concerned about the kid. I wondered if they had started out that way or if he'd pushed them over the edge.

I couldn't worry about his family relations now, though. I'd had an hour of sleep, and Deeanne would be calling early in the morning for help in carting Royal home.

After a mile or so, I noticed that a distinctive set of headlights had been lighting up my rearview the whole way. Distinctive in that one of them was dimmer than the other. The car was big. It looked a lot like Floyd's Camaro, but the street wasn't very well lit and I couldn't be sure. Were his headlights messed up this way? I'd never noticed them. Sloppy work on my part. It wasn't strange that someone coming from the vicinity of the hospital would turn up Drake, the only main street around. The question was: Would he stay on Drake and keep going if I turned off onto a side street?

I sped up, passing College of Marin, passing the Art and Garden Center and the gated estates of Ross. The headlights dropped back. When I got to San Anselmo, I turned a corner, then another, wandering through downtown. Then I cut over to Center Road and headed toward Fairfax. The headlights stayed with me. Had to be Floyd. Who else would be following me? I went straight through Fairfax and back onto Drake, hung a fast right at the gas station, left again, cut my lights, and pulled into a dark driveway. It was a wonder, through all that, that the alert Fairfax cops hadn't stopped me for speeding or driving stoned.

The car was nowhere in sight. Had I really lost him? I waited a while. Nothing. I pulled out of the driveway and cruised, watching the rearview, back to Drake and east again to my own street. No uneven headlights. No Camaro. The only other car moving on the street was a VW bus that still had its flower decals. Not a Command kind of vehicle, unless they were slicker and sneakier than I thought they were.

Even so, I was nervous. After I got in the house I stationed myself by the front window and watched for half an hour.

No uneven headlights. I went to bed.

D eeanne called me at six o'clock. I'd been asleep for maybe two hours.

"He wants to go home. Can we do it now?"

"Sure. I'll pick you up."

"I'm at the hospital."

She had slid around the letter of Artie's instructions. He had told her to call the hospital in the morning, call me, and then go to get Royal with me or Rosie. I'd seen Artie take her home; I wondered how long she'd stayed there before she'd turned around and gone back to Royal's battered side.

"See you in a few minutes," I told her. "Need some coffee or something."

I could have just gone by myself, but it occurred to me that this would be my first sight of Royal's parents and his home, and I wanted Rosie's sharp eyes along. I called her, waking her up, and told her I'd be there in ten minutes. She said, "Glmf." I mentioned that I thought I'd been followed the night before.

She yawned. "Okay. I'll pick you up, then. I'll drive. That Falcon of yours is just too damned distinctive."

Which no one would ever say about Rosie's white Ford Taurus. A car favored by cops, PIs, and other people in hiding.

This morning, Rosie informed me as I stepped into the Taurus, she'd decided to carry a gun. The thing was, she said, she wanted to be sure that if any warriors were waiting outside the hospital or outside Royal's house, she'd be able to convince them we didn't need a lesson in skinhead justice, curb-stomping style. She had also been negatively impressed, she said, with their treatment of Gilly.

In order to carry the weapon, she was wearing a little ou' she'd ordered from a catalog of "fashions for the gun-ca

woman." Slacks and a blousy jacket that had a concealed, lined pouch made to hold a handgun.

Honest. There's a catalog.

She's been trying to convince me to get a weapon, too. Maybe one of these days I will.

When we got to the hospital, Deeanne was sitting beside Royal's bed, but he wasn't in it. The toilet flushed and he came out. He didn't look any better than he had the night before, but at least he was ambulatory.

The eye above his purple cheek was swollen shut, and bruises I didn't remember from the night before had bloomed beneath the dirty-looking stubble on his square Aryan jaw. His arms below the T-shirt's sleeves were scraped. His lips were scabbed. He nodded to me, picked his jacket off the back of a chair, and indicated with a slow movement of his hamburger head that he was ready to go. That was when I saw the bandage on the back of his skull. At least the prep work had been easy—no hair to shave. I thought of mentioning that, but didn't think either he or Deeanne would find it funny.

I held up a hand—wait a second—picked up the phone, punched 9 for an outside line, and called his parents' home.

The father answered.

"I talked to you last night, Mr. Subic. Royal is coming home now. His girlfriend Deeanne, and I, and my friend Rosie will be with him." There was a tense silence on the other end.

"Listen, Mr.—what's your name anyway?"

I remembered that Royal had told me his folks had no connection with the Command, didn't know it existed as a group, and that they hadn't liked the warriors they'd met. So I told him my name. Another silence. I wanted to see the inside of Royal's home, but his father needed reassurance before that was going to happen.

"Mr. Subic, you haven't met me. I've been trying to help your son ʼeak away from that bad bunch of punks he's been running with."

"You some kind of social worker?"

"ʼot exactly." I let him chew on that.

ʼn, a sigh. "Thank you. We'll be eating breakfast. I'm sure we ʼ enough for everyone."

"That would be very nice."

I was curious about these people, about anyone who had raised a boy like Royal: ignorant, easily conned by bigots, stupid and silly, but still, underneath all that, and somewhere inside that thick skull, brave and even capable of shifting gears once he figured out which end was up. I was curious about this father he seemed ashamed of, too. Sounded like a decent enough guy—shut-off, scared, but okay.

Royal showed us with gestures that his head hurt and he didn't want to drive, and Rosie said that was probably best anyway.

"If the warriors are keeping an eye on you, it's just as well that your car stay parked near the hospital for a couple of days, so they think you're still here."

Of course. Rosie's always thinking. I told him we'd drive his car over to his house later in the week. Deeanne hadn't had any trouble finding a parking spot close to the entrance when she'd arrived at who-knew-what hour, so Rosie and I watched them get into Deeanne's old Corolla and told them to wait, locked in, until we pulled our own car around. We got the Taurus and followed them out of the hospital lot, down Drake to the freeway, and north to San Rafael.

The Subic house was located in the Canal district, an area where you could open a body shop, find a cheap apartment, motel room, or homeless shelter, buy a boat, or drive through on your way to an expensive development. A California bungalow: small, pink, and stuccoed.

The woman who came to the door was tall and thin, wearing a blue paisley granny dress faded enough to be an original. Her graying hair was long, straight, and parted in the middle. She didn't have any flowers in her hair, but I had the feeling that if I squinted and clicked my heels three times I'd be transported to Golden Gate Park, 1967. I was reminded of the sellers of the cottage-and-cottage I wanted to buy. People of the time warp.

She stared at Royal's face, whimpered, and touched his shoulder tentatively.

"I'm okay, Mom."

"Oh, good." She looked happy to believe him, and turned to greet Deeanne pleasantly. Clearly they'd met before.

"And this is Jake and Rosie," Deeanne said. "They're detectives." Well, that cat was out of the bag and running around the living room, screeching.

She shook her head sadly. "That's such a violent thing to do for a living." In an abrupt non sequitur, she added, "Please join us for breakfast."

We followed her through the small, expensively furnished living room—the Persian rug looked real—and into an even smaller dining room that was stuffed with a gleaming sideboard, mahogany table, and six chairs. The table was set with blue-patterned dishes that looked pricey and silverware that, unlike mine, actually seemed to be part of a set and actually looked like silver. Mrs. Subic waved vaguely at the table, heading through the doorway to the kitchen and saying she'd "be right out."

The man of the house appeared next, shuffling down a hallway that I assumed led from the bedrooms. He couldn't have been much past his mid-fifties, but he was a tattered, potbellied, stooped version of his son, dressed in baggy gray pants and a gray seersucker shirt that sagged on his round shoulders. The same square jaw was just visible under the drooping skin. The watery pale blue eyes were resting, loose-lidded, in a bed of fine wrinkles.

He patted his son's shoulder, barely glancing at the cuts and bruises. "I want to thank you for trying to help Royal," he said, rubbing his lower back and sitting himself down at the head of the shiny table.

"Our pleasure."

Everybody else sat down, following his lead. Everybody but me. I went to the door of the kitchen and asked the woman if there was anything I could do to help. She smiled blandly at me and shook her head, waving me back into the dining room. But before I went, I took a long look at a roomful of big, gleaming, new appliances, and a tiled cooking island hung with copper-bottomed pots and pans. The dishwasher was one of those top-of-the-line models with a control pad that looks like a computer keyboard. The refrigerator was huge, with glassy black double doors, and had an ice dispenser.

This was a very weird house and a weird household, too. A low-end bungalow in a low-end neighborhood. With tens of thousands

of dollars in furnishings. With a father who looked like a laborer and a mother who was a flower child gone to seed.

I sat down next to Rosie. Mrs. Subic—I'd never heard a first name—brought in a chafing dish full of scrambled eggs and a basket of buttered toast. She smiled and set them down, returning to the kitchen and coming out again with a silver coffeepot that could have been made by Paul Revere himself. Maybe it was.

"Guess what they do for a living, Martin?"

"Social work?"

"They're detectives."

He digested that for a full ten seconds, sighed, and took a piece of toast. Either he wasn't impressed, didn't care, or didn't want to know about it before breakfast.

The food was good, and I, for one, was hungry. I scooped some eggs onto my blue and white plate. These dishes sure looked like the real thing to my unschooled eyes. Even I am not nervy enough to pick up a host's dinnerware and look at the name on the bottom, but I ran a cautious finger around the rim of my cup and it rang like a bell. Rosie watched me do it. Then she picked up her own still-empty cup and waved it around, gesturing in the general direction of the sideboard.

"This is a lovely house," she said.

She was good. I was probably the only person in the room who noticed she was reading the bottom of the cup.

"Thank you," Subic answered. "We like it." For some reason, maybe the condition of his son's face, maybe not, he looked terribly sad.

"Yes," Mrs. Subic said. "We love it here. It's a nice working-class neighborhood. The people are the salt of the earth. We're a working-class family, and we like to be among our own." A sudden memory hit me. The Brit Thunderskin web page had ranted about being working-class. Amazing how the same term could mean such different things.

Royal groaned. I couldn't tell if it was because of what she'd said or because he'd tried to eat with his curb-stomped, ruined mouth.

"Don't mind my wife," Subic said, rubbing his back again, sighing, and grimacing.

What do you say to that?

"Are you all right, Mr. Subic?"

"It's just this back of mine again. Hurt it on the job. Disability." They weren't living on disability.

"Oh. I'm sorry. What kind of job?"

"Teamster. Twenty years." They weren't living on union retirement benefits, either.

I ate the eggs. They were pretty good. But I hadn't missed the hot, angry look in Royal's eyes when his father talked about his working days, and the injury that had ended them. I was remembering that edge of anger I'd first heard when the boy talked about his father's money.

And I wanted to know where all this family's money came from. The cash that Royal had given me. The money hidden in expensive furnishings inside a cheap little house.

We finished breakfast, and Deeanne gave Royal a sad little kiss on an undamaged part of his forehead. Mr. Subic thanked us again for bringing his son home, and for helping him. He might have been talking only about the fact that we'd been at the hospital the night before and had brought the kid home this morning, or he might have been speaking more generally. I couldn't tell, and he didn't ask any questions or make any statements about how else we might be helping.

Mrs. Subic just smiled at Rosie and me like a tripping hippie.

As we were walking out to the curb, Rosie whispered, "Wedgwood."

I stopped Deeanne before she got into her car. "What's with that house, Deeanne?"

"What do you mean?"

"The money. Royal says his dad has a lot. You can see it in the furniture, the dishes, the silver. But they live in a poor little house in a lower-middle–class neighborhood."

"Oh, yeah. That's because of the robbery."

I stared at her.

So did Rosie. "Robbery?"

"Royal told me. He really hates it, but he told me because he trusts me. See, back when his dad was working, he didn't like some

stuff that was going on in his company. They were, like, hiring women and blacks and he, like, wanted more overtime. Or something like that. I don't know. It wasn't, like, real, real clear. But, you know, he was all, 'I'm gonna lose my job to a woman' or something. And he went out and robbed some places, or some guys did—I don't exactly know, but he got a lot of money and then he pretended he hurt his back and quit working. About ten years ago. He's pretty old."

"What kind of place did they rob?" Obviously, they'd made a nice haul.

"Oh, Royal says it was a bunch of stores, big ones. Places they knew because they drove trucks, you know? Not here. Someplace else. Some city. Maybe in Los Angeles? I don't remember. But nobody ever got caught."

"And he's afraid to display the money outside the house." No wonder Royal was cop-shy.

"I guess."

"And he's still pretending he hurt his back and even seems to believe it now himself." Or maybe he was crippled by guilt and fear. The father and son seemed to have a lot in common.

"Yeah. Royal says he knows his dad's got a whole lot of cash stashed somewhere, maybe buried. Digs it up or whatever, every few months. Wicked, huh?" She half smiled. Yes, there was something funny about the situation, but it worried me that she saw it that way. I was still trying to get my mind around the story when Rosie answered her.

"Yes. Wicked." Rosie didn't smile. "And Royal isn't too happy about the stolen money, is he?"

"He hates it. But he uses it. You know, he goes, it's kind of hard not to."

The story went a long way to explain some of Royal's problems. A boy could grow up pretty confused in an atmosphere like that.

"Who knows about the money, Deeanne?"

"Well, Royal's real careful about it. But you know, now that you bring it up, you're making me remember something. Like maybe he told Zack, too. Because when they were, you know—" she bit her lip and a sick look flashed across her pale face "—he came back

for a second and leaned over Royal and said, 'You better be glad Pete didn't believe in stealing, even from robbers. But, like, Pete's dead now.' Or something like that."

Terrific. I wondered how long he would honor Ebner's wishes. I could just see it—the Aryan Command swarming over that little stucco house with shovels, looking for buried treasure.

"But don't say anything to anyone about it, okay? And could you not tell Artie I was already at the hospital?"

Aha.

"Deeanne, you're taking too many chances. I don't think you understand how dangerous this is. I want you to stay away from Royal's house. When he gets better, you can meet him somewhere if you're careful. Promise me now, or—" Or what?

"Okay. I promise."

She seemed to mean it.

J ake, Deeanne's not going to stay away from Royal," Rosie said as we drove away from the Subic house.

"You're probably right."

"She's got this 'Teen Angel,' 'Leader of the Pack,' 'My Guy' mentality."

I could hear all three songs in my head. They were coming from a radio at a drive-in where my dad took me for lunch every Saturday when I was a little kid. The place was full of teenagers in their Chevy Bel Airs and Ford Fairlanes, their hair in ponytails and DAs, their hearts, I later realized, full of romantic tragedy. No accident that Romeo and Juliet were adolescents. Deeanne probably thought she was willing to die for Royal. Nuts.

Rosie was right, no doubt about it. Artie was going to have to watch Deeanne, maybe even send her away somewhere until this was over. "Let's go talk to Art."

"Can't, Jake. Got to pick up Alice at home and get to the office by nine. There's a prospective client coming in."

Oh, right. She wasn't just my partner in this fiasco, she was the CEO. With any luck, we'd be needing more clients soon. Maybe it was better this way anyway. Artie Perrine and I had been friends for a long, long time, from way back in the days of my divorce, way back to my first few California years. We could talk one-on-one and figure things out. Possibly.

Rosie dropped me off at my house and I called Artie. His wife, Julia, answered.

"Jake! Honey! You're such a stranger!" That was Julia's way of saying she hadn't seen me for a couple months. She'd never lost that New York accent of hers, and she'd never lost the East Coast big-city attitudes that went with it. Straight out, tell it like it is, take

the offensive before someone takes it away. Chicago people have some of the same kind of edge, but our speech and our actions are softened by Midwest caution. And I think it's easier for us to turn into Californians, too.

I promised her we'd set up a double date for dinner soon. Before she could start interrogating me about the woman I was planning to bring, I told her I really needed to see Artie—was he home or at the magazine office? He was home, she said, but she didn't call him to the phone—she yelled, "Artie! Jake wants to come see you!" I heard a vague background mumble and then she was back on the line. "Sure. Come on. See you soon."

I headed for 101 south, and Mill Valley.

Artie and Julia Perrine, their son Mike, now a Berkeley freshman, and occasional assorted visiting relatives lived in a redwood canyon just outside the Mill Valley city limits in southern Marin. Once, a few years back, I'd spent some time in that canyon figuring out who killed a guy. The cops thought Artie's visiting nephew was the best suspect. So did some of the neighbors, and an odder assortment of woods-dwellers you couldn't hope to meet.

I parked in the lot at the bottom of the canyon and walked up the narrow path, and then the steps, to Artie's house. Not much fun when you're carrying groceries, but a good way to stay in shape, which Artie still never managed to do. He'd once had to pay a crew triple wages to do some foundation work, just because they had to carry the sacks of concrete all the way up.

The house was redwood and glass with two decks and two fireplaces. It was worth the walk.

Julia opened the door for me and gave me a big, wet smack on the cheek, calling me a schmuck and all the other affectionate terms she reserved for people she loved and didn't see often enough. I promised to hang around more. She told me I had to "do something" about Deeanne.

Before I could even try to answer that, Artie wandered out to meet me carrying a sheaf of papers. He was wearing a brown hooded sweatshirt that, along with his top-of-the-head bald spot, made him look even more like Friar Tuck than usual.

"Listen," Julia said, "I'd love to put in my two cents' worth but

I've got a meeting. You know where the coffee is. There's some pineapple upside-down cake, too."

I don't know anyone who makes or even eats that anymore—except for Julia and Artie.

Artie led me back to his home office. Stacks of paper-clipped manuscripts and notes and magazines and newspapers on the computer desk, the computer, the bookshelves, the tables. More magazines and books piled on the floor. He lifted a mesa of *Probe* magazines off a wooden straight-back chair and told me to sit, planting his short round self in his own padded swivel.

"What's happened now?"

"We took Royal home."

"Deeanne went right back to the hospital, didn't she? The minute I fell asleep?"

"Probably."

"And what else?"

"Nothing much else, but you're going to have to use a stronger hand with that girl, keep her away from Royal." Easy for me to say. "She was lucky last night. They could have taken it into their bald heads to beat her up, too, just to punish Royal even more."

"Yeah. I know. Julia and I were talking. Maybe I'll take away her car." That would be pretty effective. Sure, there was public transportation in Marin, but I'd never figured out how anyone got anywhere on it. But then I had to admit, maybe that was just me. I hadn't taken a bus since I'd left Chicago.

"How about sending her away for a few weeks?"

"She's got school. And I don't know where I'd send her. And how would I know she'd stay where she was put? She'd be running after Royal again in two days. She might move in with him, for God's sake."

"She couldn't move in with him. He lives at home with his folks, and I don't read them that way. Though they seem to like her."

"She might rent a room near him. I'd have to go find her and bring her home again."

"Take away her money." Royal would probably give her all the cash she wanted, but maybe she wouldn't want to take it. Then again, maybe she would. "I'm doing what I can, but I'm not so sure

Royal isn't going to end up dead. She hangs around him, she gets caught in the crossfire."

"I'll take away her car and her money. Did she get to school today?"

I told him she'd been on her way the last time I saw her, and that Royal had probably just wanted to crawl into bed and pull the covers over his head.

"I'll call school. Wait."

It took him five minutes to find the school number in the book, then he punched it in. They wouldn't tell him if she was there, so he tried it another way. He said there was a family emergency, that he was her godfather and he needed to talk to her. Another ten minutes and she came to the phone.

"No emergency, Deeanne. Not at the moment, anyway. I just wanted to see if you were okay. And tell you to come right home after school so we can figure out what to do to keep you safe." Pause. "Well, you're going to have to think about yourself. I'm not gonna give you any choice." Pause. "I'll see you here by three-thirty, okay? You can call Royal when you get home." Pause. "Good. 'Bye."

He put the phone down and rubbed his eyes. "Well, she still sounds scared. That's a good sign." He looked up at me. "What's next on your agenda?"

"Not sure. Maybe Pauline can give us something on Gilly. Maybe there's something we don't know yet about the dead guy, Ebner, that'll help. The cops'll be watching Switcher. What I need to find out at this point is what the Command's Plan B is. Now that Plan A's been leaked, are they going to go after someone else? The real question is what's next on *their* agenda."

"How you going to find that out? You're not exactly, what's it called, Inner Circle."

That was too true. And now Royal, my only entry to the warriors, was not just out of the loop but also out of circulation. Still, I had a few things I could do if nothing broke on its own. For one thing, I wanted to talk to Karl. He'd warned me about Floyd, for some reason. Maybe he'd tell me what that reason was. And Floyd. My buddy Floyd. If I poked him with a sharp stick would anything leak out? There was also Leslie. Sure, she was a monster, and she

didn't trust me at all, but she'd done more than grunt at me, and I couldn't say that about the other warriors. I was also very interested, the more I thought about it, in talking to Maryanne. She'd be disgruntled about being 86'd from Thor's, and that could be good. I didn't even have her last name. Maybe Leslie would give it to me if I was real tricky.

Artie wished me luck, and I wished him the same.

In the hour I'd been up the trail at Art's house, the trees and the birds had added a few features to my car. I brushed redwood debris off the upholstery, including a few of those acorn-size cones—why do the biggest trees make the smallest seedpods? Or whatever they are?—and used a stick to pry a glob of birdshit off the dashboard. The disadvantages of a convertible. I put the car in gear and headed out between the giant trees, aiming for the road that would take me to Miller Avenue, which would, in turn, take me back to the freeway.

Suddenly, from the right, a familiar green Camaro pulled in front of my car. I was still going slowly enough to stop in time, but the driver just sat there, not moving out of the way. Floyd. A cold wash of adrenaline made my hands grip the wheel harder, but I couldn't go anywhere unless I wanted to back up and try hiding behind a redwood. I yanked the brown wig off my head and fumbled with the glove box latch, which, true to form, refused to release.

He slid out of the Camaro and walked toward me, smiling. I dropped the wig on the floor and planted my foot on it. He was leaning in the window.

"Jason, as I live and breathe. Or is it Jake Samson, I presume?"

"What are you talking about?"

"That's one hell of a funny-looking spider you're squashing down there."

He reached down toward the hairpiece under my foot. I stopped him by grabbing it myself and waving it in his face. The best defense being a good offense, as I've always said. When you're dealing with terminal assholes, anyway.

"What's your point, Floyd? That I shouldn't go out with women who leave their wigs in my car?"

"Nice try, pal!" There was something different about the way he was talking.

"You followed me last night, didn't you? You need to get your headlights fixed."

He laughed.

"Is there some reason I shouldn't be taking care of my cousin? He didn't do anything wrong, you know."

"No reason at all." Still grinning. I kept expecting him to pull a gun and shoot me between the eyes. Maybe Rosie was right. Lie down with gun nuts, get up with guns. Or something.

"Did you sit outside my house all night?"

"Yeah, well, down the street. And I'm tired. I followed Rosie to her place, and checked out the address. Vicente. A PI. And I followed you here. And checked out the address. Arthur Perrine. *Probe*. Not exactly a right-wing publication." Publication. That word was too big for the Floyd I knew and loved. "You a PI or a reporter? Who you working for, friend?"

"I'm working for myself, buddy." My heart was pounding in my ears. I forced myself to stay cool. I was going to keep faking it until I couldn't fake it anymore. Then what he'd just said registered. "You checked out the addresses?" Karl could have, with a computer. But... "How the hell did you do that?"

He reached in his pocket and pulled out a Berkeley PD shield. The ID name was Byron Kern.

I stared at it, trying to decide if it was real. Waiting for the pounding of my heart to stop deafening me, waiting for the images of Royal's bashed face, and my own face looking just like it, to go away. I'd been caught, but maybe not by a Nazi. My vitals began to simmer down.

But still, I thought, stirring up the juices again, maybe this was all part of a Command game, the ID was fake, and Floyd was trying to lull me into a false sense of security so he could kill me. Then again, what did he really have on me? A girlfriend who was a PI? An acquaintance who ran a magazine? That could be enough, if he looked a little closer at both the girlfriend and the magazine. I had to admit neither one of them was a great match-up for an apprentice Nazi like Jason Dormeister.

My heart started pounding again and the adrenaline gushed. I was sweating. My foot reached for the accelerator without my mind telling it to.

Floyd reached in and touched my arm. "It's okay, Jake. I'm undercover in the group. Just like you. Nothing to fear from me."

I wasn't going to fall for that. A phony shield, a phony line, and I'd end up curb-stomped or worse. And so would Rosie and Artie—my God, this bastard knew where my friends lived. I'd screwed up. Royally.

Had I missed any news stories about a Berkeley cop named Byron Kern being killed and robbed of his wallet?

I decided to stay in character. Jason's character. All this back and forth is-he-or-isn't-he was exhausting me. "Undercover, huh? Thanks for telling me, cop. Or maybe I should say 'spy.' I think there's some people who should know about that. I think you just confessed to the wrong person." I could step on the throttle and get the hell out of there....

"Wow. You're good." He shook his head. Sumbitch was making fun of me.

Then, really fast, he reached over the steering column and yanked my keys out of the ignition. I grabbed for his hand, caught his wrist, and held on, hard.

"Take it easy. Jesus! Calm down, would you? Okay, I'm going to stop playing with you—though God knows you deserve it, hanging around with that bunch of killers. Guess you want proof, huh? Proof I didn't buy the shield?"

"Sure—prove to me why a cop would blow his cover the way you just did." I wasn't ready to give up yet, and I was really getting into the sneering.

"I will. Why don't you follow me up to San Rafael? There are some people I'm working with on this side of the Bay. Unless you'd rather go right to my own shop in Berkeley? Maybe that would be better?"

"Are you arresting me? Taking me in for questioning? Do you expect me to rat on someone? I don't know enough about the group to do that. You're the expert, you're the guy on the inside. You're the traitor." If this was a test I was damned if I was going to

fail. At the same time, I kept thinking, Pauline, you screwed up. How come you didn't know about Floyd?

"Yeah. That's right. Guy on the inside. Come in for questioning, will you?" He smirked at me. Jesus, how I hated this smug...cop? I had to admit I was beginning to believe him. This cop character was a pretty different guy from the Floyd character. Whoever Floyd was, he wasn't what I'd thought.

Because there it was again, the subtle difference in his speech patterns, his facial expressions, his body language. Almost like he was a different man. He could be telling the truth.

Or the shift was designed to make me trust him, and this guy was a better actor than I'd ever thought he could be, a lot smarter or shrewder than I'd thought Floyd was.

"No. I'm not going with you. Not anywhere."

"Okay, just a suggestion. Now you know. And I know, and we can pool our resources." He looked more serious then. "I wanted you to understand you could count on me when the shit hits the fan, because I think it's about to, real soon."

"And what makes you think that?"

He just shrugged. Okay, no giveaways here.

"I'm a loyal member of the Command, Floyd."

"Right. And the only way you can prove to me that you're a loyal member of the Command is by snitching on me." He was grinning. "You going to do that?"

Damn.

"There's a memorial service for Pete Ebner today. At Hal and Helen's. I'm going. Are you?"

"Nobody told me about it. What time?"

"One."

"I'll see you there."

"Yeah. See you there."

Fine. I still don't trust you, Byron, Floyd, or whoever you are.

He got back in his car and drove down Montford toward Miller, while I sat watching and shaking with nerves. When he was out of sight, I used my car phone to call Rosie. I told her about Floyd, and gave her the license number and description of the old green Camaro, including the headlight problem. She said she'd get on it

right away. She also said she had talked to Pauline and was waiting for what she thought was going to be some very interesting information about Pete Ebner's corpse. And oh, by the way, we had a new client. I told her I would be right there.

During the drive to San Rafael, I tried to get my head around the possibility that Floyd really was undercover. I was remembering, now, how Karl and Floyd had gotten into it at the ball game when Karl had said Floyd looked like a cop. Was he guessing, was it just his way of being insulting, or did he know something? I don't much believe in coincidence.

Saturday at the Coliseum I'd seen Karl near the phones, and it was when he came back from there that he had attacked Floyd. Maybe he'd been talking to someone, and got the word? But who from? And how?

And why? Why was he checking up on Floyd in the first place? Was that his job in the Command? His real job? And if it was his job, why hadn't anyone killed Floyd yet? Why was he still a member of the Command? And, on the other hand, why was Karl still running around loose, free to expose Floyd-Byron to the group? None of this was making sense, as usual.

Rosie was sitting at her desk, Alice at her feet, when I walked in, my head still circling the possibilities, my nerves still buzzing. "You okay?"

"Sure, Rosie. What have you got?"

"About your friend Floyd, I gave Pauline the name he gave you and his description and she didn't even have to ask around. She knows the guy. Byron Kern. A Berkeley cop. He's done some undercover work in the past. She says she didn't know he was doing any now, never heard he was working with San Rafael."

"Whoa, that's a relief. That he's a cop. Not so good that Pauline was totally out of the loop."

"I know. She says this is super-secret, though. She asked a couple questions and ran into a blank wall." But Floyd-Byron had said he was working with some people in San Rafael. Were those people also in the Command? "By the way, Pauline doesn't like the guy, this Floyd-Byron whoever, wouldn't say why, just said he was a dickhead. But you're probably okay."

"There's a thought. Me being okay. Anyway, Pauline doesn't like me, either, so I won't worry about that part."

"It's not that she doesn't like you. She just has her ways. She's still a good contact."

"Right. A good contact who didn't know her own shop was involved in the Aryan Command. A wonderful contact who thinks all men are slime, when she isn't busy grabbing their butts. I'm going to go chip myself an ax-head now and grab her by the hair. Thanks."

"Oh, I asked Pauline about Milly Levine. Says she's not one of theirs. Says she got a hint, wouldn't say where, that Gilly-Milly might be Israeli." The woman who'd called her by name had said she was from Los Angeles. She could be both.

"One more little item—and we never heard this from her. In fact, we never heard it at all. The weapon. From the size and shape of Ebner's wounds, a buck knife is a good possibility."

"That's not such a little item, Rosie. Kind of implicates old Red, doesn't it?"

"Possibly. And I called it little because the big stuff is really big. You're going to love this. The other thing I was waiting for?"

"Tell me already. I have to go to a memorial service."

"For Ebner?"

"Yes."

She grinned. "I'll go with you and mourn his passing. I guess when they planned the memorial they were missing some information."

"Which is?" She was enjoying this too much.

"Seems Ebner's sister came to claim the body, and guess who was with her, all broken up?"

"Rosie!"

"Okay, no more guessing games, but I'm beginning to wonder if anyone who belongs to that group of jackasses *isn't* working undercover. Pete Ebner's sister showed up with Cary Frasier. And they were both real upset."

Mulling that one over, I drove home to change clothes and get ready for the memorial service from hell.

Maybe Floyd didn't know yet, about Ebner. Maybe I wouldn't tell him.

At home, there was a message from Sally. The broker with the BMW, the guy with two first names, had made an offer on the house. A good one. We were ready to start dealing on the Scenic property.

osie was still chuckling when she came to pick me up for the drive to San Rafael in her six-cylinder marshmallow. She was glad to hear about the house, sure, but that news was running a slow second to the way the case was breaking. The last time I'd seen her so smug was the day I told her I'd decided to move to Marin and work for her.

"Pete Ebner!" she kept saying over and over again. "I can't wait to see which one of those dorks turns out to be from the Polish Resistance." Rosie liked old World War II movies.

When we got to Hal and Helen's, the front door was standing open so we went in, stopping just inside the doorway to scope things out. The oversized Aryan Command flag was hanging in the living room and twenty or so folding chairs were lined up in rows facing it. They weren't expecting much of a crowd. My original estimate of maybe two dozen members seemed to be holding pretty well. Deduct Ebner, Floyd, Gilly, and probably, a San Rafael cop I still hadn't pegged, deduct half a dozen who were probably just hangers-on who'd drift off to a new group in a few months, and this was a very small army, more than half of them stupid kids looking for excitement. And so far, the only "enemies" they'd managed to off were one of those kids and one of their own leaders, who was turning out to be—well, I didn't know what Ebner was, yet.

I reminded myself that the world had underestimated Hitler, glanced at Rosie to make sure she wasn't still giggling, and walked into the room. A few people, mostly warriors, were clumped around the wet bar, where Karl stood pouring beer. A table nearby was laid with a frayed white cloth and the requisite bowls of chips, puffs, and pretzels of many shapes and sizes.

I didn't see Floyd, Hal, Helen, Red, or Steve. Karl saw me and waved. I went to the bar.

"Where's everybody?"

"Big meeting. In the bedroom. There's some out-of-town guys. It's about Gilly. You know, about how could a thing like that happen, a ringer like her and nobody caught on. Not even me." He smirked and shook his head. "And about Pete's murder."

"Out-of-town guys? Who's at the meeting?" I was also wondering if anyone had heard anything about Ebner's connections to Cary Frasier, whatever they were.

"Inner Circle. And the guys are from, I think, Chicago." Karl raised his eyebrows, letting me know these were very important or very secret people.

"Is Floyd around?"

"No. Not here yet."

"How come you're not in the meeting, Karl?"

He picked at a dirty Band-Aid on his neck and scowled. "Not Inner Circle. And somebody's gotta keep an eye on who shows up. Want something to drink, Rosie?" He gave her what had to be his best smile. His teeth were gray.

Floyd—he would always be Floyd to me—pushed through the front door, spotted Rosie and me with Karl, and strolled over to join us.

"Hey, Jason. Rose." He didn't bother to greet Karl.

"Floyd."

"Where's everybody?"

Karl was glaring at him. "Meeting. Inner Circle only."

"Yeah? They been in there a while?"

"And they'll probably be in there a while longer."

"Yeah? Jeez, it's hot in here. You guys want to take a walk? Not you, Karl. You're working." Karl stared back at him coldly. We were about to follow Floyd out the door when Leslie came through it from outside, waving an *Examiner* in Floyd's face.

"Did you *see* this?"

She was angrier than usual. Floyd took her to a corner table and spread the paper out. Karl went along. Rosie and I trailed them.

We read over Floyd's shoulder.

"Unbelievable," Floyd said.

The story, on an inside page, was short, but told the rest of the tale on Pete Ebner. He had been identified. In the Seventies, he'd been loosely connected with the Symbionese Liberation Army before they kidnapped Patty Hearst. He had disappeared and then surfaced again as a member of several radical-left groups in the Eighties. Somewhere around 1992, he'd become a member of ThePeople, Frasier's group. But a couple of years later, he'd pulled out, or at least drifted off.

To become a Nazi? Certainly possible. There are people who just want to be on the outer edge, right or left, the ones who are just plain pissed off and don't spend much time thinking. Still, I was having trouble seeing Ebner as anything but a Nazi. It suited him so well.

Suddenly, as if she'd just noticed we were there, Leslie swung around and snarled at us.

"I don't know why they let you two in here. I don't know why you're not in the hospital with Royal. Or dead." She said it loud. Zack and Skink were watching. I wound up for a fast righteous-indignation pitch.

"You listen to me, Leslie. I'm sick and tired of this crap. You don't know who the hell to be suspicious of. You're like a goddamn mosquito. You'd better learn who your friends are. And you'd damned well better be grateful there are still loyal people like me and Rosie interested in what happens to the Command. Seems like you've got more than enough traitors to deal with as it is. We're here, we're loyal, and we're staying. You need us now, more than ever." That last bit sounded vaguely familiar. From some commercial or something? "You're way out of line, little girl." She actually took a step back and shut up.

I'd seen that before, with bullies like Leslie. They're bluffers, and they can be bluffed. Aggressors respect aggression. For all she knew, the way things were going, I could be the next warrior boss.

Zack and Skink came over to see what we were reading. They squinted at me, but they didn't say, "Oh, yeah?" or anything smart like that. They leaned over the table, looking at the paper.

Skink looked confused, kept glancing at Zack as if he was

searching for a cue. It occurred to me that maybe he couldn't read. Zack could. He turned red and started punching his right fist into his left palm, walking in a tight little circle. What a bunch of clowns. Struggling against the laughter that kept threatening to blow it all, I didn't dare meet Rosie's eyes, or Floyd's. I looked at Karl, who hadn't said a word. He was watching Floyd.

"I bet those guys in the meeting don't know about this," Leslie said.

"Bet you're right." Floyd grabbed the paper off the table. "I'll take it in there."

That was one way to get into the secret huddle. Leslie went with him. I asked Karl for a couple of beers. As he turned to walk back to the bar Rosie and I avoided looking at each other. This memorial service had turned out to be more fun than we'd ever expected.

We caught up with him and waited for our beers. I wanted to find out more about Karl's take on the Ebner fiasco. "Hey, Karl, what's the story here? Didn't the Command know Ebner had a bad past?"

Karl was pouring, careful about the head. Not too much foam. He shot me a look I couldn't classify.

"I mean, is it a problem that he saw the light, had a change of heart?"

"He never said any of this, Jase. Never said, Hey, I made mistakes but I got my head screwed on now. He lied. He told the Command he was always one of us."

"Maybe he was afraid to tell the truth."

"Ebner wasn't afraid of anything."

Leslie had marched back in and headed toward the bar. She'd heard his last remark.

"No. He wasn't. He sure wasn't."

"What's everybody saying, here? I'm a little confused." Rosie was wearing her best please-explain look, a sweet version of Skink's dumb I-don't-get-it sneer.

Karl didn't speak. Leslie did, but pretended she wasn't answering Rosie, turning away and talking directly to Karl. "He must have been a ringer, just like Gilly. And he really wanted us to kill

Switcher because he wanted Switcher dead. Not for any other reason."

"I can't believe that," I protested. "How many ringers we got, anyway?" I was counting in my head: Gilly, Ebner, Floyd, Royal, Rosie and me…that left Steve, Karl, Red, Hal and Helen, Leslie, Zack.… Maybe.

Leslie must have been reading my mind. She snarled at me, "Then there's you and Royal." She was still trying, but she wasn't very convincing. The Command was shrinking, spies were everywhere, her little world was in big danger of collapsing. She looked scared.

"Now, come on…" Karl said vaguely.

Floyd came back. The Inner Circle hadn't let him stay, either.

"They're going to be in there for a while. Rosie? Jase? Want to take a little walk now?" Leslie looked sullen, left out, but he gave her a sly look and she relaxed. I could practically hear her thinking: Oh, yeah. Floyd was going to do some interrogating, check us out, maybe push us around a little.

Outside, I asked him if they'd kicked him out of the meeting.

He smiled and shrugged, which probably meant yes. "Did you two check me out yet?"

"Yeah, Byron."

"Good. I hope you're not going to keep trying to scam me. You're here like I'm here. Only I'm here legitimate. Must be tough being around these guys and being a Jew. You and Gilly, huh? Pretty funny."

I didn't like it that he'd said "Jew" and not "Jewish." I didn't like the sound of the word in his mouth, and I was busy stewing about it when Rosie went for the big question.

"Did you know about Ebner?"

"Funny, huh? There's some stuff that's not in the paper yet, too." He didn't say yes but he didn't say no, either.

I still didn't like Floyd-Byron, cop or not. I poked him in the clavicle. He stepped back. "You going to tell us or just play cute games? I think you owe me."

"I don't owe you nothing, Jason. But I'll tell you this, Homicide thinks Ebner was involved in another murder. A kid who was a war-

rior. Friend of Royal's, matter of fact."

"Richard?" The kid who was thinking of turning left. He nodded. "Why'd he kill him?"

"Don't know. Maybe it was just part of his act as warrior-leader. I'm betting some of the warriors know about it, too. I'll bet Zack does. I've always had a feeling Ebner was the killer. Hints, you know?"

Rosie groaned. "What a mess. So maybe Ebner really was a convert, then."

"Not a chance. He was still connected with that bunch of lefty assholes in Berkeley."

Aha. ThePeople. Then maybe Richard died because he found that out and threatened to tell the Command. Had that possibility occurred to Floyd? That Ebner was a lefty ringer whose cover was about to be blown by Richard. So he killed him. Or got the warriors to do it. Nice bunch of guys, all the way around. Could be. In fact, the more I thought about it, the more I believed it. With Ebner dead, I wondered if we'd ever know for sure.

Okay, he'd given us some information, I could give him a theory. Even trade.

"What about the possibility that Ebner killed Richard before he could finger him?"

"Finger him? Finger him? All you private eyes talk that way?"

"Shut up, Floyd."

"Okay. Well, as a matter of fact, that's probably the case."

"Can't tell the players…"

"But you and me, we've got a program. Hey—" he paused for dramatic impact "—you two want to take in another ball game?"

Rosie laughed. "Fat chance, Byron."

He grinned at her. I didn't like him grinning at her. I asked big question number two.

"Who are these people at the meeting? Besides the Command, I mean?"

"Three guys I never saw before, but Steve seems to know them pretty well. One of them was telling Red something about his connections in Europe."

"Steve knows all the right people, doesn't he?"

"Yeah. I told you enough now. We better get back. Meeting might be breaking up. I got to be there." He turned and headed for the house again.

"Hang on, Byron. We're not done." He shook his head, but he slowed down and Rosie and I caught up with him.

"Who's next on the Command's hit list, Floyd—Cary Frasier?"

"Don't know, Jase."

Rosie grabbed his arm, trying to slow him down even more. "Who else is a ringer? If you knew about Ebner, maybe you've got some other ideas. And you said you work with San Rafael—is one of their people in that house today?"

"No ideas. No nothing. Back off." And that was all he'd say.

When we got back inside, the big-guys meeting had broken up and everyone was out in the living room. Three middle-aged men with bad haircuts and limp white shirts were standing at the bar drinking, scowling, and talking to Red, who was all puffed up with self-importance. Steve stood behind the bar, pouring a beer. Was I imagining it or was his hand shaking? His lips were a thin line, his face white.

The Chicago Three didn't look scary to me. They looked like unsuccessful insurance agents. I was surprised they weren't wearing pocket protectors.

One of them was saying, "...sorry we didn't get to him first. Show him..." There might not be a memorial service today, but it looked like this little hate-fest wasn't going to end any time soon. After all, you come all the way from Chicago, you don't want the trip to go to waste.

I spotted Hal and Helen standing near the kitchen door, holding hands, their eyes blank with what was probably shock. Helen's mouth was hanging open, too.

A few more people had arrived. The place was humming with Ebner's name, and Gilly's. Byron-Floyd stayed with Rosie near the bar; I started wandering through the room. I heard ZOG mentioned when I passed a couch where Zack sat with Leslie and Washburn, and wondered if everyone had decided that Ebner, too, worked for ZOG. Zack looked like he'd been crying, his eyes and nose all red.

I found Karl sitting alone in a chair in the corner, drinking a

beer and eating a bag of tortilla chips.

I squatted down next to him. "Real mess, huh, Karl?"

"What part?"

"Well, that Gilly thing—I can't get over that. And now Ebner was a ringer?"

"Yeah. Son of a bitch."

"It's just hard to believe he could get so high in the organization, be leading the warriors, and be doing the things he was doing when he didn't even, you know, believe any of it."

"Hey, Pete Ebner was a crazy man. He was willing to do anything. Doesn't surprise me. He wanted Switcher dead, he'd join Aryan Command to do it. Tell you something else. He was deep into the idea of a race war. I guess he thought his side would win or something." I couldn't even begin to guess what that meant.

"Who do you think killed him, Karl?"

He smiled. "Wouldn't be at all surprised if it was someone from the group he came from. Trying to stop him. He made a real good member of the Aryan Command. Maybe they thought, too good." That was a pretty interesting idea.

"You act like you know that's true, Karl."

"Not me, Jase. I don't know anything."

"I wanted to ask you something else. A while back you told me to be careful of Floyd. What did you mean by that?"

He stood, fidgeting with the bag of chips. "I don't know. I don't know anything anymore. Got to go talk to Red." And he left me squatting all by myself in the corner.

Zack was sitting on the couch alone now. He had the newspaper spread out on the coffee table and was staring at it as if he wanted to burn a hole in it. Or at least burn that story about Pete Ebner to ashes.

He was crying again. He began to beat his fist against the newsprint, slowly, rhythmically. I expected that next he would start rocking, or beating his head against the wall, but instead he gave the offending story one last bash and jumped up, red-faced with rage, screaming, "Skink!"

Skink, who'd been talking to Red and Karl, turned and stared at his friend, who was weaving through the crowd toward him.

I wanted to hear what Zack said to his buddy. I moved closer, pretending to be very interested in a bowl of pretzels.

"You know that thing we thought about doing? And Pete said not to? We're gonna do it now."

Skink looked doubtful, but allowed Zack to grab his arm and start to pull him away.

Red stopped them, putting a hand on Skink's shoulder. "Hey, Zack, don't forget. Tonight. Seven sharp."

Zack looked back at Red blankly. Then he nodded. "Yeah, right. Back room." And they were out the door.

Whatever Zack had in mind for the afternoon, it couldn't be good. And I had a pretty good idea of what it was. I looked around for the Berkeley PD but Floyd was nowhere in sight.

There wasn't any time to find him, and Rosie seemed to have disappeared. I didn't have my car! I was about to panic when she came wandering into the living room, probably from the toilet. I ran to her. Outside, Skink's motorcycle started with a roar.

"Rosie, give me your car keys, now!"

She hesitated for a second before she shook her head. "I'm going, too. You can explain on the way."

Blink of an eye and we were both out the door. The bike was just turning the corner when Rosie slipped the Taurus into drive.

It was a hard call, and I was scared we were making the wrong decision, but after I told her what was up, we agreed that we shouldn't blow our cover with the Command by calling the San Rafael cops.

We were a block behind when they zoomed across Grand and into the Canal district. Skink was in and out of lanes, skimming close to the slow-moving traffic. He may have been reluctant to join Zack at first, but he seemed to be getting into the spirit of it all now.

Now I was sure. Zack and Skink were headed for Royal's house.

Without the cops, all we could do was shoo the boys away with Rosie's Smith and Wesson ten millimeter and hope they didn't come back anytime soon.

I'd never seen either of them with a gun, only with the night-sticks they'd used at Frasier's demonstration. There was no telling

what Skink was packing on that hog, though. When we pulled up, I noticed Royal's car in the driveway. Who'd brought it from the hospital? The boys were at the door of the Subic house. Rosie skidded to the curb and I jumped out.

I heard Zack saying, "…apologize to you, man…" and before I could yell out a warning, someone had opened the door and let them in.

Was it true? Were they there to apologize to Royal, now that they knew the truth about Ebner? Why didn't I believe that?

I believed it even less when I heard a woman scream.

The door had not closed entirely behind them. Rosie kicked it open and drew the ten millimeter out of her gun-carrying-woman jacket, all in one movement.

What a picture, and everyone staring at us. On the floor, holding his head, was Mr. Subic. Zack was standing over him brandishing his nightstick. Skink had Royal pinned to the floor. Deeanne stood frozen in the kitchen doorway, a big iron pan in her hand, Mrs. Subic peering out from behind her. It was true what Royal had told us: The warriors didn't carry guns except for special assignments. It occurred to me that might have been Ebner's doing, one way he could keep them under some kind of control and make sure they only killed people he wanted them to kill.

"Drop the stick, Zack." Rosie waved the gun at him.

Zack didn't move, didn't answer.

"They're robbing Mr. Subic," Deeanne said. "They came for his money."

Somehow, I had to keep up the cousin act with Rosie standing next to me aiming a pistol. The scenario still had to be: Cousin Jase and his tough girlfriend, loyal Command hangers-on, racing to stop the warriors from making a terrible mistake. I didn't believe it myself.

"Jesus, Zack," I said. "You swallowed all that crap? There's no money. Not anywhere. Except for whatever Royal steals. I can't believe you thought it was true. He made the story up."

The hand holding the nightstick wavered, but just for a second.

"Bullshit! Bullshit! It's here."

"Zack, maybe…"

"Shut up, Skink. It's here. Lots of it. Why would Royal make it up?"

I didn't have an answer for that, so I just kept on talking. "You gonna beat the old guy to death trying to get it off him?"

"Maybe."

Rosie pointed the pistol at a spot in the floor between his feet, and fired. The wood splintered.

He dropped the nightstick.

She was the gun, I was the mouth: "Now get out of here and leave my family alone, you little shit. And let me tell you, Red's gonna hear about this. And Floyd, too." I wasn't sure what I meant by that threat: that the big guys would kick their butts, or would even kick them out of the Command? I left it vague. Like I knew something they didn't. Which was, of course, true, at least about Floyd.

"We were gonna give some of it to the Command," Skink protested.

But they were on their way out the door when he said it.

Subic got up, wiping blood off his brow, insisting that he was okay. His wife brought him a plastic bag of ice, which he held to his head.

I helped Royal get up and gave him his orders. "Lock all the doors and windows, and keep them locked, and don't let anyone from the Command in. If someone shows up again, call the cops." The motorcycle popped, sputtered, and roared, and its noise faded as it rolled away. Clowns. All of them.

I turned toward Artie's wayward ward. "And Deeanne. How did you get here? Artie was going to take away your car."

"I took a cab to Royal's car and used that." There was my answer to one question.

"You get home. And you stay there. And you go to school in the morning. And you stay away from this house. I've got a feeling you're going to be grounded for the rest of your life."

Deeanne didn't say anything. She was staring at Rosie's Smith and Wesson.

Mrs. Subic did, though. "I didn't know she wasn't supposed to come here." She sounded mildly, peacefully insulted.

"Not for a while, anyway. Let me put it this way, Deeanne. Dee-anne, look at me." She raised her eyes from Rosie's pistol. "You come near this house again and I personally will go to the police and tell them all about the Subics' cash stash, and where it came from."

Subic glared at me, then at Deeanne. He pointed at the door with his ice bag. "Get out. All of you."

We did.

We took Deeanne home, calling ahead to make sure someone was there. Julia was, and she was waiting when we climbed the steps. We handed Deeanne over and didn't stick around to hear what Julia said to her.

Rosie dropped me off at home and went back to the office. I told her I'd heard Red tell Zack to be at the bar at 7:00, in the back room, and said I'd pick her up at 5:45. I went inside, fed Tigris and Euphrates, took off my shoes and socks, and lay back on the couch to think.

When I woke up, I was depressed.

Sure, it was all pretty funny. Seductive Jewish spies. Left-wing crazies masquerading as right-wing crazies and sending skinhead punks on political suicide missions. Cops and PIs chasing each other around in circles. Warriors trying to steal from thieves. Rosie and I were working with the police in the person of Floyd-Byron, but he wasn't giving us much in the way of either help or information. I couldn't stand him, I didn't trust him, and we hadn't felt free to call the San Rafael cops for help.

From the beginning, nobody was who he was supposed to be. Zack was supposed to be Royal's friend; Gilly was supposed to be a Nazi. Pete Ebner, it seemed, had belonged to the lunatic or semi-lunatic left, and not to the altogether lunatic right. Could have fooled me.

Did Ebner kill Royal's friend Richard? If he did, the motive for that murder, and for his own, depended on who and what Pete Ebner really was, and why he was a member of the Aryan Command. He'd been leader of the warriors, and that made him responsible for a lot of violence and fear. For swastikas in a cemetery, a fire in a church. People had gotten hurt. Even Cary Frasier had

gotten hurt. Had that been staged? Was Pete's violence encouraged and maybe even planned by Frasier and ThePeople? Or was it Pete's own idea to lead the Command to a political cliff and right on over the edge?

Crazy, twisted thinking. With human sacrifices.

Either way, Richard had been getting too close to Ebner's real territory, and Ebner would have been afraid he'd be exposed somehow to the Command.

On the other hand, if Ebner was a double—triple? I'd lost track—agent, maybe it was Frasier's group he was afraid of.

One thing was sure: Ebner was somebody's renegade. So if there was any sense to any of this, that somebody was the most likely killer, or had sent the killer. I thought of Zack. Too bad his shock and grief at the memorial service had looked so real. He'd be the perfect hit man. Just tell him his hero was a traitor, hand him a knife, and send him off. But I was pretty sure he'd been unaware of Ebner's betrayal until he saw the story in the paper.

Red? Red, who wanted Ebner's job with the warriors. Red, who didn't like Ebner very much. Red, who had a buck knife.

I shook my head to clear it and looked at my watch. Five o'clock. I made a pot of coffee and a smoked turkey sandwich with pickles, tomatoes, and mustard.

But the truth of it was, I didn't have to care about Ebner. Figuring out what he was and finding his killer was not my job. Floyd could do that. The Berkeley homicide people could do that. Protecting Royal and getting him out of the mess he'd made of his life—that was my job.

Unfortunately, I hadn't done it very well so far.

At this point, the only way to save Royal, not to mention Deeanne and Rosie and me, was to be sure the Command's fangs—*all* their teeth—were pulled. That way, we might be safe. And that way, Royal could maybe ease his load of guilt over Richard.

So far all we'd managed to achieve was the dubious accomplishment of saving Preston Switcher's life, or at least postponing his death. Oh, yeah. We'd also protected a man guilty of armed robbery, kept him from getting mugged by Nazi skinheads, and gotten thrown out of his house by way of thanks. And what about the men

from Chicago? Would they make sure someone paid for the trouble the local group was having or would they just shrug, go home, and go bowling?

And we still didn't have a handle on whether the Command planned to kill Switcher or another target, and what changes they'd made in the schedule.

Five-thirty. I put on my shoes and went to get Rosie.

Thor's was nearly empty. Steve was behind the bar. He grunted at us but gave us coffee. Karl was there, slumped in a chair at a table near the jukebox. Before we could sit down with him, he mumbled something about the bathroom and took off. I thought he'd had too much to drink.

This was going to be tough, but we had a plan. Rosie was going to hang around the bar, talking, watching, and listening, and making sure there was jukebox noise to cover any I might make. I was going to do something else. About five minutes into the coffee, I got up and went to the men's room—and past it. I pushed the door to the back room, lightly. Unlocked. The rear exit, on the other hand, was locked from the inside, and I didn't want it to be. I yanked the bolts and turned the knob button. Ready for business.

Then I returned, slugged back my cold coffee, told Rosie I had a couple of errands to run and I'd see her in an hour or so, and went out the front door, over the fence next door, and around to the back.

Through the barred, dirty window, I saw Karl coming out of the toilet, and waited until he'd gone back into the bar and the hallway was clear.

The outside door squeaked, but the jukebox was playing heavy metal and I felt fairly safe. I slid quickly along the hall to the EMPLOYEES ONLY door and pushed, praying that no one had showed up early and blown our scheme. If someone was in there, I'd have to say, "Oops, sorry, silly me, wrong door," and back out again. It opened quietly and I peered inside. The back room was empty.

Six-thirty. I had to make a quick decision: The door I'd noticed before at the back of the room—a closet?—or the stage. I didn't

know where the door led, and I didn't have the time now to pick the wrong hiding place. I went straight to the plywood stage. Eight feet long. Probably just two-by-four framing. I could lift it if it wasn't nailed to the floor. It wasn't. I squatted, got my fingers painfully under the side, heaved, got down on my knees, wrestled the plywood over one shoulder, bruising myself for certain, and swung around inside, losing my grip at the last minute and getting a bashed calf as I slid under.

The stage was about two feet high, and big enough, I thought, so I wouldn't run out of air soon. Once I was under it, in the dark, I could see that the corner to my left was warped enough to let in plenty of oxygen and also give me a very narrow view of that side of the room.

There were no knotholes, no other gaps anywhere. I would not be able to see anyone coming in the door. I put my face close to the crack and waited. Just a few minutes later, the hallway door opened and someone came in, very quietly. Halting footsteps crossed the room to the right of the stage, still out of my field of vision, all the way to the back. The door, the one to the hiding place I'd decided not to use, opened and closed.

I waited to hear someone rummaging around, to hear the door open again, but there was nothing.

I held my watch up to the crack of light but couldn't read it. A few more minutes passed, and the hallway door banged open. Nothing sneaky about this entrance. This was someone who knew he belonged.

"Shut the door good." Red's voice. Another invisible person complied.

"Okay, here's what we're gonna do. We're gonna forget all that crap Ebner planned. We're gonna go right to Plan B, if you understand my point."

No! I don't! Whoever he's talking to—make him explain.

Zack obliged. "You mean Frasier? When do you want us to do it?"

"Tonight. He always leaves home at eight o'clock Tuesday nights for one of his meetings. We know that, right?"

"Yeah."

"What time you got?"

"Seven sharp."

"Your car running?"

"Yeah."

"Good. I got guns in the truck, outside. Get your troops together and get to his house by eight o'clock. Catch him outside. On his way to his little meeting. That way you won't have to worry about getting in."

"We got in at Subics'."

"That's 'cause Royal let you in, dumb fuck that he is."

So, Red knew about the boys' raid on the Subic house. Maybe the Command needed money. Or maybe Red did.

"Any special orders?"

"Yeah. Leave this on his body."

This? This what?

Zack giggled. "Shit, that's a good one."

"Get moving."

The hallway door opened and closed again. I thought, from the sounds, that they had both gone out. But I couldn't be sure. I lay there, waiting a little longer. Then I heard the other door, the door at the back of the room, open, and the sneaky someone—who was it? I couldn't see!—moved to the hallway door. Soft, hesitating footsteps. I could barely hear the door close behind him or her. If it was safe for the creeper to leave, it was safe for me.

Getting out was not as easy as getting under. No room to maneuver, no leverage. I gripped a two-by-four corner, lifted, and got a few fingers, then a forearm under the rough edge. Then both arms. I stuck my head out like a turtle peeking out of its shell, and scraped my shoulders through.

My arms and back were raw. I hoped my shirt was still in one piece, without blood spots, and that none of the bruises and scrapes on my arms, hands, and neck would show in the dim light of the bar.

Stopping with my hand on the doorknob, I listened. Voices outside. Floyd's and someone else. I waited. Both voices disappeared into the men's room across the hall. I opened the door a crack. No one else was in the hallway. It was now or never. I opened it

enough to slide through, ran for the rear exit, closed the door behind me, and headed back over the fence again.

And in the front door. A few more people had come in. The three guys from Chicago were sitting at a table now, drinking beer. Rosie spotted me and headed my way.

No Zack, no Red, but there was Floyd, walking into the bar from the back. He caught my eye. I stared at him to make sure he was paying attention, then I jerked my head in the direction of the front door.

Very casually, Rosie and I went outside to wait for him. I started to tell her what I'd heard, but Floyd showed up in two minutes.

I put it to him straight up. "Was that you in the closet?"

"What?" Okay, maybe not.

"Closet?" Rosie was practically bouncing on the balls of her feet waiting to hear what was up. I told them what I'd learned.

Rosie ran down what she could remember of people's movements in and out of the bar. Karl had come back from the bathroom, she said, left Thor's for a while, then came back. One of the men from Chicago had gone outside, and she'd seen him talking to Red. She'd lost track of Steve for about ten minutes, thought he'd been outside with another one of the out-of-towners.

Floyd-Byron nodded slowly, looking thoughtful. Not urgent, just thoughtful. Karl came out of the door and nodded to us but kept on walking.

As soon as Karl was out of earshot down the street, I said, "I'm going over there. To Frasier's." With Rosie and her pistol.

"Don't. I'll notify Berkeley PD and go myself."

He was off down the street before I could get in another word. I didn't have time to try very hard. I was busy following Rosie to the car.

As much as I didn't trust Floyd-Byron, I thought it was a safe bet that he would call the Berkeley PD, which meant that Rosie and I didn't have to make any long explanations to the 911 dispatcher about a supposed hit that was forty minutes off. Just the same, Rosie is very protective of her license—another reason not to have one, as far as I'm concerned: who needs something else to protect?—so we covered ourselves by leaving word for both Pauline in San Rafael and Hank in Berkeley. Maybe with everyone calling everyone else, someone would get there in time to save Cary Frasier.

Maybe they wouldn't.

We had the marshmallow, and Rosie was driving, so I made the calls, and I was very careful to mention Byron's name. If there was any police heat about anything connected with this operation, I wanted to be sure he was the one who got burned.

We were fifteen minutes, tops, from Frasier's house at the other end of town. I'd heard the address on only one occasion, but I'd never forgotten it: "Two-six-oh-five Barclay Street," chanted over and over, as a threat, the day the warriors had attacked Frasier's demonstration at Farrier's.

On the way up Ashby Avenue, I noticed a familiar vehicle three cars ahead, an old brown VW fastback. Still a few of those around Berkeley, but I was pretty sure this was the one that belonged to Karl Tullis because it had all the right dents and scrapes. And that helped a few other things fall into place. I pointed it out to Rosie. She said he could be going anywhere. I explained why I thought that it was more than possible he was on his way to Frasier's, just like we were.

Floyd had been my best first guess about the other eaves-

dropper, but the slight irregularity I thought I'd heard in the gait could have been more than just sneaky tiptoeing. It could easily have been a limp. Karl's limp. From what Rosie had said about his movements, he could have gone to the men's room, checked the back door—finding it unlocked, thanks to me—gone into the bar again, out the front door, over the fence and in, just like I had. And this latest conference might not have been the only one he'd ever overheard.

I was remembering the night way back last week, it was one of the first times I'd gone to Thor's. Karl had rushed away from our table and disappeared; Ebner and the two boys had met in the back room and come back out again. Royal, knowing he was in for a warrior assignment, nervous, had spilled his drink and dashed to the bathroom, nearly colliding with Karl who was reappearing from the hallway. Maybe from the toilet, maybe not. But if he'd been eavesdropping, then or now, I could guess why—he was tired of being out of the Command loop. After all, he was the smart one, wasn't he?

Which brought up the other point. If his "guess" that Floyd was a cop was more than just a guess, if he'd actually found something out, why hadn't he exposed Floyd to the group? Why had he just teased him with the possibility? What was he after, anyway?

Rosie listened to my questions and my theorizing in silence. Then all she said was, "Karl. Hmm. Karl." And then, "So why's he heading for Frasier's? To get in on the assassination?"

Or maybe to get there first and do the job himself? That was a possibility. Or maybe he was just another ringer from God knows where.

The brown fastback turned left; so did Rosie.

We fell back a bit, watching the VW. No doubt about it, Karl was heading for Frasier's. He parked down the street, ran into Frasier's driveway, and disappeared at the back of the house. Rosie also parked half a block away and we walked toward number 2605. Twilight was just about to drop into night, and there were no signs of life in or around the house. I maneuvered down the driveway, Rosie just behind me, sliding from shrub to shrub. The curtains were drawn in the dark windows all along the side. One light in a back

room made the nearer part of the backyard brighter than I wanted it to be. Rosie stepped ahead of me and drew her gun. I reflected again that I might have to get one of those. I hate playing second fiddle when the chips are down. I would never say that out loud, by the way, not in her presence. Rosie hates mixed metaphors.

If Karl was in on this job, was maybe even the chosen killer, we'd have to stop him somehow. But what if he'd come to warn Frasier, or even to save him? If he spotted us sneaking around, he could easily guess that we were there on Command business, that we had been assigned to kill Frasier for the Command and prove our loyalty. Either he or Frasier could be armed, and they might not stop to chat with us. In either case, whether he was the killer or the savior, I was afraid Rosie might have to shoot someone. Probably Karl.

Poor Karl. It would be just like him to try to grab a little glory and get killed in the attempt.

There was no curtain in the window next to the back door. Standing far enough away in the darkness to see and possibly not be seen by the people in the lighted room, I looked in.

Karl was there. He and Frasier were sitting at the kitchen table, Karl talking a mile a minute, waving his hands. Frasier nodded, got up, went to the phone. I moved closer so I could hear.

"…bunch of Nazis, coming here…kill me…"

He was standing with his back toward me so I couldn't tell how many numerals he'd punched in. He could have been calling 911 or some of his followers or friends.

Then he went to a kitchen drawer and pulled out a pistol, an automatic. I'm no gun expert, but I could at least see that the weapon was big. Bigger than Rosie's ten-millimeter.

Frasier waved for Karl to follow him to the front of the house. Karl shook his head and came right toward the back door. Toward me. He pushed it open and put one foot on the stoop.

Rosie stepped out of the bushes, pointed her pistol at him, and said, "Hi, Karl."

The skinny little guy nearly jumped out of his jeans. He started babbling hysterically. "Oh, Jesus. What are you guys doing here? They sent you, didn't they? You followed me, didn't you? They

know, right? Steve? This is your membership test, catching me, oh shit, Jase, I thought we were friends. Cary! Cary! Help!"

He was crying. Cary Frasier didn't come.

I figured by now several armies were on their way to this quiet street. I wasn't sure I wanted to be there at all, but if I was going to stay I wanted to know what was going on.

"Karl, we're not going to kill you. Just tell us, fast, what the hell you're doing here."

Cary had apparently thought better of abandoning Karl. Suddenly he was in the doorway, pointing his automatic at us.

"Drop it, lady."

She didn't drop it, but she talked fast. "Look, we're not here to kill you, either. We've been working undercover. We're PIs. Royal hired us to, well, I guess save him from himself, and we—"

"—didn't do such a good job!" Karl laughed, sounding a little less hysterical now that he had Frasier, and Frasier's gun, beside him.

I moved a couple of steps away from Rosie, to give Frasier a more confusing target. "Pete Ebner wasn't the only ringer in the group from ThePeople, was he, Karl?"

"No, but he was the only crazy one."

Suddenly I was sure who had killed Ebner. "And ThePeople had to stop him, didn't they, Frasier? Or risk taking the blame for the race war he wanted to start, not to mention all the killings he was planning. That would have been wonderful. The guy gets caught and tells the press he was really a member of your group. Just what you need, right?"

"Who are these people, Karl?" He actually spoke through gritted teeth, something you don't get to see too often.

"I've got one of our agency cards in my shirt pocket, Frasier. Can I reach in and get it? I don't have a gun."

"Karl, you get it."

He did, his fingers barely touching the body behind the fabric, and handed it over to Frasier.

Who looked at it and handed it back.

"You can't prove Pete Ebner was killed by any of us."

"You're right. I can't. I'll just let the cops sort it all out."

And that was when we all heard the car squeal to a halt in the driveway. No headlights. We heard running feet, and Floyd-Byron, flanked by two of Berkeley's finest, raced around back, guns drawn, and nearly ran right into me and Rosie. Frasier dropped his gun. I heard the cop car pull out again. I wondered how many cops would be hiding in the bushes on this side of the block.

Karl was laughing and pointing at Floyd. "Hey, it's really true, son of a bitch. You are a cop. Hah! I knew it. Son of a bitch!" He was ecstatic.

"What the hell—Karl? Go home, Jake. And you too, Rosie."

I answered for both of us. "No."

"Then go watch from your car."

Nothing I wanted more, but I didn't like his attitude. "Screw you."

"Now! They'll be here in ten minutes, ready to kill Frasier, primed. Unless Karl was point man—listen, Frasier, did this guy try to off you?"

"This man is one of mine," Frasier intoned. What a jerk. "He came to warn me. ThePeople are one!" Well, maybe it wasn't exactly true that Ebner was the only crazy member of Frasier's group. Floyd-Byron looked at Rosie and burst out laughing.

"Jesus. They're all nuts. But go sit in your car anyway."

I wasn't ready to go. "What about Red? What about Steve? What about the three stooges from Chicago?"

"We raided Thor's about five minutes ago. And the house in San Rafael. Conspiracy to commit murder."

"Okay," I said, surprised he'd give us that much, relieved and suddenly exhausted. "Rosie, let's go sit in the car."

The cops took Frasier and Karl away, and we got out of the mix, back to the Taurus marshmallow. Rosie started it up and tucked it into the driveway of an unlighted house just a couple of doors down. Most of the car was behind a couple of trees. Perfect spot for watching fireworks. A couple more lights went on in Frasier's house. The cops, probably trying to make sure the warriors knew Frasier was still home.

The warriors showed up, at precisely eight o'clock, Zack at the wheel. Skink and Washburn were with him. They slid to a stop

outside the circle of yellow cast by the streetlight about six feet from where we were sitting, hunched down low behind the dash.

Skink stuck his arm out the passenger-side window, pointing to a new Volkswagen Beetle parked at the curb. "That's Frasier's. He's here. Let's go." He opened the door and jumped out into the light. He was holding a gun. Special issue from Red, keeper of the arsenal. Washburn climbed out of the back seat. "Hey, Skink, wait. We're supposed to wait until he comes out." The two of them stood there, looking back toward Zack.

Zack turned off the ignition, and slowly, deliberately, stepped out of the car and walked over to Frasier's Beetle, lifted his boot, and kicked out one of its tail lights. Like Leslie, he favored steel tips. "Fuck it. Let's go in now."

They walked quickly, and considering the boots, pretty quietly up to Frasier's house.

I was thinking these kids didn't follow orders very well, for Nazis. This was working out pretty neatly.

Zack was doing something to the front door. It looked like he had a picklock in his hands. Skink, holding his weapon, trotted around to the back of the house. Suddenly Zack swore, yanked at the knob, tossed the picklock into the bushes, pulled a gun out of his jacket, and kicked in the door. Maybe he'd missed a couple of lessons at locksmith school.

I heard a crash from the back of the house a split second later. Skink had broken a window.

Seconds after the boys entered front and back, guns drawn, so did the police.

Not a shot was fired.

M r. Samson, this is Harry George."
"How nice of you to call."

He ignored the sarcasm. "I just wanted to tell you that we were aware of the activities of the Aryan Command, and were, in fact, attempting to follow their connections through Steve Dahl. Of course, he's gone now. But we'll find him."

"I'm sure you will."

"It's always difficult to run a covert operation, take it as far as we need to, when other people get involved."

"Like me. And the police."

"Yes. Mr. Samson, you really need to have more faith in your government."

"Mr. George?"

"Yes?"

"Maybe you really need to have more faith in your citizens. By the way, was Gilly Johns working for you?"

"Good-bye, Mr. Samson."

"Good-bye Mr. George." You big purple glass-eyed ball of fuzz.

It was true about Steve. The owner of Thor's and the visiting three little pigs had gotten away. Nobody seemed to know how that had happened.

I told Rosie that I would always wonder if Floyd-Byron had tipped them. She said Pauline was wondering the same thing, and so was Hank, and he had told her he wasn't the only one in the Berkeley PD. And even though I didn't want to give Pete Ebner credit for telling the truth about anything, I couldn't forget what he'd said to Royal about the Command having cop members. Or at least, member.

But Red hadn't been tipped off. They'd picked him up standing

outside the bar, staring at the door. Probably wondering why it was closed.

Pauline also mentioned that the San Rafael PD had been bounced out of the game a little early when their undercover cop, Maryanne, got 86'd from Thor's with her boyfriend. So I'd never had anything to fear from the skinny skin-chick with the buzz cut. She wasn't even a kid. Turned out she was a young-looking twenty-seven.

Skink had been willing to tell the police anything they wanted to know about everyone, including Zack, to cut his own time. Desperate, I supposed, to get back to that big black motorcycle of his. He even talked about the just-for-fun vandalism some of his fellow warriors had committed, and about the attempted robbery at the Subic house.

The back of this local subgroup of subhumans was broken.

The police were puzzled by the object they'd found in Zack's pocket, until Skink told them that Red had given Zack the photo to plant on Frasier's corpse as the killer's calling card. It was a newspaper picture of Desmond Tutu.

Royal was mending nicely. It was going to take a wad of his daddy's ill-gotten cash to fix that mouth, and I wondered if he would always feel guilty about his expensive new teeth.

Maybe Rosie and I should have mentioned Subic's supposed involvement in a years'-old robbery, but we didn't. We decided to treat it like a figment of Deeanne's imagination.

Although I suspected Leslie of taking part in all sorts of unpleasant Command activities, and knew she'd been in on Royal's stomping, nobody mentioned her and nobody pinned anything on her, so she was still running loose. Somewhere. If the rest of this crowd was any indication, I expected to see her next at a high school pep rally wearing a ponytail and a letter sweater.

Ebner's sister had taken his body back to Montana for burial in the family plot.

Sally and I made Minneapolis chow mein, and we ate it for dinner, and breakfast, too.

The house I'm selling and the house I'm buying are both in escrow, which is a little like limbo except that there's an end-date. To

celebrate, Artie and Julia are throwing a dinner party next week for Sally and me and Rosie and a date—someone I haven't met. And Deeanne and Royal.

Artie has turned one of his best staff writers loose on the Aryan Command story with a stack of my notes. Artie's pleased with everything except the condition of Deeanne's love life.

"Damn, Jake, couldn't you have encouraged Royal to go for the skin-chick?" I'd told him about Leslie and how she'd been pursuing Royal for a while.

"Artie, I wouldn't have encouraged Hitler himself to go for the skin-chick. And Royal's really an okay kid. I think he saved Gilly's life that night, and he says he's going to volunteer at an old people's home in Berkeley."

"A guilty conscience is a wonderful thing."

"In this case, yes. Too bad Richard had to die to give him one."

"Sad, huh? About Richard?"

Karl had told the police that Ebner had killed the boy because, in his wanderings on the left, he was getting too close to ThePeople. He corroborated what Royal had told me: that it was Royal's well-meant tip to Ebner that had led directly to the boy's murder.

In a way I expected Karl to confess that he'd killed Pete Ebner, brag about it, claim credit for the death of the man who wanted Switcher dead, the Command destroyed, and his own version of political order established—no matter how, and no matter how much it hurt the group Ebner was supposed to be working for.

Karl didn't confess, but Pauline told Rosie he was the major suspect. The Berkeley cops had found the knife that was used, she said, in the water near the Berkeley Marina's shore. It was a buck knife all right. I was guessing Karl's choice of weapon had been a deliberate try at implicating Red.

But even if they couldn't tie the knife to Karl, there was blood under one of Ebner's fingernails that didn't belong to the dead man himself.

I remembered the dirty Band-Aid on Karl's neck. Poor Karl. His blood would tell. I wondered if he'd take Frasier down with him.

§

Thor's was closed now. Someone else would open something there, a bar or a restaurant.

The back room was ready and waiting. With any luck, the next gathering it would see would be a drag show, or a rally against a zoning change, or a neighborhood watch meeting, or a psychic faire.

But I had a feeling about that place. A feeling that it should just be torn down and replaced with a playground. Or, like Rosie says, a dog park.

We're fighting now over whether she should ask the Vicente World Secret Dictatorship to take care of it, or if I should contact all those relatives I must have in ZOG.

Paula Solomon

ABOUT THE AUTHOR

Shamus Award–nominee Shelley Singer is the author of twelve novels and many widely anthologized short stories. Singer has been a reporter and an editor, and has done "too many things" for a living. Currently she teaches fiction writing as a consultant, in private workshops, in college classrooms, and on-line. She lives in Marin County, California.

DATE DUE